Happy Birthday 1998

Love,
Barb

Happy Birthday 1998

EYEWITNESS

EYEWITNESS

150 YEARS OF PHOTOJOURNALISM

Richard Lacayo and George Russell

EYEWITNESS: 150 Years of Photojournalism

First edition 1990
Second edition 1995

1995 Edition
Managing Editor: *Kelly Knauer*
Photo Editor: *Rose Keyser*
Designer: *Anthony Kosner*
Copy Editor: *Ellin Martens*

NEW BUSINESS DEVELOPMENT
Director: *David Gitow*
Assistant Director: *Stuart Hotchkiss*
Fulfillment Director: *Mary Warner McGrade*
Senior Development Manager: *Peter Shapiro*
Development Manager: *John Sandklev*
Production Manager: *John Calvano*
Operations Manager: *Donna Miano-Ferrara*
Assistant Development Manager: *Allison Weiss*
Development Assistant: *Dawn Weland*

1990 Edition
Senior Editor: *Jane Kagan Vitiello*
Director of Photography & Research: *Geraldine Howard*
Photo Editor: *Marthe Smith*
Production Manager: *Jerry Higadon*
Designer: *Bruce Campbell*
Editorial Assistant: *Stacey Harmis*
Researchers: *Barbara Burke, Daniel Levy*
Copy Editors: *Terry Stoller, Dora Fairchild*
Photo Researchers: *Francesca D'Andrea (Paris), Sahm Doherty (London),
 Angelika Lemmer (Bonn), Molly Winkelman (New York)*
Associate Production Manager: *Rick Litton*
Production Assistant: *Terri Beste*

Published by TIME Books
1271 Avenue of the Americas
New York, New York 10020

ISBN: 1-883013-06-2

Printed in the United States of America

CONTENTS

INTRODUCTION

This book grew from a special issue of TIME Magazine that was published in 1989 to celebrate the 150th anniversary of photojournalism. A gallery of many of the most memorable photographs ever taken, the issue was hailed by readers, some of whom wrote to suggest the contents should be collected in more permanent form. Following their advice, TIME published *Eyewitness: 150 Years of Photojournalism* in hardcover form in 1990. The book was a greatly enhanced version of the magazine, allowing the presentation of many more photographs and permitting writers Richard Lacayo and George Russell to expand their informed and insightful survey of their subject.

This second edition of *Eyewitness* updates the final chapter of the book to include new photographs from the 1990s. These new pictures include images that have already achieved the status of contemporary icons: the grief-stricken firefighter carrying a small child from the bombed federal building in Oklahoma City, a crowd in Somalia jeering as the dead body of a U.S. soldier is dragged through the streets. The new material amply confirms Richard Lacayo's conclusion in the final chapter of the 1990 edition: despite the currency and availability of video images, the still picture retains a unique power to move minds.

In his introduction to the first edition of *Eyewitness*, Donald Morrison, then special projects editor of TIME, issued this warning to readers: "Photojournalism, the industrial-strength version of photography, is an untidy collision of art, reportage and commercial publishing. It is often not pretty. As a fair representation of the craft's 150 years, this book depicts a shocking number of wars and other tragedies." The new pictures in this edition of the book are no less troubling. Readers will find sorrow and misery in the images collected here—but they will also find courage and dedication on the other side of the lens.

—The Editors

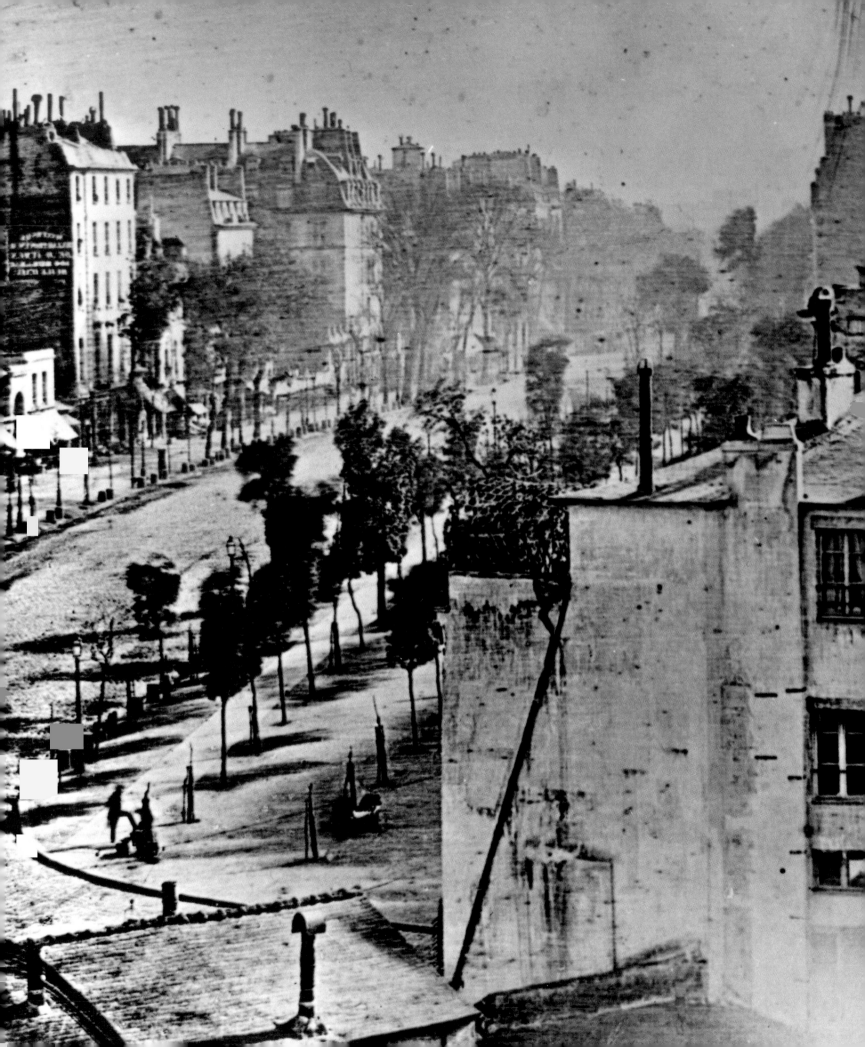

I: BEGINNINGS 1839–1880

Here is a photograph of a Paris street, the Boulevard du Temple, on a bright day sometime in 1839. Taken from an upper-story window, it shows a tree-lined avenue that slants toward the top of the frame. The eye takes in chimneyed rooftops, the drawn curtains of an apartment, even the separate cobblestones of the pavement. But because photography is still in its infancy, a new process that requires an exposure time of several minutes, nothing that moves quickly has registered on the plate. None of the carriages, horses or pedestrians that passed before the lens on this day have left a trace—with one exception. On a street corner in the lower part of the frame, it is possible to make out the small, blurred silhouette of a man. He has lifted a leg to have his boot polished, which explains why he has been standing in one spot long enough to leave his image, but not quite still enough to be in good focus. This is the first known photograph of a human being.

Once that solitary marginal smudge has been recognized as a person, the whole picture seems to emanate from the point he occupies. It's impossible to look at this image now without feeling an urge to bring that anonymous man into focus. Which leads us to the challenge that has driven photojournalists from the beginning: how to make the human race visible to itself. That quest has led them to confront hostile surroundings, nature's challenges, censorship, fallible equipment, the conventional tastes of photo editors and readers, the distorting scrims of their own prejudices, the inherent limitations on what a photograph can convey, and all the complexities that surround the question of "What is truth?" Perhaps more than any other branch of photography, it is photojournalism that has tested the capabilities of the camera, the photographer and the viewer.

Photography was not the invention of a single person or moment. It arrived at the end of a long series of discoveries, summoned by a line of chemists, artisans and tinkerers. All of them shared the intuition that light could leave a permanent imprint on a flat surface that had been spread with some combination of chemical substances. Their discoveries culminated in the work of two men. One was Louis Jacques Mandé Daguerre, a Paris stage designer and entrepreneur who took

the picture of the Boulevard du Temple. The other was William Henry Fox Talbot, an English squire with a comfortable income and a multitude of interests, which included mathematics, optics and drawing.

Daguerre perfected his method, which produced an image upon a silver-coated copper plate, on the basis of research pursued first by Joseph Nicéphore Niépce, a prosperous gentleman-inventor with whom Daguerre had joined in partnership in 1829. When Niépce died four years later, Daguerre went forward on his own until he arrived at a technique that produced clear, stable images. At that point, François Arago, a friend and member of the French Academy of Sciences, persuaded Daguerre to make his method available free of charge to the world, while he encouraged the French government to provide lifetime pensions for Daguerre and for Niépce's son.

The French Academy announced Daguerre's discovery in January of 1839. Later that year, the legislature in Paris finalized arrangements to share Daguerre's process with other nations (except Britain; even in this moment of global largesse, France was not about to oblige its perennial rival). The news was greeted by the press with instant enthusiasm and by the public with an excitement that came to be called *daguerréotypomanie*. "Opticians' shops were crowded with amateurs panting for daguerreotype apparatus," one observer would write later. "Everywhere cameras were trained on buildings. Everyone wanted to record the view from his window."

Word of Daguerre's triumph came as a less welcome surprise to Talbot, who had been working separately on a different method for producing images. Unaware of the Frenchman's research, he had put aside his experiments in 1837, though not before obtaining a series of promising results. With Daguerre now being lionized, Talbot rushed to perfect his process.

He called his method the calotype, from the Greek words *kalos* and *tupos*, meaning "beautiful picture." Its great advantage was that it produced a paper negative from which any number of prints could be made. (Though it was technically possible for daguerreotypes to be duplicated, it was so difficult that nearly all of them remained one-of-a-kind pictures.) A disadvantage was the rough texture of the paper, which deprived the calotype of the mirror-surface clarity that was the daguerreotype's chief fascination. Even that seemed attractive to Talbot, a sometime artist who prized the atmospheric blurring of edges that his method produced. ("Rembrandtish," he called

Boulevard du Temple, Paris (detail)
Louis Jacques Mandé Daguerre, 1839

HARPER'S WEEKLY.

JOURNAL OF CIVILIZATION

Vol. VIII—No. 394.] NEW YORK, SATURDAY, JULY 16, 1864. [$2.00 FOR FOUR MONTHS.
$6.00 PER YEAR IN ADVANCE.

LIEUTENANT-GENERAL GRANT AT HIS HEAD-QUARTERS.—[PHOTOGRAPHED BY BRADY.]

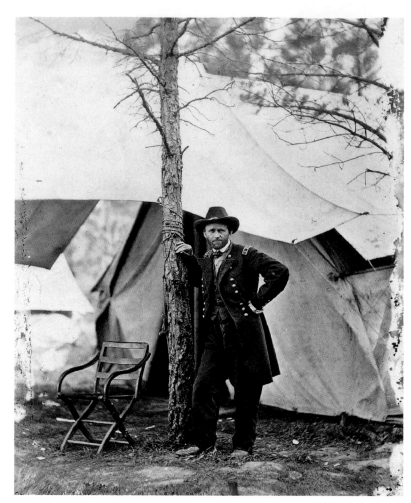

Wood engraving from *Harper's Weekly* of Union General
Ulysses S. Grant at his headquarters

Photograph on which engraving was based *by Timothy O'Sullivan*

it.) The calotype lends a gentle timelessness to many of the pages of *The Pencil of Nature,* the famous volume of photographs he published in segments between 1844 and 1846. Setting up his camera in various spots around his country estate, Lacock Abbey, Talbot made pictures—of a haystack, a solitary bush, a broom propped by an open doorway—that possess an air of the picturesque and the immemorial. There is no hint of any turmoil in the wider world.

Talbot's process never became as popular as Daguerre's. As late as the mid-1840s, there were probably no more than a dozen practitioners of the calotype anywhere in the world, while daguerreotype studios were appearing by the dozens on both sides of the Atlantic. Because the calotype method was patented, any photographer using it was obliged to pay Talbot a fee, giving professionals one more reason to prefer the daguerreotype. And the slight fogginess that made the calotype attractive to artists made it less satisfying to the typical customer for a portrait—a major drawback, since portraiture rapidly became the most common and profitable use for photography.

It would be fair to say that neither of photography's two

inventors was entirely sure just what this new discovery would be useful for. It did not take long, however, for some of their contemporaries to pose an obvious question. Why shouldn't this pencil of nature serve as a pencil of history too? If lace and flowers could inscribe themselves on the photographic plate, why not battles, ribbon cuttings and earthquakes? In 1852, in a review of the first all-photographic exhibition held in England, the *Times* of London recognized the larger potential of the camera. "It secures precise and charming representations of the most distant and the most evanescent scenes," the paper's correspondent wrote. "It fixes, by almost instantaneous processes, the details and character of events and places, which otherwise the great mass of mankind would never have brought home to them."

To the 19th century mind, with its penchant for the scientific and the mechanical, the camera quickly came to be regarded as the supreme mechanism, a kind of trap for facts. Able to capture a scene in high detail, operated with a minimum of human intervention, it seemed from the first to have a special purchase on the truth. But while dozens of illustrated period-

icals in Europe and the United States would have liked to adopt the new form, none was able to. For decades there was no practical means to print photos and text on the same page. The first workable method, called the halftone process, would not enter into widespread use until the 1890s. Until that time, newspapers and weeklies could at best publish engravings copied from photographs—sometimes copied closely, sometimes altered to make them more lurid, patriotic or sentimental.

In any case, the bulky camera gear of the 19th century hardly lent itself to stop-action coverage. By the mid-1850s, both the daguerreotype and the calotype were being abandoned by photographers in favor of a new method, the wet-plate process. It combined the clarity of a daguerreotype with the calotype's ability to produce duplicate images from a single negative, opening the way to a crucial advance, the mass production of images. In other respects the new process was more cumbersome than its predecessors. Each negative was formed upon a sheet of glass that had to be coated with an emulsion before it was inserted into the heavy box camera. After the picture was taken, the plate had to be developed at once. That obliged photographers working out of doors to travel with a darkroom, usually a horse-drawn van or a tent that could be pitched at the site. Action shots were ruled out because the wet-plate process could require exposure times of 15 seconds or more. And while history might be made at night, photographs almost never were. Flash powder did not come into use until the 1880s.

In its early decades, photography was best suited not so much to fast-moving events as to the motionless rubble and corpses left in their wake. The photographers who worked in that era did not think of themselves as photojournalists, even though their pictures might sometimes be picked up by the illustrated press. The appearance of the first self-described photojournalists would wait until the last decade of the century, when the necessary technologies were all in place and the mass-circulation press had evolved into the tabloid world of scandal and circulation wars. Hoping that photographs would provide an edge over the competition, press lords like Joseph Pulitzer and William Randolph Hearst hired the first full-time news photographers. Yet through all the early years of the camera's history, there were photographers who, while they never took the name "photojournalist," understood themselves to be pursuing timely subjects for a wide audience—in effect, to be reporting. Though they may have been souvenir peddlers, artist-entrepreneurs or just camera-equipped adventurers, they were also photojournalists.

The first event memorialized by a camera was a typical news subject—a disaster. After fire destroyed much of Hamburg, Germany, in 1842, two German daguerreotypists, Hermann Biow and Carl Ferdinand Stelzner, made a series of views of the charred remains. Neither man's pictures were widely seen at the time, however, and Biow's have since been lost. In the United States the first photograph of a public event was made two years later, when Philadelphia was shaken by anti-immigration riots. William and Frederick Langenheim, two of the city's most enterprising photographers, aimed their daguerreotype camera out the upper-story window of their studio to capture a scene of the unruly crowd assembled outside a bank. That image too received little notice at the time.

That was to be the fate of most of the earliest photographs of current events—to disappear before reaching much of an audience. During the Mexican War of 1846-48, an anonymous daguerreotypist made a series of pictures that did survive, mostly portraits of officers and enlisted men. Though they are probably the first photographs from a war zone, it appears that they were never displayed. Yet the audience for such pictures was growing. With the press embarking upon a period of quick expansion—the result of increasing literacy and advances in rapid printing that made it possible to produce huge editions—"the people" were becoming "the public." Civil life would be transformed. Popular prejudices were magnified by the press, leading to a louder clamor and intensified passions. In such a climate the Mexican War became a hugely popular campaign of expansion, at least on the American side, inspir-

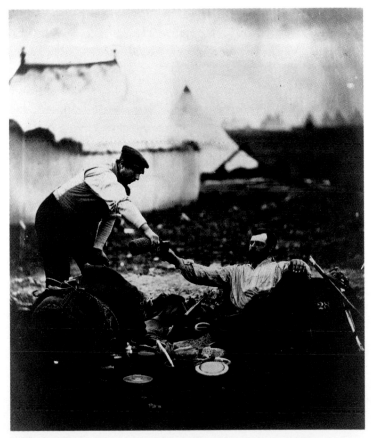

British officer at ease in the Crimea *Roger Fenton, 1855*

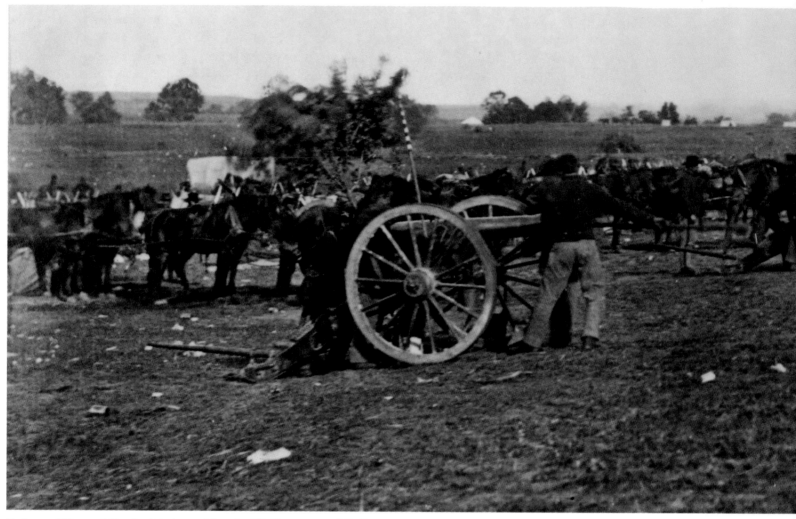

Union artillery at Fredericksburg *Timothy O'Sullivan, 1863.* O'Sullivan, one of some 20 photographers employed by Mathew Brady during the Civil War, took this picture just as the heavy guns went into action, and had to hurry his equipment wagon out of the line of fire.

ing newspapers to send off the first war correspondents. One sign of photography's growing prestige and impact was that editors took to promising their readers "daguerreotype reports," stories with a photograph's immediacy and detail—without the photographs themselves.

It took another decade before a significant body of war photography was at last brought before a wide audience. Perhaps it's only fitting that the pictures—scenes of the Crimean War made in 1855 by the British photographer Roger Fenton—demonstrate not only the capabilities of the camera but also the pitfalls. Fenton worked with the cooperation of the British government, and he served its purpose: to make pictures that would dampen public outcry about the mismanagement of the war. His pictures open the history of photojournalism with a cautionary tale, an episode of original sin.

Victory notwithstanding, the Crimean War was for the most part a disaster for Britain, which had joined France, Turkey and Sardinia to block a Russian push against the Ottoman Empire. The British military establishment was unprepared

for modern warfare or for the harsh conditions of the Crimea, a Russian peninsula on the Black Sea. The fighting men suffered terribly from disease and hunger, the septic conditions of their field hospitals, the interruption of their seaborne supply lines and the incompetence of their officers. Cholera swept through the ranks, eventually killing even the British commander Lord Raglan (something of a blessing for the troops, given Raglan's maladroit battle tactics). The war found its perfect memorial in *The Charge of the Light Brigade,* a poem that blows a fog of sanctity around a lethal military blunder.

This was the war that Fenton documented and, in some measure, sanitized. Like Talbot, he was a well-to-do Englishman, the son of a mill owner and banker. Though trained as an artist, he pursued a legal career until the 1850s, when he put aside the law to indulge his passion for the camera. Fenton became one of photography's great early masters; his landscapes and architectural studies in particular are some of the most elegant products of the 19th century camera. A cofounder of the Royal Photographic Society, he also made por-

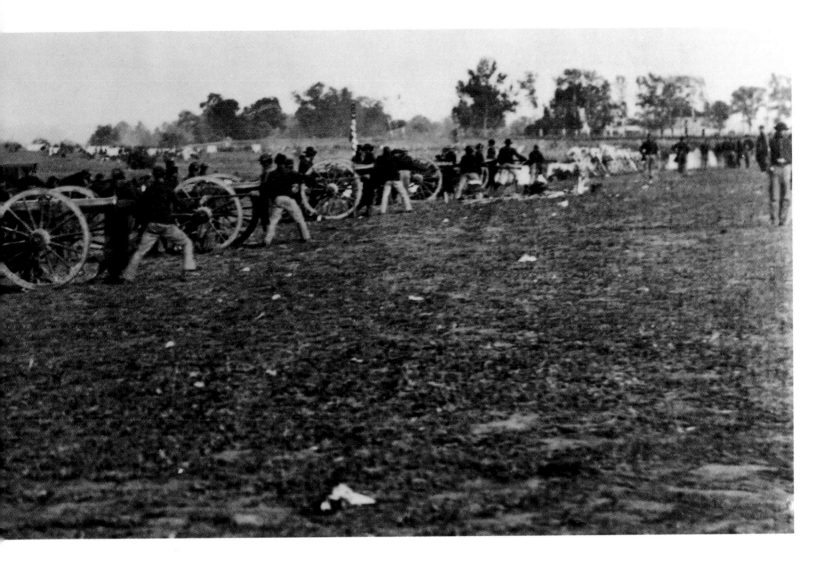

traits of the British royal family, a connection that would eventually gain him entrée to the battlefield. As the government's mishandling of the war came under fierce criticism from the press, Fenton embarked for the Crimea with a commission from the Manchester print seller Thomas Agnew and letters of introduction from Prince Albert.

The Prince, an enthusiastic promoter of British photography, understood the camera's powers of persuasion. Fenton's mission, in effect, was to counter the critics by bringing home pictures of a war zone more coherent than the one described in the *Times* of London. In March 1855, he arrived at the Black Sea port of Balaklava with 700 glass plates and an old wine seller's van he had converted into a traveling darkroom. Even at dockside, the chaos was so great that during the unloading of his equipment he broke several ribs. Though hobbled by his injury, Fenton was able to complete his project, returning to England four months later with more than 350 usable negatives—and a serious case of cholera. He recovered, though not soon enough to guide Queen Victoria through the exhibition

of his Crimea pictures that opened promptly in London. They were also seen in Paris, published as wood engravings in the *Illustrated London News* and sold singly and in volumes, though sales dropped off after the actual fighting ended.

Fenton's pictures were discreet by the bloody standards of battlefield imagery to come: no glimpses of combat, no punctured flesh that might offend Victorian sensibilities. There are scenes of officers at leisure and soldiers drowsing at a mortar battery. A viewer with an understanding of battlefield conditions might recognize that the flat plains of the Crimea were a soldier's nightmare, offering the enemy a clear line of fire in all directions. (Fenton himself was nearly shot several times, and shellfire once ripped away the roof of his van, which looked to Russian gunners like an ammunition truck.) But with the exception of one famously ominous scene—a stark gully littered with cannonballs—most of Fenton's pictures give the impression that the war was, if not quite ceremonious, then at least no more brutal or unsightly than a camping trip.

The images also suffer from a thinness common to much of

the early photography of events—a sense that the heart of the matter is elsewhere, just outside the range of the camera, just beyond the frame. Even so, no one can dispute that Fenton's pictures represented a watershed. Cameras had arrived on the battlefield. The curtain had gone up on the theater of war.

In the decade that followed, Fenton became deeply disillusioned with photography. Just 11 years after he took up the camera, he put it down. Selling off his equipment and his prints, he returned to the law, never to take another picture. Though his motives have never been entirely clear, there is some evidence that he was repelled by the growing commercialization of photography. This was a common sentiment among those in Britain and on the Continent who were eager to see photography granted the status of art. Scarcely had the camera been invented than there were complaints that it had fallen into the hands of philistines and opportunists. As early as 1857, the great French photographer Nadar was muttering about hustlers swarming into the field of portraiture. "Photography," he sniffed, "is now within the reach of the last imbecile."

There were fewer scruples on that issue in the United States, where the first generation of noteworthy photographers consisted largely of businessmen more worried about bankruptcy than commercialization. Yet it was one of those studio entrepreneurs—and eventual bankrupts—who was chiefly responsible for bringing photography to one of its greatest achievements, the chronicling of the American Civil War.

When the fighting began in 1861, Mathew Brady was already the nation's best-known photographer. The son of poor Irish farmers from upstate New York, he won fame as an early

practitioner of the celebrity portrait. At his studio on lower Broadway, Brady displayed the "Gallery of Illustrious Americans," a daguerreotype inventory of politicians, generals and men of letters.

Brady's pursuit of the famous led him to maintain a second studio in Washington, so he was well situated to record the war's earliest clash of troops. The first Battle of Bull Run broke out on July 21, 1861, in the wooded areas about 25 miles from the capital. No sooner had news of the fight reached the city than Brady rushed toward the lines with his cameras and two wagonloads of darkroom equipment. All the glass-plate negatives he was able to expose that day were lost in the scramble of a Union retreat. Brady himself spent three days wandering lost in the woods. He returned to find press reports that blamed his camera for the Northern rout. "Some pretend, indeed, that it was this mysterious and formidable instrument that produced the panic!" one correspondent reported. "The runaways, it is said, mistook it for the great steam gun discharging five hundred balls a minute, and took to their heels when they got within focus."

Brady was not to be discouraged, however. As it would do for Ulysses Grant, a failed businessman who found unexpected greatness as a merciless general, the war mobilized Brady's resources. It led him to conceive a project that dwarfed all his earlier ambitions: to document the whole conflict through photography. To that end he fielded and equipped his own small army of about 20 camera reporters. The wooden darkroom vans of "Brady's Photographic Corps" became a familiar sight at the edge of battlefields. Soldiers even came to consider them a bad omen, a sign that fighting was imminent.

Brady's "corps" included three men—Timothy O'Sullivan, Alexander Gardner and George N. Barnard—who went on to become some of the best-known photographers of the century. That they are remembered at all owes much to the fact that they eventually left Brady's employ, angered by his practice of attaching his name to their work. Brady rarely operated the camera himself. His name on a photograph was more of a company trademark, a label that covered the work of his small army of operatives in the field.

It was an age that trusted the camera more than was deserved. The popular bi-weekly *Humphrey's* even went so far as to claim: "Brady never misrepresents." We now know that several pictures made by Gardner were falsifications. The most famous involves his use of the same corpse in separate pictures to represent both a Union and a Confederate soldier. After taking the picture *A Sharpshooter's Last Sleep,* a portrait of a dead Union soldier, Gardner dragged the body, already stiff with rigor mortis, about 40 yards to serve as a Confederate corpse in the picture *Home of a Rebel Sharpshooter.*

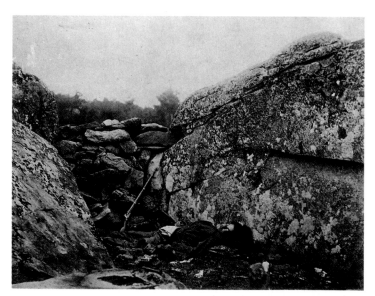

Home of a rebel sharpshooter *Alexander Gardner, 1863.* To create this picture of a purported rebel casualty, Gardner used the same corpse he had represented earlier as a Union soldier (see page 24). He merely dragged the stiffened body to a new location and repositioned it.

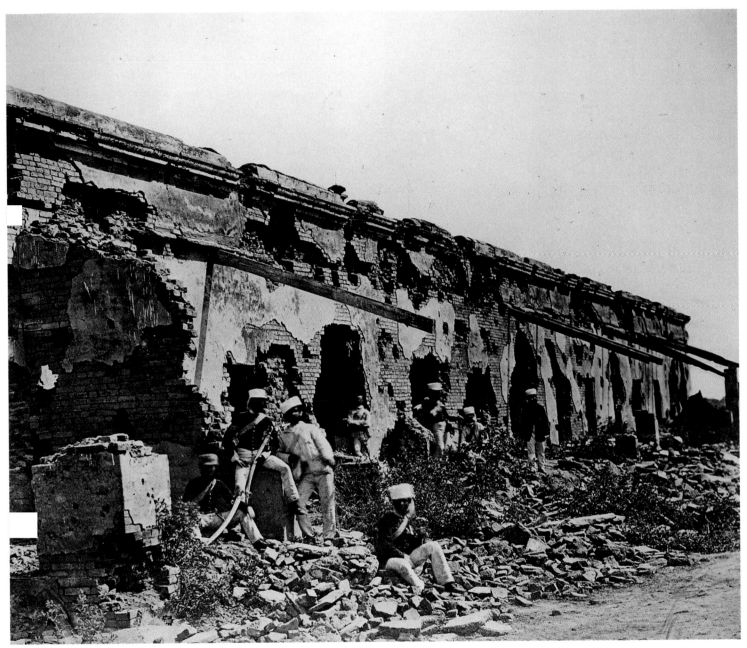

A British entrenchment during the Indian Mutiny *Félice Beato, 1858.* With his pictures from China and his earlier scenes from the mutiny—an uprising against the consolidation of British rule in India—Beato was a forerunner of the 20th century photojournalists who would witness the consequences of colonialism in the Third World.

It's not hard to understand the frustration that led Gardner to his ghoulish deception. One of the painful discoveries of the early photographers was reality's resistance to the human impulse to moralize. Painters could dramatize events and arrange scenes so that emotions like patriotism and pathos enveloped the image. The real world was less tractable. Then, as now, it couldn't be counted on to provide the camera with neat allegories of virtue triumphing over wickedness. As Gardner discovered, it could not even be counted on to provide a suitable Confederate corpse.

In the end, photography's bluntness proved to be a new kind of resource. The camera changed the depiction of battle at a time when war itself was changing, and with it the public understanding of warfare. The Civil War was slaughter on an unprecedented scale, more highly mechanized, with larger numbers of men set against one another. It was the beginning of the end for the venerable notion that war was a glorious pursuit (an idea that has never been altogether dislodged from the public imagination, but that becomes harder to sustain with each new episode of slaughter). There was something about the candid, unflinching character of camera imagery that suited this emerging understanding and perhaps helped draw it out.

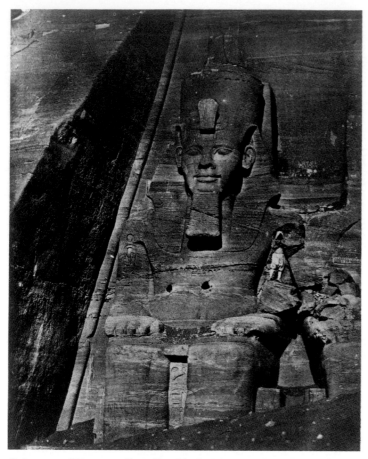

Colossus of Ramses II at Abu Simbel *Maxime Du Camp, 1850*

The pictures that came out of these battles gave war a new face, stark and squalid.

The Civil War photographers were not the first to display combat casualties. That distinction probably belongs to James Robertson, a British photographer who succeeded Fenton in the Crimea and documented the captured city of Sevastopol. There were even partially decomposed bodies in pictures made by Robertson's colleague Félice Beato during the Indian mutiny of 1857-58, in which Sepoy regiments rebelled unsuccessfully against their British officers. Two years later, during the Second Opium War, Beato photographed the swollen remains of Chinese defenders who had died during a British assault on their fortress.

To the Western viewers of Beato's images, it made a difference that the dead were Asians; their remains were not accorded the reverence that Westerners reserved for white corpses. But there was no escape for Americans looking at other Americans sprawled dead across the rain-soaked field of Gettysburg. Newspaper editors could cushion the pictures with soothing phrases, rolling out conventional sentiments about the gallantry and nobility of those who fall in battle; the pictures resist the consolations of wartime pieties. What fastens your eye to the page is not the nobility of the scene but its wretchedness. These are plainly men who have fallen in the raw postures of death, mouths open.

Oliver Wendell Holmes, the American physician and man of letters, wrote frequently about photography. Holmes also knew the scenes of war firsthand, having searched for his wounded son on the battlefield of Antietam, an indecisive engagement that was the bloodiest clash of the war. Later, Holmes left a moving record of his first encounter with Alexander Gardner's photographs from the same site:

"It was so nearly like visiting the battlefield to look over these views, that all of the emotions excited by the actual sight of the stained and sordid scene, strewn with rags and wrecks, came back to us, and we buried them in the recesses of our cabinet as we would have buried the mutilated remains of the dead they too vividly represented."

In 1866 a number of Civil War pictures were collected in two important books, the first examples of photographers resorting to books as a way to organize their pictures into a historical account. The first of the books was Gardner's *Photographic Sketch Book of the War,* a leatherbound double volume that assembled 100 pictures taken by various photographers. All of them are carefully credited under their own names. Barnard's *Photographic Views of Sherman's Campaign* is a more curious and fascinating volume, an exercise in post-apocalyptic landscape photography that follows the path of the Union General William T. Sherman's merciless March to the Sea. On page after page, fire-gutted and shot-blasted buildings are silhouetted against a white sky.

Only a wealthy few were likely to have seen deluxe volumes like Gardner's, to say nothing of Barnard's, which sold for $100. But the years just before the war also saw the rise of new methods for the mass distribution of inexpensive photographs. By the 1860s, photographic portraits of the famous and infamous became available in a cheap format called the *carte de visite,* after the French term for a visitor's calling card. Measuring about 3 1/2 by 2 1/2 inches, *carte de visite* portraits of victorious generals, fashionable women and the latest opera tenors proved enormously popular, becoming a crucial early step in the creation of the modern celebrity culture. The soprano Jenny Lind and the femme fatale Lola Montez owed much of their fame to the *carte de visite* in the same way that Madonna made her mark on MTV. In the aftermath of the firing on Fort Sumter, *carte de visite* portraits of Major Robert Anderson, a Union hero of the engagement, sold at the rate of 1,000 a day.

Another form of image making—the three-dimensional stereo-view picture—had also gained popularity in time to become a key format for bringing scenes of the war to ordinary households. To produce a stereo view, a camera with two lenses was used to take simultaneous pictures of the same subject

from two slightly different angles. The nearly identical prints were held side by side in a small cardboard frame, which was inserted into a stereo viewer that resembled a pair of binoculars. In the second half of the 19th century, stereo-viewer equipment was nearly as common a household item as the VCR is today. By the late 1850s, the London Stereoscopic Company, one of the world's largest, had sold 500,000 viewers and could offer customers an inventory of 100,000 pictures. By the last decade of the century, millions of stereographs were being produced each year; they were still being turned out as late as World War I. After the Civil War, news events continued to be a favorite topic. Scenes of the Chicago fire, the Johnstown flood and the wreckage of the battleship *Maine* were all available as stereographs.

The other chief subject for stereo views was faraway places, one of photography's first important subjects. In November 1839, just 10 months after Daguerre's invention of photography was announced, a Paris optician named N.M.P. Lerebours commissioned two fellow Frenchmen to make daguerreotypes in Egypt. It was a natural destination for early photographers, and not only because the Sphinx, which had not moved for 4,500 years, could be counted on to hold its breath and sit still for the camera. The 19th century imperial expansion of the European powers fed an enormous popular appetite for depictions of foreign lands. In part to compensate for the loss of its American colonies, Britain moved to consolidate its hold upon India and to seize new territories in Africa. In the France of Napoleon III, who ruled from 1848 to 1870, the national imagination was fired by the Emperor's pretensions to empire. The 1860s saw the French embark on a joint expedition with Britain against China, establish an ill-fated outpost in Mexico and seize Saigon, setting the stage for another war in another century.

Throughout the 1850s in particular, the lands around the Mediterranean became a vast photo opportunity. With the French and British increasingly comparing themselves to the great empires of the past, monuments of antiquity gained special interest for both nations. So much the better if the monuments were located in lands that had actually fallen under their domination. In Egypt, for instance, the French entrepreneur-diplomat Ferdinand de Lesseps gained the concession for the Suez Canal in the mid-1850s, which in turn led Britain to step up its own interference in Egyptian affairs. Under such circumstances, pictures of the Pyramids were not just exotic views but also inventories of imperial plunder, a means by which the past was annexed to the self-regard of the present.

As the Industrial Revolution took root in Britain, France and Germany, a new kind of landscape was springing up at home: the brittle geometry of the machine-made world. Photographs that showed the diagonals of an iron truss or the plunging lines of a new bridge were themselves a kind of news, bringing word of the spreading dominion of manufacturing. Some of the most memorable pictures of the Industrial Age were produced by a young English photographer, Robert Howlett. Early in 1858, the *Illustrated Times* published nine engravings based on Howlett's photographs of the dockside construction of *Leviathan*—later renamed *Great Eastern*—which in its time would be the largest steamship in the world. Despite the British preference for romantic views of thatched cottages and ruined abbeys, Howlett recognized in the brute silhouettes of industrialism the outlines of a new aesthetic, one based on hard forms and angular lines of force. It was a new kind of beauty that was being discovered by a number of British and French photographers. Examining its possibilities would become one of photography's chief preoccupations in the next century, but Howlett did not live to proceed further upon his own intuitions. He died not long after the pictures were published—a victim, some argued, of the chemical fumes he inhaled in his work.

American photographers had another new landscape to contend with. After the Civil War, they found their next great subject in the natural formations of the West. Some joined the geological surveys dispatched by Congress to explore the new territories Easterners were poised to occupy. Others were sent West by the railway companies that were laying the transcontinental lines, the nation's great postwar economic undertaking. Many of them were the same photographers who had covered the war. It had accustomed them to the physical discomforts that were in store for any traveler West, and taught them how to take pictures under difficult conditions—which is what they found in such places as Nevada, where the former Brady photographer O'Sullivan nearly drowned while navigating the rapids of the Truckee River. As early as 1869, engravings made from O'Sullivan's Nevada pictures appeared in *Harper's Weekly*, which later supplied an outlet for the work of another important Western photographer, William Henry Jackson.

What the Western photographers depicted was not just scenery but once again news—tidings of the young nation's vastness, its inhuman scale, its economic potential and its hard physical challenges. What they had also discovered was a new psychological territory, a screen upon which Easterners could project their fantasies of a fresh life, a place that could be sublime or forbidding or both at one time. In O'Sullivan's picture of Pyramid Lake in Nevada, the water is a ghostly tank with three cones of forbidding rock. The Carson Desert sand dunes are an immense vacancy that could be the stage set for a Samuel Beckett play. It's a fugitive's dream of paradise: a clean slate waiting for history to be written across it.

After the Great Fire of Hamburg
Carl Ferdinand Stelzner, 1842

The daguerreotype method permitted great detail, but it produced one-of-a-kind images that could not be used to make multiple prints. Stelzner's daguerreotype views of the ashes and ruin of his native town, among the first camera images of a catastrophe, were not widely seen.

The open door
William Henry Fox Talbot, 1843

Talbot's calotype process could be used to make prints, but its soft textures lent themselves more to poetic scenes like this, taken at his estate, than to the recording of daily events.

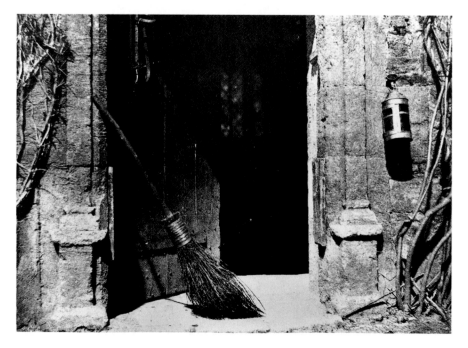

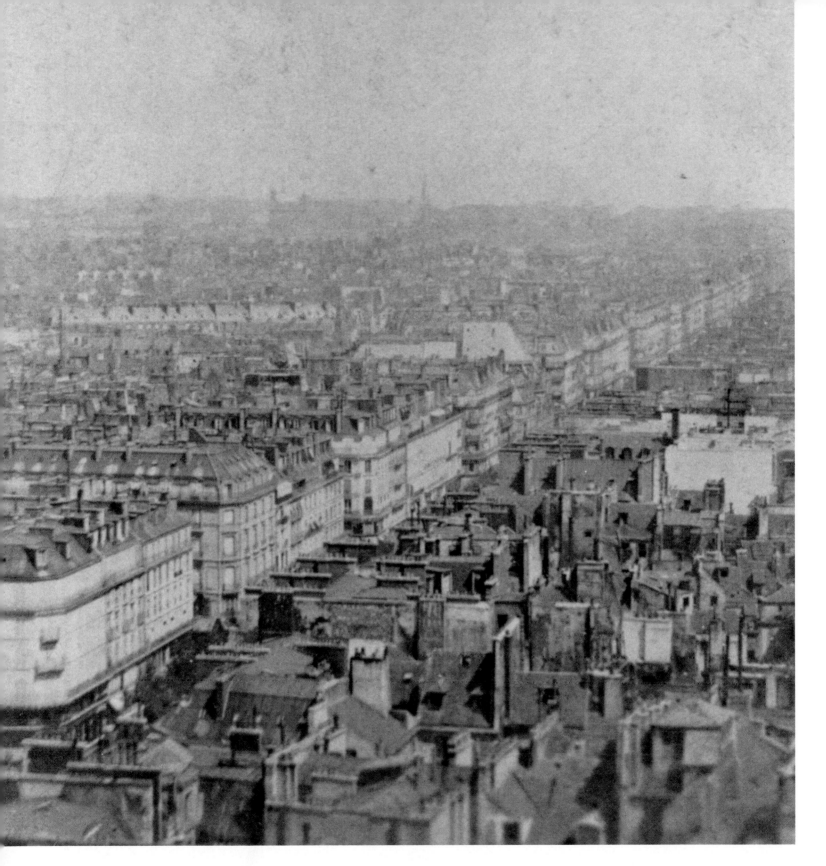

Aerial view of Paris *Nadar, 1859*

It was the wet-plate negative that finally made it possible to create truly detailed pictures that could also be reproduced as prints. Though the equipment was heavy and the process of preparing and developing the plate unwieldy, determined photographers like Nadar, who took this shot from a balloon hovering over the city, lost no time in exploring the heights to which the new method could take them.

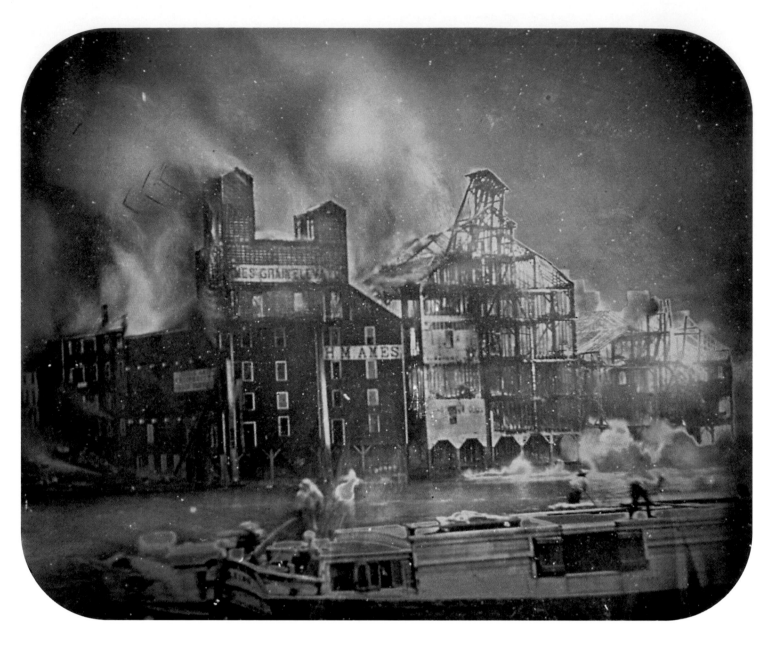

Mill fire in Oswego, New York
George N. Barnard, 1853

From its earliest days, the camera was trotted out to
record the sort of disasters that later became a staple
of the illustrated press. Barnard's daguerreotype of a
burning mill exists in a version that was hand tinted
to suggest the infernal light of the flames. During
the Civil War, Barnard documented the swath of
devastation cut through the South by General
Sherman's March to the Sea.

**A slightly damaged house, Johnstown,
Pennsylvania**
George Barker, 1889

The looming quality of the three-dimensional
stereograph was perfectly suited to dramatizing
catastrophes, like this scene from the aftermath of
the Johnstown Flood. Oliver Wendell Holmes, the
American man of letters, was so enthusiastic about
the potential of the stereograph as an educational
tool for every household that he invented a more
affordable viewer.

Stranded in the Niagara River *Platt D. Babbitt, 1853*

An early example of a picture showing a person trapped in terrible circumstances, a subject that was to become central to photojournalism in later years.

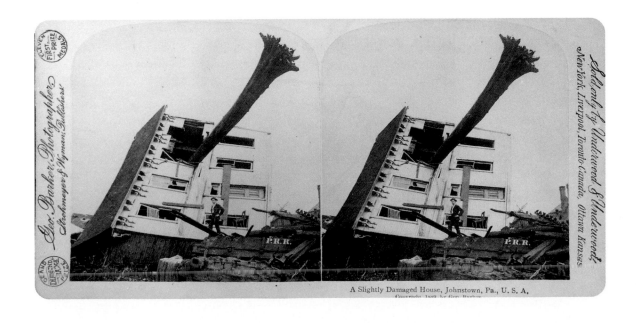

A Slightly Damaged House, Johnstown, Pa., U. S. A.

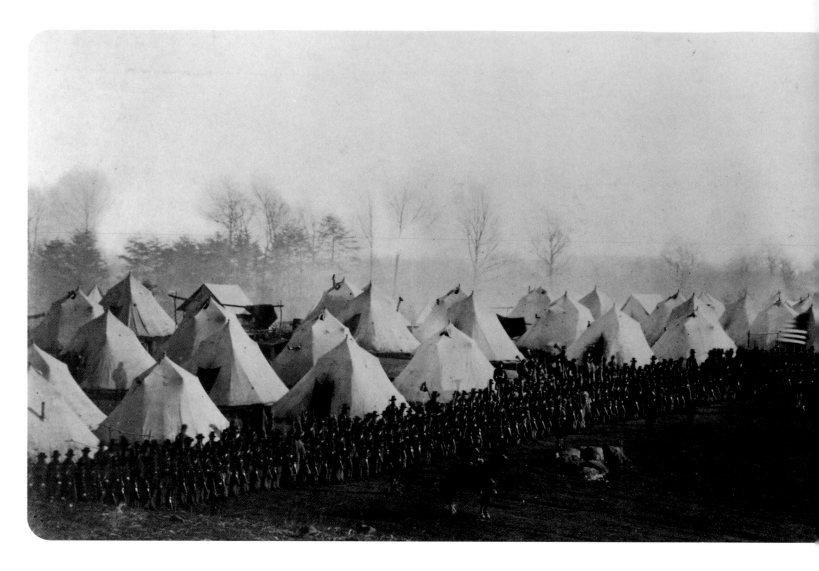

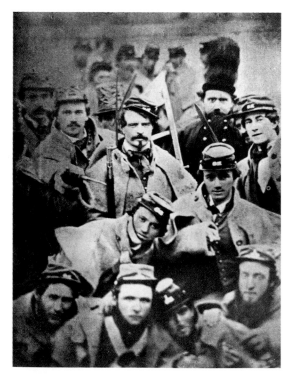

Northern troops encamped near Washington
Photographer unknown, 1861

The long exposure times required by 19th century cameras made static formation shots a staple of war coverage. This picture of the Vermont Brigade is a memento of a unit that lost 213 enlisted men and officers in battle and 125 to disease.

Rebel Soldiers in Richmond
Photographer unknown, 1861

Confederate fighting men at the beginning of the Civil War just before the Battle of Bull Run. Southern hopes for an easy secession were still high.

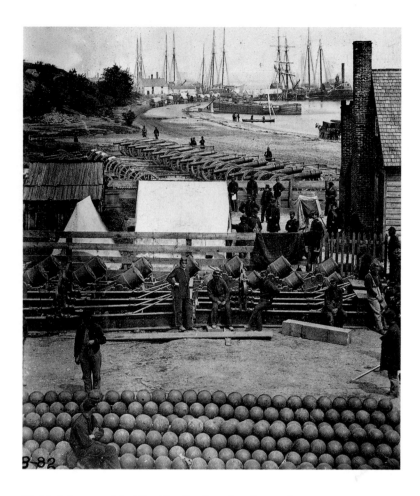

Matériel assembled for the Peninsular Campaign
Attributed to Mathew Brady, 1862

Northern General George B. McClellan had cannon shot, mortars, rifles and carriages collected at City Point, Virginia, for transport toward Richmond by the ships seen in the background.

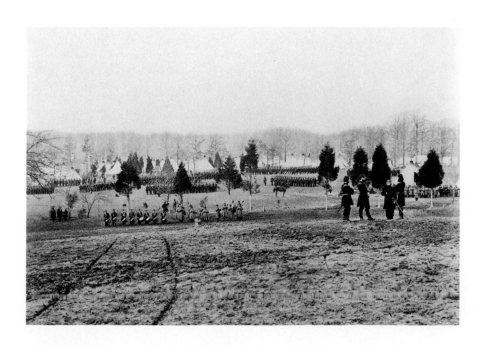

The 74th New York Infantry at drill
Photographer unknown, 1861

The Civil War depicted in old photographs is seen largely through Northern eyes; it features Union soldiers and marks their triumphs. Most of the pictures were taken by photographers attached to units of the Union forces.

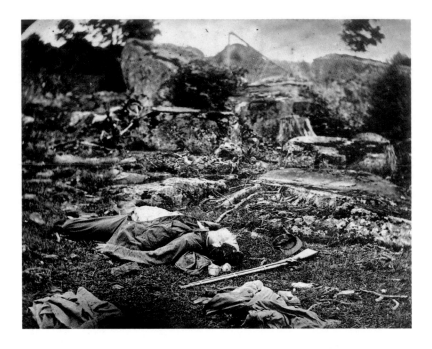

A sharpshooter's last home—or is it?
Alexander Gardner, 1863

In this case, it isn't; the corpse was moved and repositioned by Gardner to make the image known as "Home of a rebel sharpshooter" (see page 14).

A harvest of death, Gettysburg
Timothy O'Sullivan, 1863

O'Sullivan's unflinching display of the battlefield dead brought a new candidness to the depiction of American warfare.

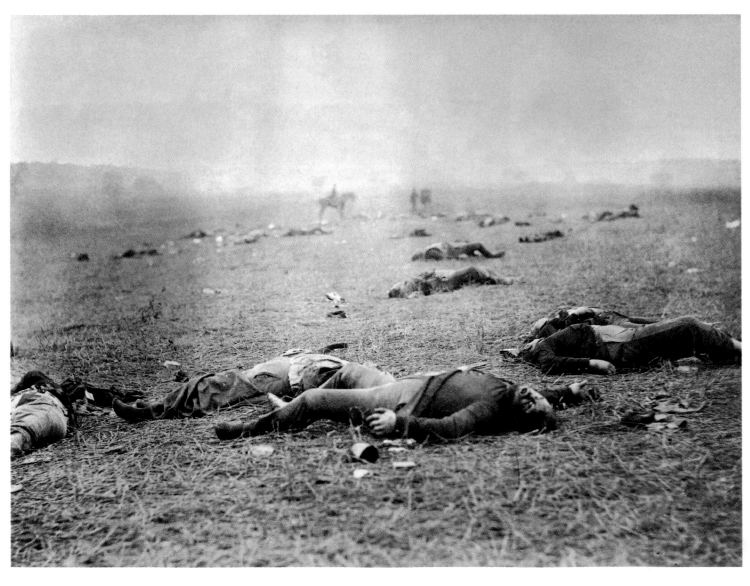

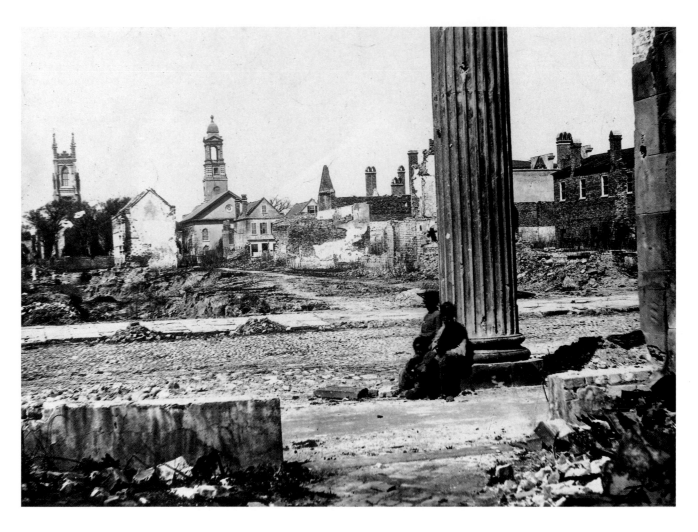

The aftermath of war in Charleston
Attributed to Mathew Brady, 1865

By the time the war had dragged to its bloody conclusion, Brady and his camera operators had produced more than 7,000 images.

Ruins of Richmond
Alexander Gardner, 1865

The jagged silhouette of a gutted flour mill offers a preview of the bomb-blasted cities of the 20th century.

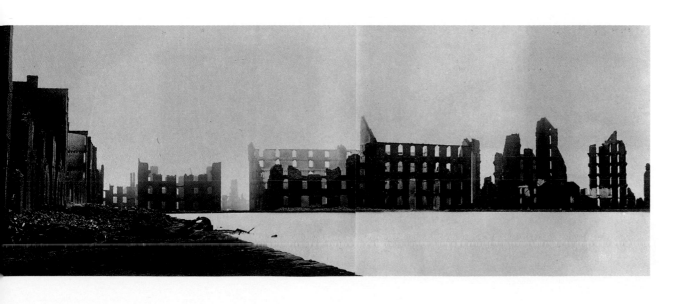

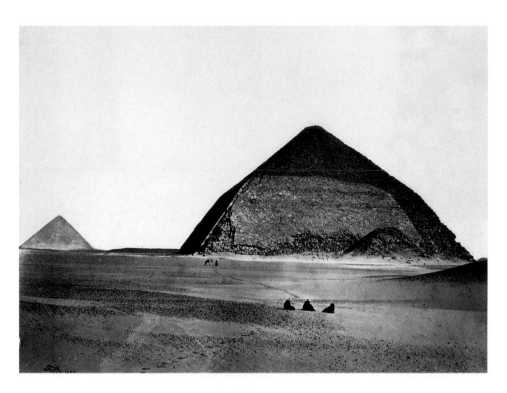

The Pyramids of Dahshur
Francis Frith, 1858

Frith worked out of a wicker carriage covered by a large canvas sail that served as both his darkroom and his sleeping quarters. The Egyptians whispered that the mysterious enclosure also housed his harem.

The *Leviathan* under construction
Robert Howlett, c. 1857

The completion of the giant steamship—at the time, the world's largest—was an event for the British, further confirmation of their global economic pre-eminence.

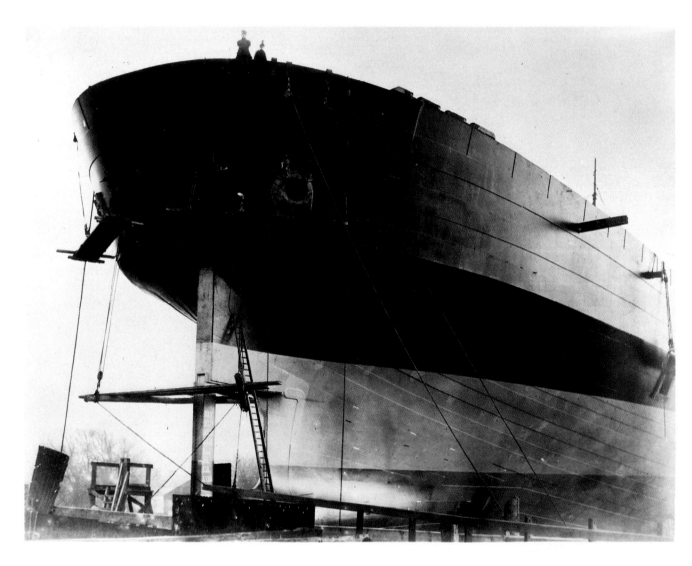

Limón Bay, Panama, at high tide *John Moran, 1871*

Though construction of the canal did not begin until 1904, American fascination with Panama grew markedly after the late 1840s, when settlers heading West for Oregon and the goldfields of California made the isthmus a popular transit point.

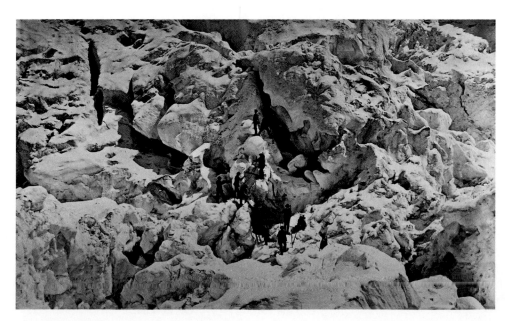

Passage des Echelles, the second ascent of Mont Blanc
Louis-Auguste and Auguste-Rosalie Bisson, 1862

The Bisson brothers made photography in the French Alps one of their specialties. Glass-plate negatives that were both fragile and heavy made the task extremely difficult. In the eyes of their contemporaries, the Bisson brothers' mountain views had a political significance—they celebrated France's acquisition of Nice and Savoy from the Kingdom of Sardinia, which brought Mont Blanc onto French territory.

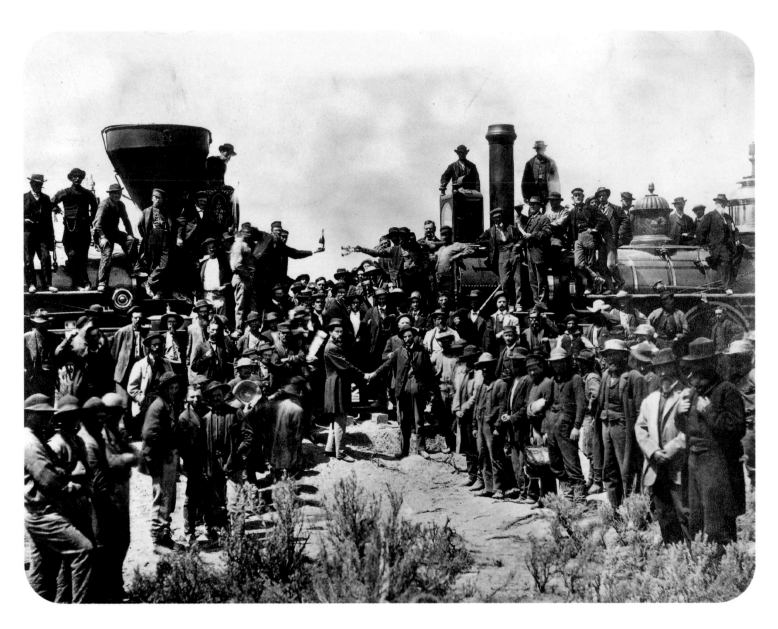

Meeting of the rails, Promontory, Utah
Andrew J. Russell, 1869

Russell's famous picture of the linking of the eastward and westward rail lines records not only a key development in American expansion West but also an early example of a media event. Telegraph-key operators transmitted the news coast to coast as soon as the golden spike was driven to mark the spot.

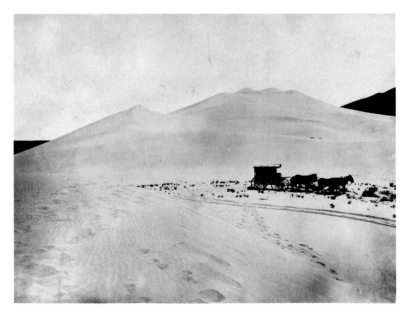

Sand Dunes, Carson Desert
Timothy O'Sullivan, 1867

On an expedition through Nevada, O'Sullivan paused to record the wagon that held his equipment and darkroom as he turned back from the forbidding wasteland.

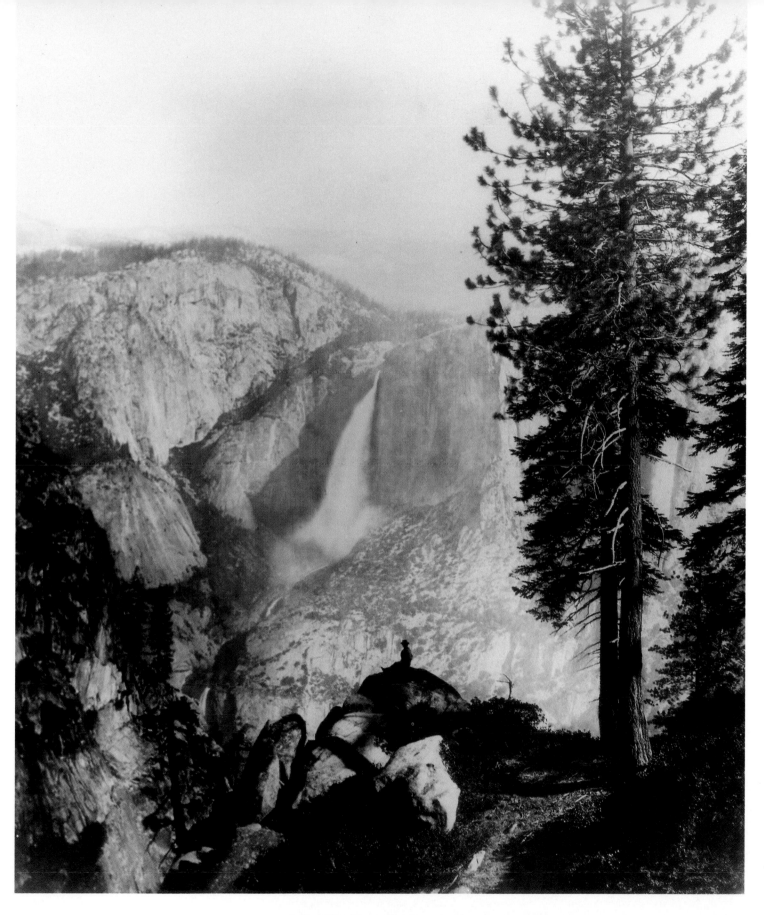

Falls of the Yosemite *Eadweard Muybridge, 1872*

Today it is almost impossible to imagine the impact of the first photographic images of the American West. They showed Easterners a world just beyond theirs: strange, vast, majestic.

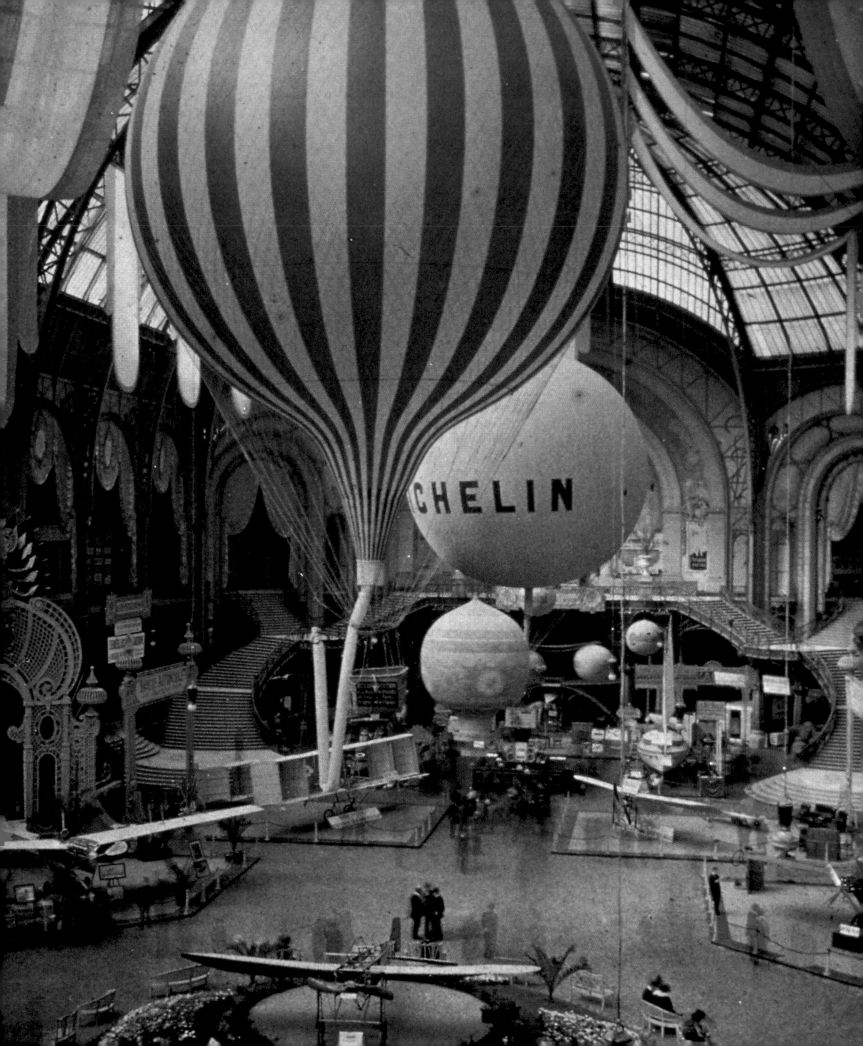

II: GLOBAL NEWS 1880-1920

"This photography is not a profession," stormed King Ferdinand of Bulgaria during the 1912 Balkan War. "It is a disease!" Like a war-horse beset by stinging insects, the Balkan autocrat was outraged to discover that his military campaign was infested with a vexing breed of newsmen: mobile, cynical, often uncontrollable, reporting back to masters whose interest in the fray was limited to its capacity to fascinate—or instruct—huge reading audiences with its images.

The images themselves caused most of the unease. Half a century before, heavily caparisoned picture takers like Roger Fenton and Mathew Brady were forced by the limitations of their equipment to focus on the landscape of war rather than the action itself. Depictions of battle were sanitized by distance and time, leaving the viewing public outside the process of war itself. The newsmen of the new century, by comparison, left most of those constraints behind. Their equipment—increasingly liberated from bulky tripods and lengthy exposure times—allowed them to go virtually anywhere a soldier could go. With their newfound technological freedom, photographers tried to look upon the human face of war: tense, bloody, anguished and unexalted.

The development of halftone printing made those images, as they had never been before, directly accessible to the public. Instinctively, Ferdinand and the other military statesmen of Europe knew that something subversive was afoot. The public was extending its visual reach into military statecraft, with unpredictable consequences. In the new era of the picture press, photojournalism was truly born. "It is the photographer that writes history these days," exulted *Collier's* magazine in 1913. "The journalist only labels the characters."

In the era of mass photography, the status of the journalist-photographer underwent a complex change. He—or she—was transformed from an independent petit bourgeois who sold the output of his own studio (in the form, for example, of *cartes de visite*) into a more proletarian hired hand, whose success depended on the extent to which his efforts were broadcast by press proprietors. The economy of photojournalism was a dependent one, which situated the photographer in a nest of economic relationships while freeing him up for the visual task at hand. That contradictory nature eventually gave photo-journalism a strong populist streak that would color its nature for decades to come.

All those developments took years to accomplish, and could begin only with a fundamental change in the picture-taking process. Something akin to an industrial revolution in photography blossomed around 1880, piggybacking on advances in industrial chemistry. By 1873 a variety of inventors had found ways to supersede the old wet-plate system of sensitizing a surface for photographic exposure. The method involved creating a silver bromide gelatin that could be spread thinly on glass, then dried. In 1883 a method was found to substitute celluloid for glass, though the brittle glass plates remained popular for decades. The change in process meant, in effect, that the photographer no longer had to carry his darkroom on his back or in a cart when he took pictures, as most of America's pioneering landscape photographers had been forced to do. The dry-plate technique also greatly speeded up the act of taking pictures. With the contortions of wet-plate exposure, photographers often took only two or three pictures a day. With the new dry plates, the number was limited more by how many of the bulky plates the photographer could carry—but that still multiplied the number of images by 10. Dry plates also fixed images much faster than the wet process: exposure times began to drop into fractions of a second. Both those developments pulled the photographer away from the painterly conventions that had dominated the picture taking of his predecessors.

Alongside the photochemical revolution came a proliferation in the mechanics of photography. Dozens, perhaps hundreds, of different types of cameras were being invented, large and small (including so-called detective cameras that could peep through a buttonhole), round or square, fixed on tripods or hand held. Both the single-lens and double-lens reflex systems, the mainstay of contemporary picture taking, were invented before the turn of the century. By 1891 Thomas Rudolf Dallmeyer produced the first telephoto lens.

No single individual had a greater effect on the photo revolution than George Eastman, a mild-mannered junior bookkeeper at a bank in Rochester, New York. In 1877 he became absorbed with the possibilities of photography and opened a dry-plate business based, essentially, on European processes. He quickly seized on the idea of applying photosensitive emulsions to celluloid film, and by 1885 was offering rolled film for sale. Initially it did not fare well. Eastman's essential genius,

Aerial exposition at the Grand Palais, Paris *Leon Gimpel, 1909*

however, was to realize that the future of photography lay with the mass audience. That meant producing cameras and image-sensitive products that simplified the vexing technological complexity of picture taking. In 1888 Eastman produced his popular masterwork, the Kodak hand-held wooden camera with a simple lens and a roll of film wrapped around a detachable spool holder. As the film was advanced, it took up to 100 exposures. When the picture taker was finished, he shipped the entire device back to Eastman's factory, where the film was developed and the camera reloaded, then returned.

Eastman's radical simplification of photography did not immediately affect the professional classes of picture takers—it was originally offered to "Holiday-makers, Tourists, Cyclists, and Ladies," among others. Professionals and serious picture takers preferred the quality of the dry-glass plates for detail, and relied on more sophisticated reflex cameras like the Graflex. Nonetheless, Eastman's breakthrough had two far-reaching effects. The first was to broaden immeasurably the ranks of people who would eventually become professionals. He deepened the American talent pool. The other, and perhaps more profound effect, was to increase the number of people who looked at and handled pictures and thus became photo literate. It was no coincidence that the United States thereafter became one of the wellsprings of photographic mass communications.

Throughout those innovative years, the entire American Republic, engrossed in civilizing its great internal spaces, was in a fever to know about itself and about the rest of the world. Between 1880 and 1890, the number of U.S. newspapers grew faster than ever before or since: two new publications a day for a decade. The number of newspaper subscribers increased by 37 million people (compared with fewer than 11 million in the previous decade), and then grew by another 37 million between 1890 and 1900. The great Joseph Pulitzer, William Randolph Hearst and the other American press lords cast their shadows—and their views—across the journalistic landscape.

The welter of newspapers was slow to absorb the final innovation that wedded photography to ink: halftone reproduction. Joseph Pulitzer bought the New York *World* in 1883, but it was another decade or more before the newspaper became home to photography. The New York *Tribune* did not publish a halftone picture until 1897. In 1898 the celebrated sinking of the battleship *Maine* was announced, first with line drawings that simulated photographs. A full week passed before a halftone picture was published. The first picture newspaper in Britain, the *Daily Mirror*, made its debut on January 7, 1904, and its American counterpart, the New York *Illustrated Daily News*, did not appear until 1919. The ever cautious New York *Times* did not publish photographs until World War I, and then only as a wartime supplement.

Time was a major constraint. However many breakthroughs had taken place in the business of picture taking, words still traveled faster than images in the late 19th century. (The theoretical breakthroughs that led to the electronic transmission of pictures were made in 1907, at the University of Munich.) The process of producing halftone images on the same printed page as type was also arduous and complicated.

Thus the logical venue for photojournalism was less the daily newspapers than the elaborate illustrated magazines that already used line drawings. In 1884 the *Leipziger Illustrierte Zeitung* published the first halftone illustration in a European publication, Ottomar Anschütz's image of German army maneuvers. In 1886 Paul Nadar, son of the flamboyant photographer impresario Felix Nadar, produced what could be called the first photo interview in the history of journalism, taking pictures of his father in conversation with the distinguished French chemist Michel-Eugène Chevreul, in honor of Chevreul's 100th birthday. The pictures were run with the interview in *Le Journal Illustrée*. Soon Gustave Eiffel and Louis Pasteur, among others, received the same treatment.

By the 1880s, the illustrated-picture magazine format had crept across much of the industrialized world. In Britain the *Illustrated London News* vied with publications such as *Black and White, Graphic* and *Sphere*. In the United States magazines like the *Illustrated American* battled with *Leslie's Illustrated Weekly*, while periodicals that initially shunned photographs in favor of line drawings—*Harper's Weekly, Scribner's Century*—had converted to the new technology. Other magazines, like *Munsey's, McClure's, Cosmopolitan* and above all *Collier's*, turned to photography as a means of boosting circulation. In 1889, in an innovation that would change American adolescence forever, the *National Geographic* magazine published its first photograph of a bare-breasted Zulu bride.

The photo magazines were eclectic in format and omnivorous in scope. Typical of the breed was Lorillard Spencer's *Illustrated American*, founded in 1890 and dedicated to the "picturesque chronicling of contemporaneous history." Its photographers took pictures of yachting regattas, the 1897 inauguration of William McKinley, sporting events and train wrecks. The *Illustrated American* and others like it introduced a new category of employee, the staff photographer, and also made use of self-employed free-lancers. As early as 1886 Frances Benjamin Johnston, one of the most important of the professional photojournalists, was able to declare that she was "making a business of photographic illustration and the writing of descriptive articles for magazines, illustrated weeklies and newspapers." Washington-based, Johnston became so famous for her pictures of political celebrities that she was known as the photographer of the "American court."

OUR PENAL

CHING-HING-WY: "FOR LIFE."

INTERIOR PRISON SOLITARY.

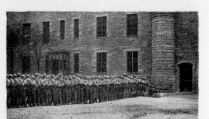

"LOCK STEP:" MARCHING OUT.

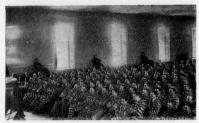

THE CHAPEL: SERVICE.

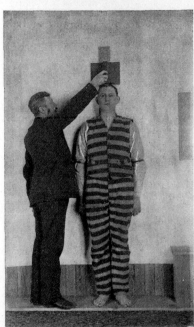

TAKING HIS MEASURE: HEIGHT.

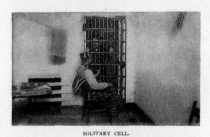

SOLITARY CELL.

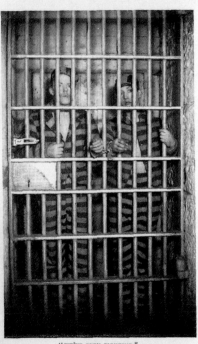

"WE'VE BEEN FIGHTING."

FROWNING PRISON WALLS.

TAKING HIS MEASURE: LENGTH OF FOOT.

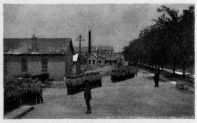

RETURNING FROM WORK.

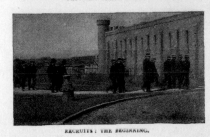

RECRUITS: THE BEGINNING.

JOLIET STATE

BEHIND PRISON BARS: A VISIT BY OUR

A page from the *Illustrated American* takes readers inside the Illinois state prison in Joliet *S.W. Westmore, 1890*

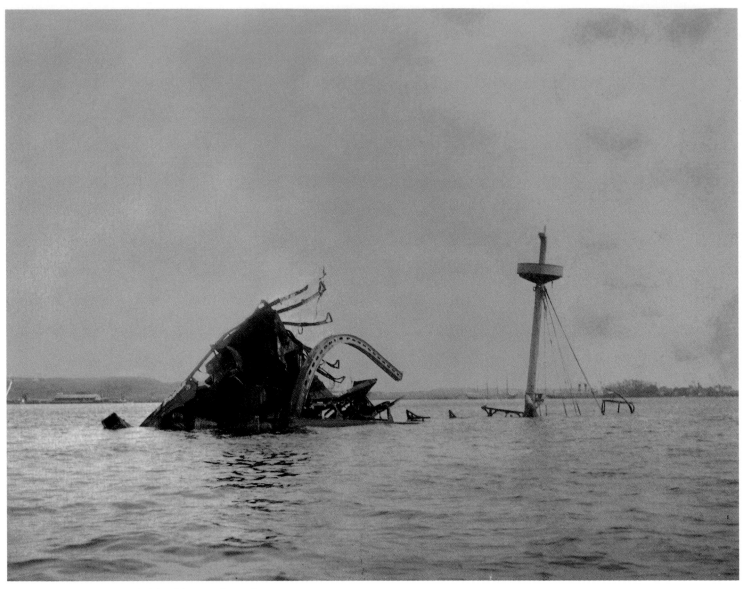

Wreck of the battleship *Maine Photographer unknown, 1898*

As the market for newspaper and magazine photographs grew, new suppliers began to fill the need. In 1894 the world's first press agency set up shop in London as the Illustrated Journals Photographic Supply Company. Located on Ludgate Hill, the firm promised 24-hour service for the delivery of any photo in stock. Within five years, it faced competition from the Illustrated Press Bureau. The first U.S. photographic agency to follow suit was Underwood & Underwood, established in 1896. It would be a long time, however, before photo agencies and cooperatives would offer the combination of on-the-spot resources and immediacy that news text services like the Associated Press (established 1848) and United Press International (1907) could provide to member newspapers. A.P. began a picture service in 1927 and started transmission by wire in 1935. For decades afterward, many small newspapers continued to receive photos by mail.

Slowly, picture journalism assembled the means to take on its most difficult challenge: coverage of war. The imperial conflicts of the late 19th century were usually carried on in inconvenient places: Afghanistan, the Sudan, South Africa. Camera equipment had improved greatly since the days of the American Civil War. Nevertheless, lugging heavy glass plates and awkward cameras alongside expeditionary forces remained a considerable exercise in fortitude and logistics. There was still no question of sending back images to complement more immediate press reports. The rise of amateur photography did give Victorian photojournalists an opportunity for scavenging that had not existed: a talented amateur on the scene might take a picture for himself, from which he could be parted by offers of money or shared glory, or simply by guile (which is how some of the most striking press images of wartime in the 1890s found their way into print).

The expressive power of early wartime photography was on display in the lengthy and frustrating Boer War of 1899 to 1902. Some of the most compelling images of the conflict were taken by a German photographer, Reinhold Thiele, who was commissioned to cover the war for the London *Graphic*. Thiele used a glass-plate camera equipped with the recently invented Dallmeyer telephoto lens as he accompanied British troops on the relief of Kimberley. His dramatic photos of a naval artillery bombardment prior to a December 1899 assault on a Boer stronghold captured the high tension of the moment—but there was a problem. The British attack was a disaster. No mention of that fact appeared in the *Graphic* when Thiele's photos finally ran in March of the following year.

Military incompetence was plentiful in the dreary Boer conflict, and Thiele and other photographers who covered it had numerous opportunities to record British defeats: at Spion Kop Hill, on the retreat from Ladysmith, at Colenso. To them the important thing was the situation, rather than the outcome; the camera was there, capturing the fearful expressions, slumped postures and frantic activity of men in actual conditions of combat (though the cumbersome equipment still kept actual fighting out of the picture frame). By the time of the Boer War, the press photo corps was beginning to descend on conflict like their print kin, in growing numbers and under the pressure of competition. The era of the global photojournalist was dawning, in the persons of John C. Hemment, Richard Harding Davis, James Burton, William Dinwiddie, George Lynch and, above all, James Hare.

No one established the photojournalistic archetype more firmly than Hare: cocky, fearless, peripatetic, "sublimely impudent," as one contemporary put it, and obsessed with discovering the dramatic moment in every photograph. The son of a successful Yorkshire camera manufacturer, Hare was an early proponent of the small, hand-held instruments that his father did not make. The two soon parted ways. Hare began a freelance career in Britain, largely in sports photography, then emigrated to the United States in 1889. He arrived just as the illustrated weeklies were making their plunge into photography. Hare became the star free-lancer of the *Illustrated American,* then presented himself at the doors of *Collier's Weekly*.

Hare arrived at a critical time, just as Robert Collier, son of the publishing titan, began to turn the somnolent literary paper into a news-picture magazine. Two months after Hare was hired, the Spanish American War got under way—a war that press baron William Randolph Hearst had done his best

to create. Hare staged his own invasion of Cuba in a leaky boat, and teamed up with the ragtag army of insurgent Máximo Gómez. Hare ran with assaulting American troops in the battles at San Juan and Kettle hills. His reputation as a fearless, even reckless, news photographer was sealed when *Collier's* ran pages of his work in a special Cuba commemorative number. Photojournalism showed that it could pay its own way: in the wake of the much ballyhooed Cuban campaign, the magazine's circulation quintupled, to 250,000 in 1900.

By 1903 *Collier's* proclaimed that "whenever there is an army in the field and the clash of arms and bullets and the thousand tragedies of war, there, too, is a man from *Collier's*." As often as not, the man was Hare. He was one of a handful of photo correspondents who covered Japanese landings in Korea during the 1904 Russo-Japanese War, a conflict that, Richard Harding Davis noted laconically, Hare "made famous." He covered the San Francisco earthquake, and during the Mexican Revolution rode into Ciudad Juárez with Pancho Villa. In 1914 he broke with *Collier's* when the magazine would not send him to cover the Great War in Europe. Hare signed on with *Leslie's Weekly* for the job.

Once in Europe, he discovered what the growing international photo corps was finding out: Allied military leaders, particularly the French, were now acutely sensitive to the impact of photography on the home front. They allowed virtually no battlefield photographs to be taken, and even fewer to be printed. The frustrated Hare, ever in search of action, gravitated to the less strategic Balkan front. After the armistice, Hare chased the scent of gunpowder once more—when the Soviet Union and Poland clashed—then settled into a long retirement.

By that time, the nature of news photography had changed again. The picture magazines had gone into decline with the advent of the war. The days of the great free-lancers were—for a time—over. But the notion of photos as inseparable from news had been deeply imbedded in the Western psyche. After the war, nearly every major newspaper had its staff photographer—even the New York *Times*, starting in 1922. News-picture taking had come to have a sense of immediacy that rivaled print, though its last steps toward instantaneity—electronic transmission—were still ahead. The shock waves of the Bolshevik Revolution were rippling around the world, and humanity was lurching in the direction of undreamed-of achievements and brutalities. As it did, the nerve endings of mass society were attuned to the news in more dimensions than ever before.

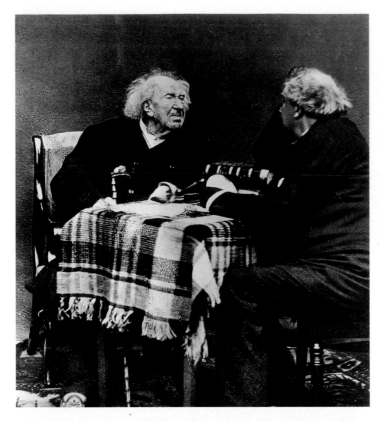
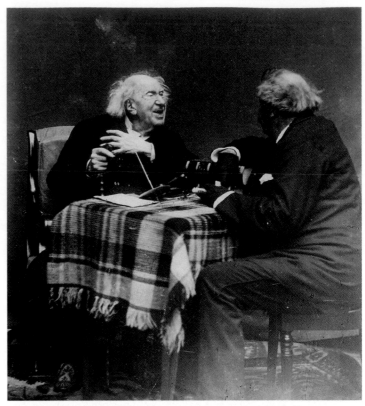
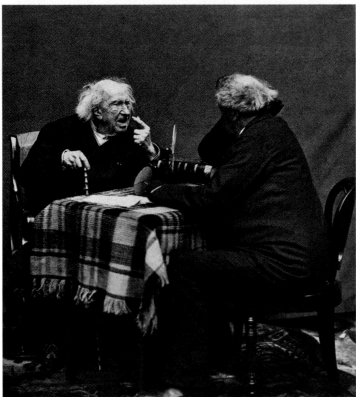

The French scientist Chevreul giving an interview *Paul Nadar, 1886*

These pictures represent the first photo-interview session. As the 100-year-old chemist and physicist Michel-Eugène Chevreul expounded on his personal philosophy to the celebrated Parisian photographer Felix Nadar, Nadar's son quietly made a series of candid pictures.

Self-portrait *Frances Benjamin Johnston, 1895*

The remarkable Johnston was one of the first women to make her living as a free-lance photographer for magazines and newspapers. Much of her work was concentrated on the lives of laborers, including coal miners, ironworkers and the women who struggled to make a living in the textile mills of New England.

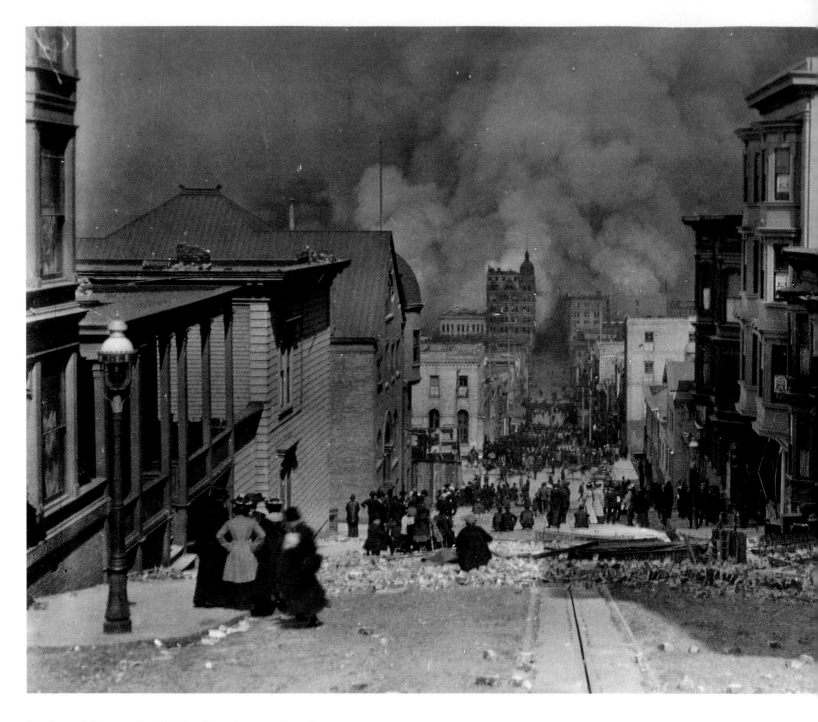

Smoke and flames after the San Francisco earthquake
Arnold Genthe, 1906

Although his own photo studio was in flames, Genthe saved his camera and made his famous pictures of the great earthquake and fire. He later sold them to the San Francisco *Examiner*. The enterprising Genthe had earlier taken a remarkable series of candid photographs in the Chinatown district of San Francisco, scenes he had captured with a small camera concealed beneath his coat.

Opposite page:

Steam-powered engine races to a fire
Barney Roos, 1910

Though Roos would go on to become chief engineer of the Studebaker car company and the inventor of the Jeep, this student photograph remained one of his proudest achievements. He took it in New Haven, Connecticut, while working a summer job for a photo agency that had sent him out to get a graduation photo of the son of President William Howard Taft.

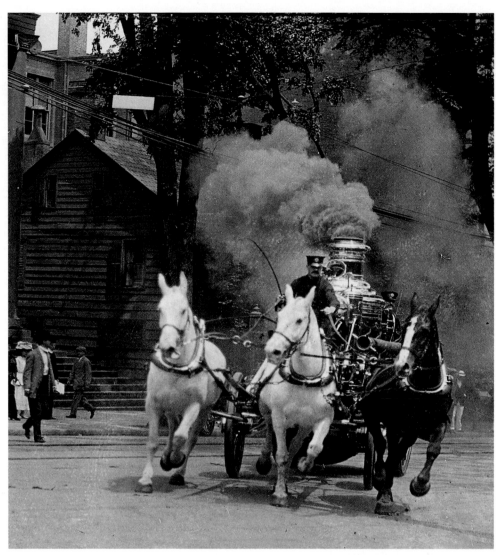

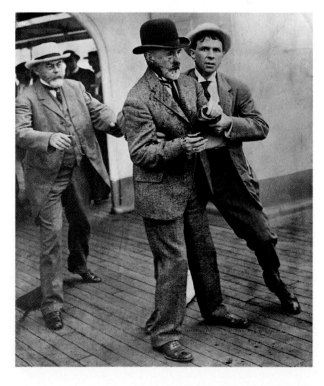

The shooting of New York City's Mayor William J. Gaynor
William Warneke, 1910

Warneke, a photographer for the New York *Evening World*, had been assigned to cover the morning departure of the mayor for a European vacation. Instead, he got this picture of Gaynor being supported by aides after he was shot in the neck and back by a disgruntled former city employee. The *World* splashed the picture across four columns. Though the reform-minded mayor lived three more years, he never fully recovered his health.

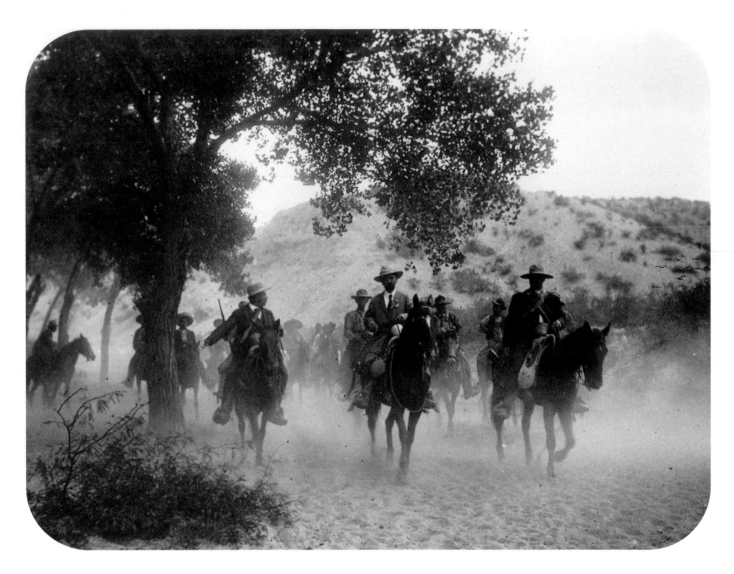

Mexican revolutionaries Francisco I. Madero and Pancho Villa
James Hare, 1911

Hare was one of the first globe-trotting photojournalists, a pioneer of the notion that the camera could prove that an event had actually taken place. A few years before he recorded Madero and Villa on their way to accept the surrender of Mexican government forces, Hare had taken a picture that proved the Wright brothers' plane could fly.

Street fighting in Juárez
James Hare, 1911

The revolution in Mexico was one of five conflicts Hare covered as a war correspondent.

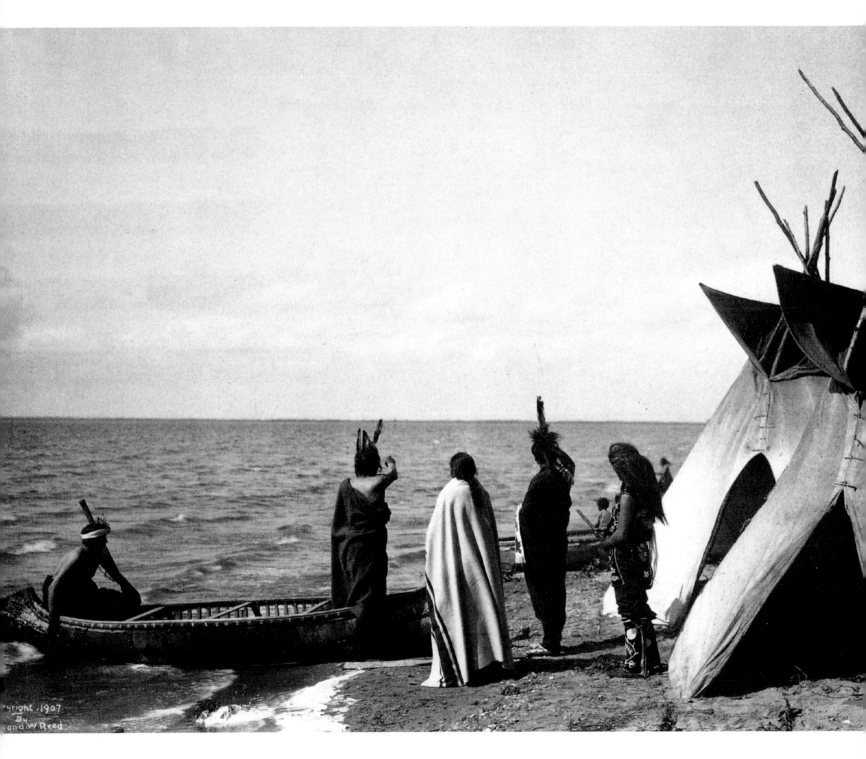

The first sail
Roland W. Reed, 1907

Reed was at one time an Associated Press photographer. In the year this picture was taken, he began to devote much of his time to documenting Indian life, using income from his Minnesota portrait studio to finance trips among the local Chippewa. Though he came to think of himself as an artist rather than a reporter, he allowed his photos to appear in the *National Geographic*.

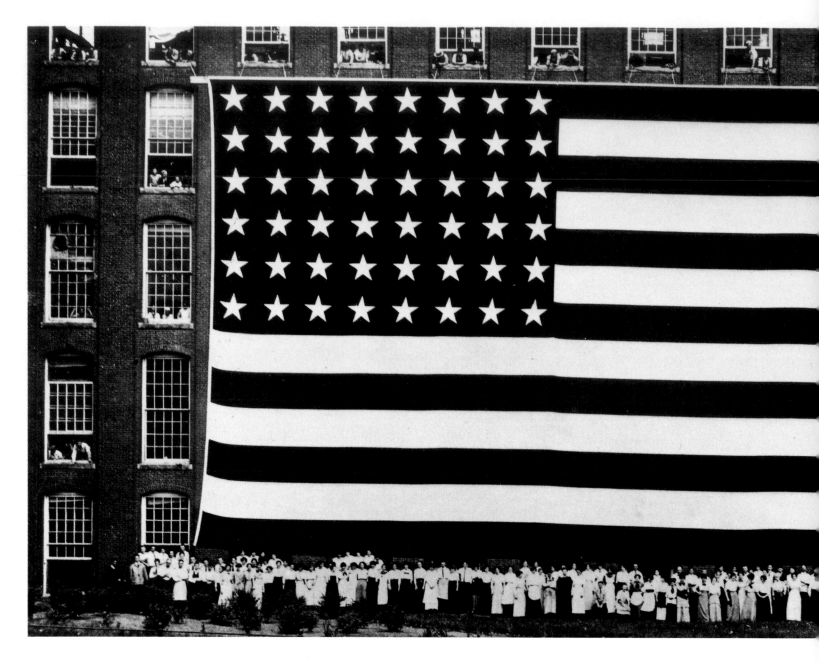

Flag woven by millworkers at Manchester, New Hampshire
Harlan A. Marshall, 1917

World War I touched off a spate of flag waving in America,
though it's doubtful that anyone ever waved this version of Old
Glory, which was 50 feet by 95 feet and weighed 200 pounds.
Marshall's picture appeared in the *National Geographic*. In 1906
the magazine began to rely heavily on photography to illustrate
its stories about travel and exploration, although it did not hire
full-time staff photographers until the 1920s.

A women's-suffrage parade in New York City
Photographer unknown, 1915

At the height of the campaign to gain the vote for women, more than 25,000 people marched up Fifth Avenue to voice their support. Marchers representing three states that had granted women the vote appear in the forefront of this picture taken for United Press International, the news agency that began distributing photographs eight years before.

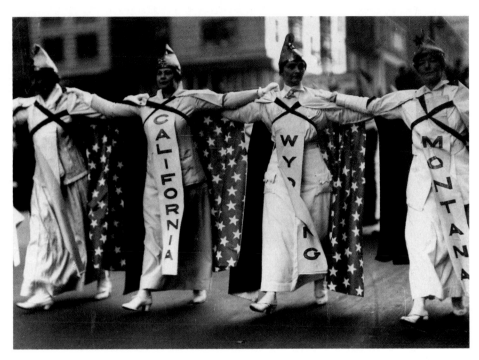

Foraging for food in the Antarctic
Photographer unknown, 1915

Dog teams of the British explorer Sir Ernest Henry Shackleton search for edibles as his ship *Endurance* sinks in the background. Shackleton died during his fourth south polar expedition in 1922 and was buried on South Georgia Island in the South Atlantic. The picture was made for the U.S. photo-publishing company Underwood & Underwood, which sometimes commissioned its own photographers to travel abroad. The circular format was common in newspapers and magazines during the first decades of the century.

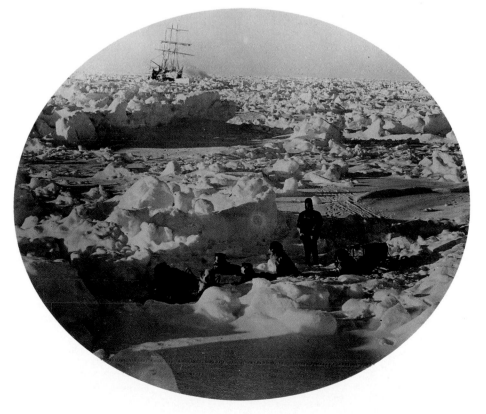

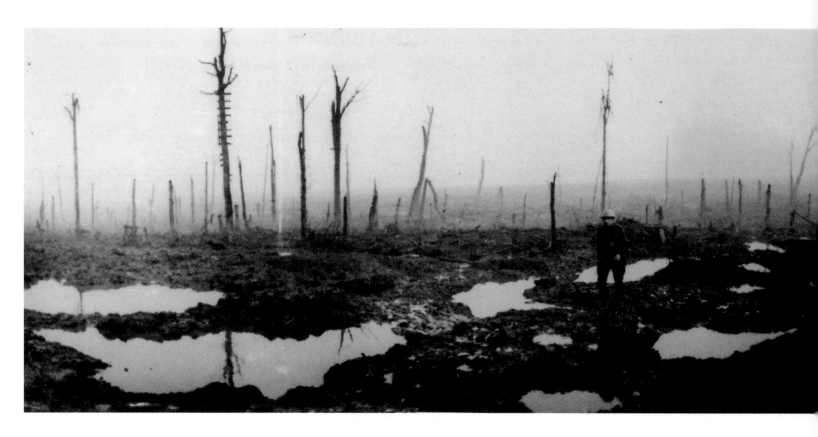

Panoramic view of Passchendaele Ridge, Belgium
Photographer unknown, 1917

The public was unlikely to find battlefield scenes like this one in its newspapers during World War I. Military authorities had learned how much photographs could sway public opinion; they kept news photographers under tight control, making it difficult for them to reach the battlefields and censoring what pictures they were able to take. Many of the most potent images of the fighting were not published until after the war.

Pro-revolutionary soldiers during the March uprising in Petrograd
Photographer unknown, Underwood & Underwood, 1917

Pro-revolutionary soldiers drove around Petrograd with red flags fixed to their bayonets. The defection of the Petrograd garrison and other troops sympathetic to insurgents was critical to the success of the March uprising.

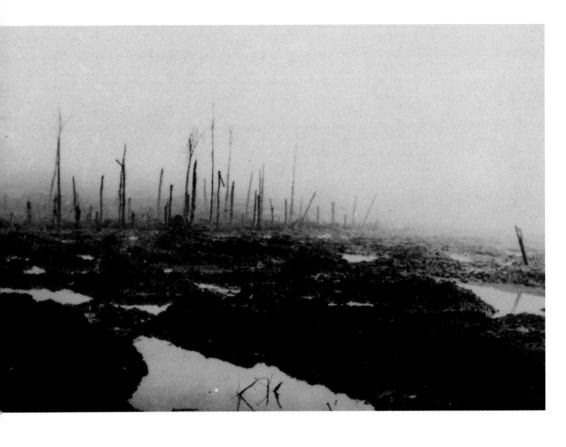

Burning public records in Petrograd
*Photographer unknown, Underwood &
Underwood, 1917*

Western news photographers hurried to
Russia in 1917 to cover the overthrow of
the Czar and the events that were to bring
Lenin to power in October. This picture
was taken by a photographer for the firm
of Underwood & Underwood, the photo
agency that had sent its operatives to many
of the battlefields of World War I.

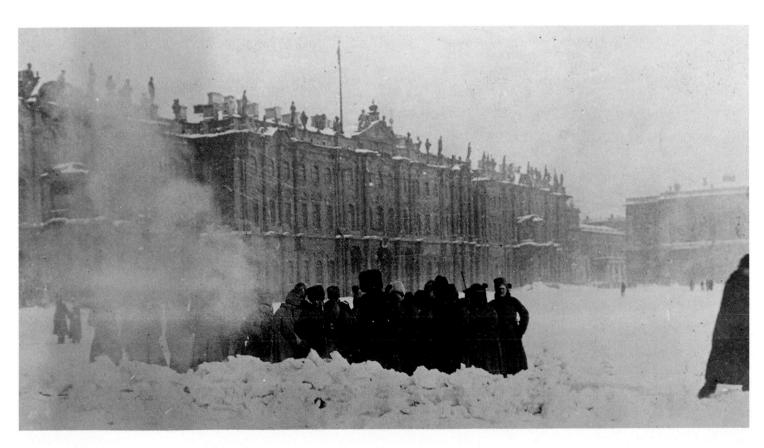

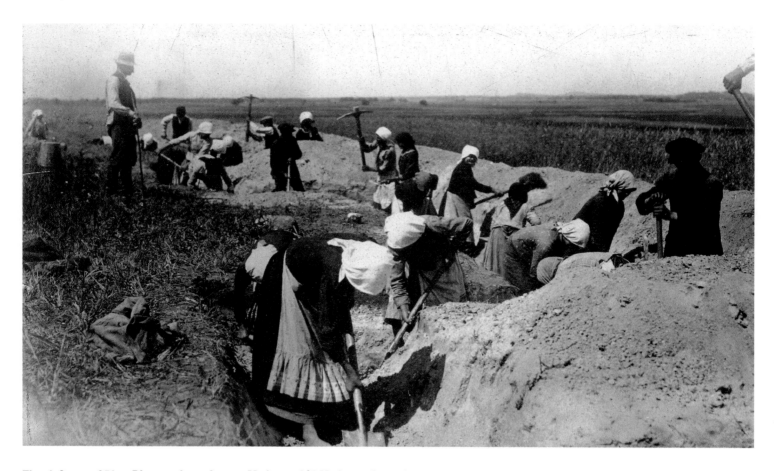

The defense of Riga *Photographer unknown, Underwood & Underwood, 1915*

When German forces on land and sea began to menace Riga, the most important Russian port on the Baltic, local women were mustered to dig trenches for the outer defense of the city.

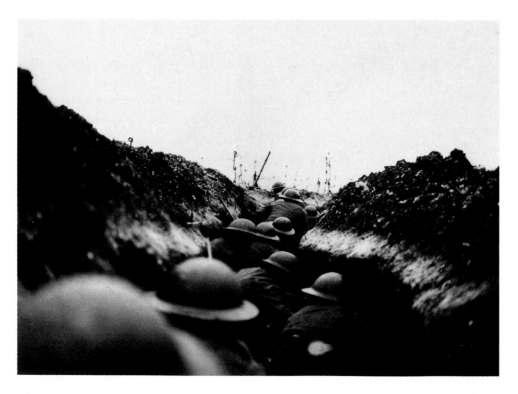

In the trenches near Arras, France
Photographer unknown, 1915

"When all is said and done," wrote the British poet Siegfried Sassoon, *"the war was mainly a matter of holes and ditches."* The most enduring images of the fighting were the vast trenches that scarred the French and Belgian landscapes; they came to symbolize the futility of the war. Hundreds of thousands of lives on both sides were lost in the bloody battles to shift the trench lines a few feet in either direction.

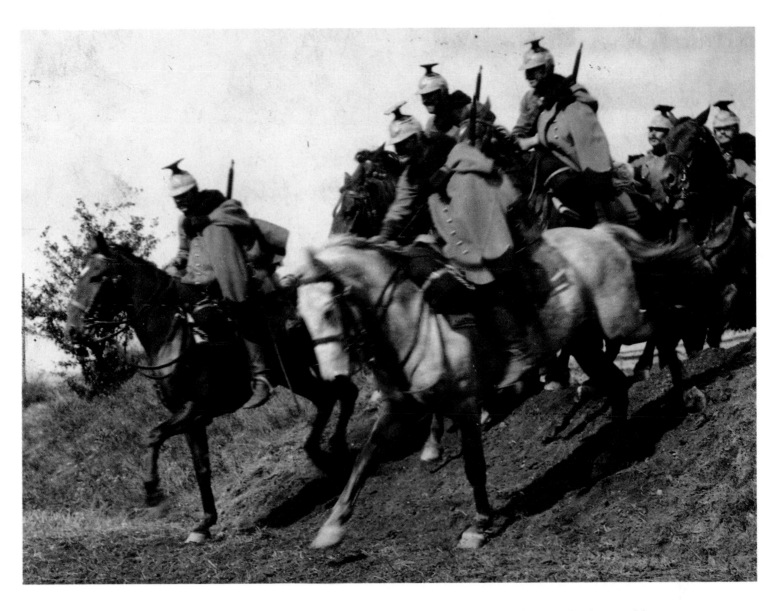

Austrian Uhlans going into position
Photographer unknown, Underwood & Underwood, 1915

World War I was the last major conflict to see the use of mounted soldiers like these, who appeared in a picture in the New York *Tribune*. Suicidal charges directly into machine-gun fire in the early years of the war finally convinced officers on both sides that the days of the gallant cavalrymen were over.

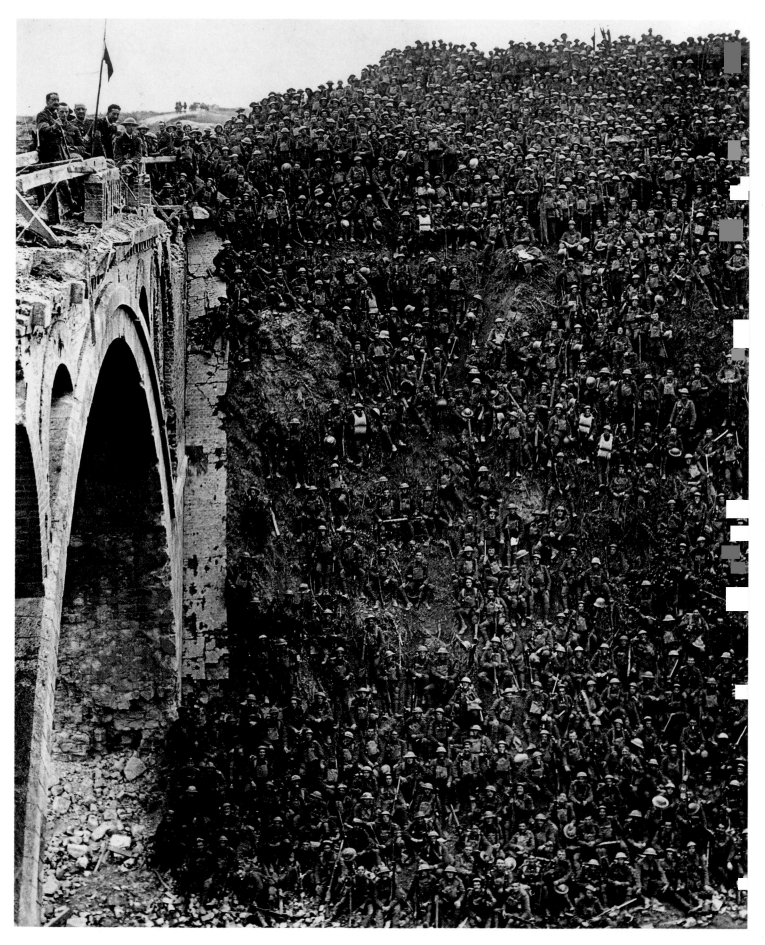

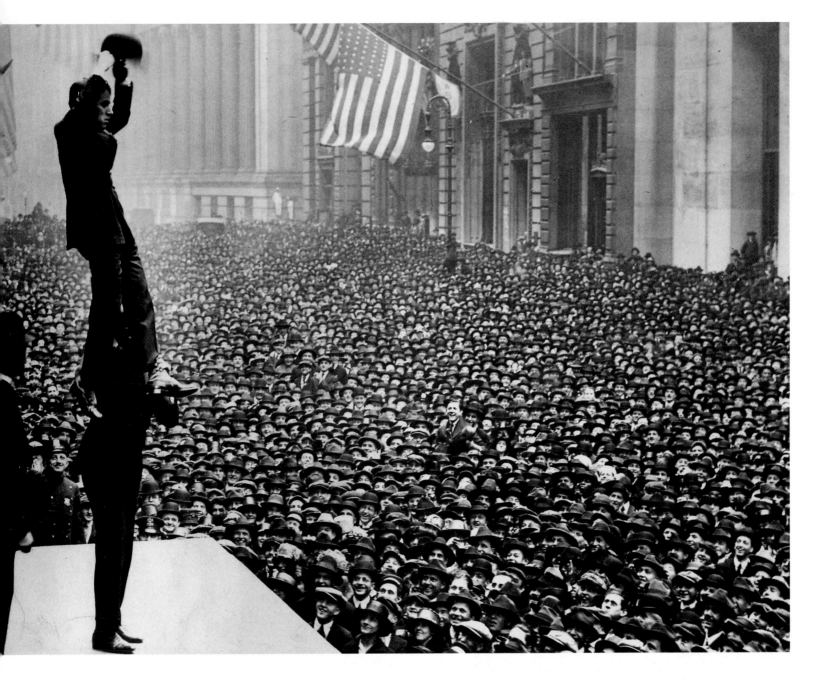

Charlie Chaplin and Douglas Fairbanks at a Liberty Loan rally
Photographer unknown, U.S. War Department, 1918

The stars of the silent screen were recruited for the wartime effort. Chaplin and Fairbanks address a crowd in the financial district of lower Manhattan to promote Liberty Bonds, which helped pay for the war.

A British officer addressing the troops
Photographer unknown, 1918

Brigadier General T.C. Campbell speaks to his men at Saint-Quentin Canal, Aisne, France.

Bombing by hand
Max Pohly, c. 1917

World War I saw the first use of aerial bombing, which, in the days before the invention of the bombsight, was an even more inexact practice than it can sometimes be today.

American soldiers in battle
Photographer unknown, 1918

U.S. soldiers fire off rounds from a 37-mm gun at a German machine-gun house in the Argonne forest in France. Years of trench fighting could turn woodlands into unearthly, blasted wastelands.

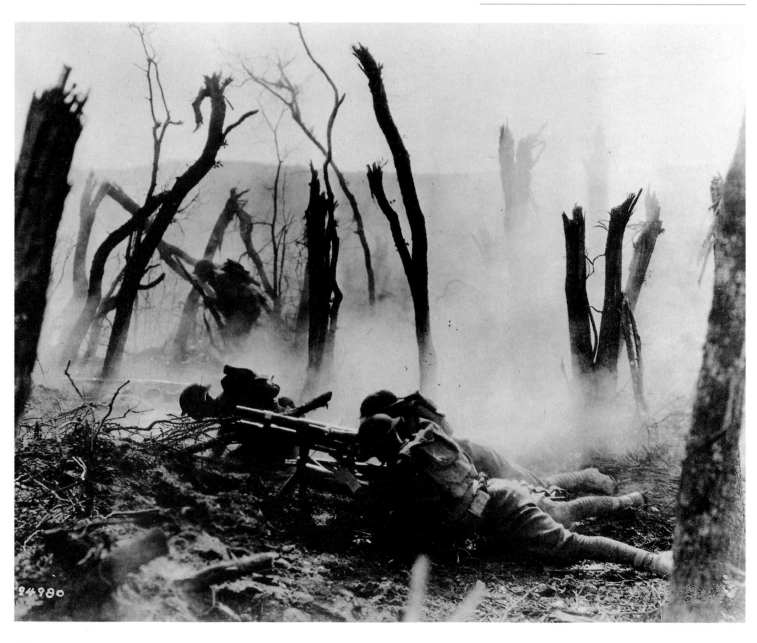

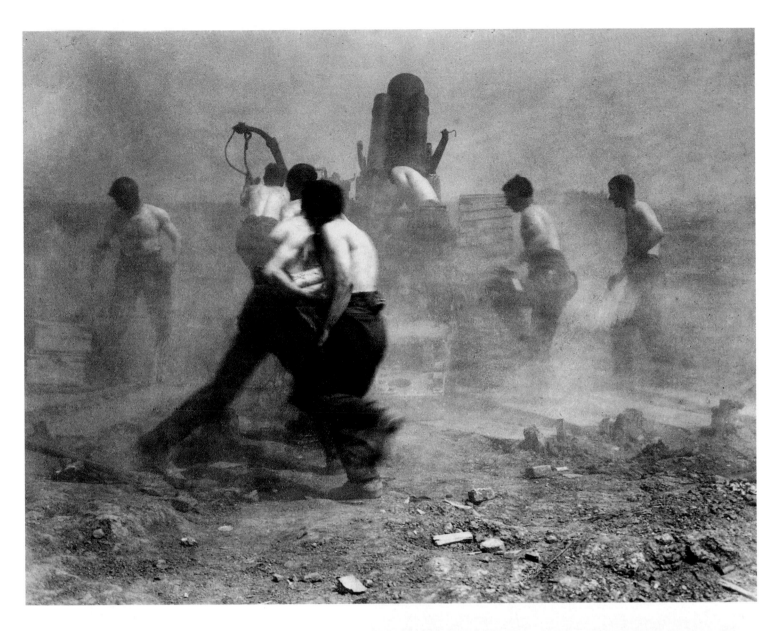

British artillerymen feed an 8-inch howitzer
Photographer unknown, 1917

World War I marked the first wide use of destructive new weapons such as tanks, poison gas and the "big guns." Giant artillery lobbed immense shells into the trenches, accompanied by an ear-piercing shriek that shattered the nerves of the soldiers.

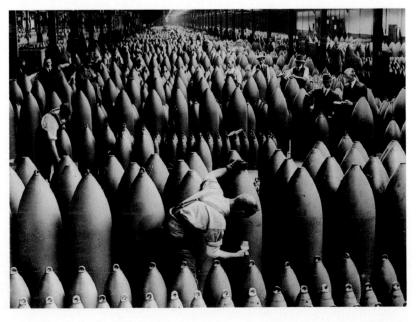

A sea of shells at a British munitions factory
Horace Nicholls, 1916

The biggest of the big guns fired shells like these, mass-produced to meet the needs of mass conflict.

The funeral of a murdered leader of the Ku Klux Klan
Photographer unknown, Underwood & Underwood

The news stories of the 1920s included the rising power of the Klan in the South and Midwest. The Invisible Empire preached a gospel of hate against blacks, Jews and Catholics, which it put into practice through murder and intimidation.

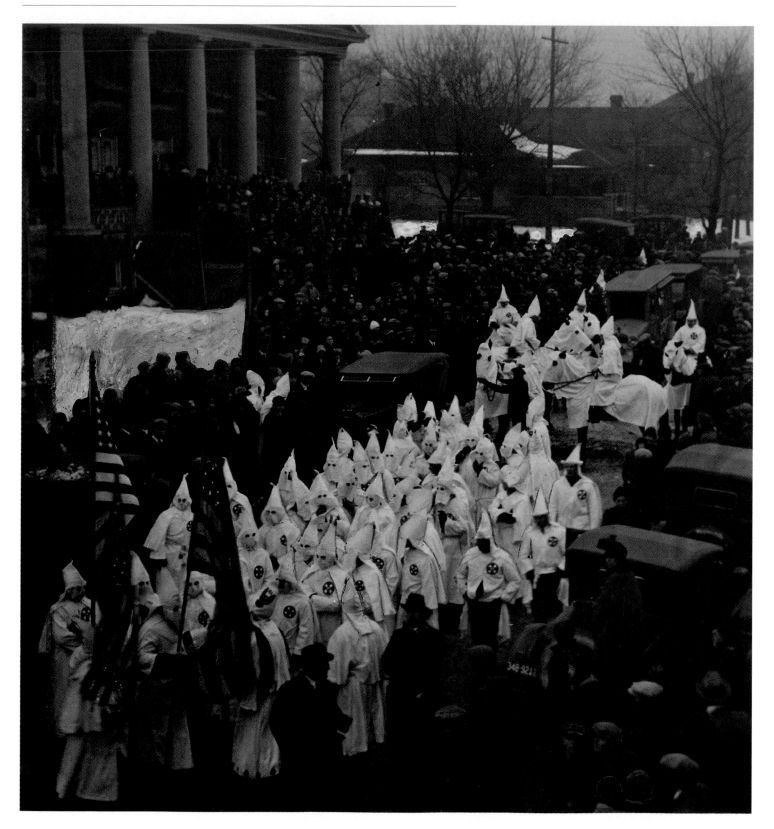

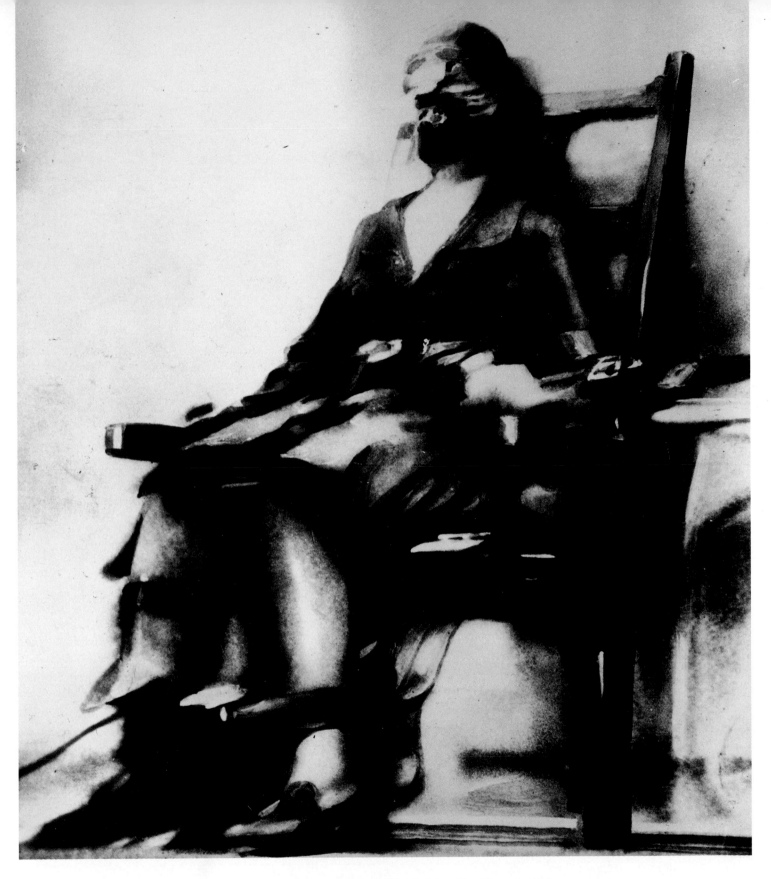

The execution of Ruth Snyder *Tom Howard, 1928*

The rise of the photo-illustrated tabloid created a generation of news photographers who would go to any length to get a picture, the more shocking the better. Howard strapped a hidden camera to his ankle to get this picture of a famous murderess at the moment of her death. The New York *Daily News* ran it under a screaming one-word headline: DEAD!

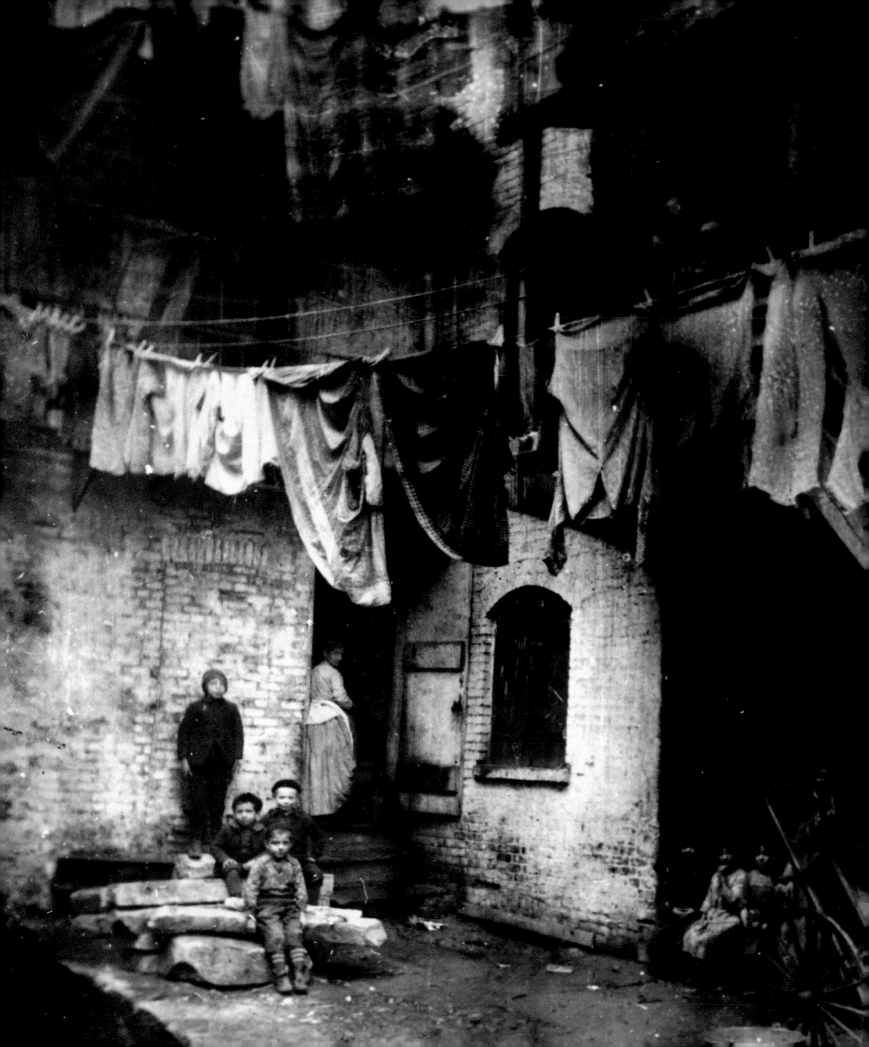

III: CONSCIENCE 1880-1920

American journalism in the last decade of the 19th century was a cluttered field of tabloid newspapers. They were big, inflammatory dailies, carrying a heated mix of scandal and sensation under shrieking headlines. Yet socially concerned photojournalism was born in their pages—in part because the slums that were its first subject lent themselves to lurid reporting and social crusading, two mainstays of the tabloid approach to the news. It took several years, but the power of photography to goad the human conscience was eventually recognized by editors everywhere. The man who taught them was Jacob Riis.

One evening in 1888, readers of a New York tabloid, the *Sun,* turned to the news that "a mysterious party has lately been startling the town o'nights. Somnolent policemen on the street, denizens of the dives in their dens, tramps and bummers in their so-called lodgings, and all the people of the wild and wonderful variety of New York night life have in their turn marvelled at and been frightened by the phenomenon. What they saw was three or four figures in the gloom, a ghostly tripod, some weird and uncanny movements, the blinding flash, and then they heard the patter of retreating footsteps and the mysterious visitors were gone before they could collect their scattered thoughts and try to find out what it was all about."

The third-person format was just a tease. The writer was Riis, a *Sun* reporter who was describing himself and three colleagues. After years of covering the police beat, Riis hit on the idea of taking pictures around the slums of the Lower East Side as a way to expose to the public the wretched conditions he found there. It was a world where immigrant families were packed four to a room and children slept on sidewalk gratings. Fatigue, filth and disease were everywhere. Riis had tried to describe the place in his reporting, but the results didn't satisfy him. Aiming to shock his readers and spur them to action, he looked to photography as a way to lodge an indelible impression in the public mind. With his pictures of dark tenements and sinister alleys, he would be Virgil, conducting the middle class on a Dantesque tour of hell.

Over the years Riis worked for two of New York's most celebrated dailies, the *Tribune* and Charles Dana's *Sun*. He had the tabloid reporter's temperament: a tough-guy view of human nature, an instinct for a gripping story, a taste for melodrama. But he was genuinely moved and angered by the wretchedness of the districts he covered. He was uninterested in photography for its own sake; he cared for it only insofar as it could expose the squalid tenements and help eradicate them. It was Riis above all others who discovered what eventually became one of the most characteristic missions of the camera: it could be pointed at misery. He virtually invented what much later came to be called "concerned photography," a combination of finger pointing, hand wringing and fist shaking now accepted as one of the quintessential purposes of photojournalism.

Riis held up his pictures of the poor at a moment when Americans were ready to see them. By the latter decades of the 19th century, the human cost of the Industrial Age was becoming impossible to ignore. After the Civil War, industrialism became the engine of American wealth. But even as it drove the economy, it pounded fiercely on the workers who kept it running. Factories were foul and dangerous. Wages were driven mercilessly downward. Depressions periodically rattled the economy, erasing jobs that paid little in the best of times. In an increasingly desperate atmosphere, labor and capital faced off across a line drawn in blood.

At the same time, millions of immigrants spilled into the port of New York. Many of them were packed straight-away into the suffocating slums of the Lower East Side. The area around Mulberry Street that Riis knew best—police headquarters was located there—had been presided over by unscrupulous landlords since the mid-1800s. But it did not become the patchwork of bursting ghettos that Riis uncovered until the 1870s and '80s, when successive waves of Irish, Germans and Italians poured into its narrow confines.

Riis learned to wander the teeming district in the hours between two and four in the morning, to catch it, as he liked to say, "off its guard." When Health Department agents made their inspections of unsanitary dwellings, Riis accompanied them. He saw for himself places where an entire family might spend the day rolling cigars in their tiny room or where a dying infant could lay untended in a corner. "We used to go in the small hours of the morning into the worst tenements to count noses and see if the law against overcrowding was violated," he later wrote. "The sights I saw there gripped my heart until I felt I must tell of them, or burst, or turn anarchist."

Baxter Street Court *Jacob Riis, c. 1895*

These were not sights that Riis was seeing for the first time. He had arrived in the U.S. from Denmark in 1870, just as the American economy was staggering toward the calamitous Panic of 1873. For years Riis remained unemployed, so desperately poor that he once walked from New York to Philadelphia on the promise of finding work there. He later spoke of having joined "the great army of tramps, wandering about the streets in the daytime with the one aim of somehow stilling the hunger that gnawed at my vitals, and fighting at night with vagrant curs or outcasts as miserable as myself for the protection of some sheltering ash-bin or door-way." He knew what it was to sleep in the flophouses that police operated for the homeless, to pick his dinner from trash cans or to beg daily at the kitchen door of the city's most luxurious restaurant. "Lunching at Delmonico's," he used to call it.

After more than three years of that life, Riis managed to secure work with a New York press association. Years later, in 1887, he returned to his old haunts, a reporter armed with a camera. Because he knew nothing at first about photography, he relied upon two amateur photographers, Richard Hoe Lawrence and Henry G. Piffard. Many of the pictures credited to Riis were actually taken by them. (Like Mathew Brady, Riis did little to discourage the misunderstanding.) Typically, there's no way to tell which of them made a particular image. Riis wasn't looking for art; he was after evidence. From time to time editors had assigned artists to paint and draw the habitats of the poor. (No less a figure than Winslow Homer went to opium dens for *Harper's Weekly*.) Riis preferred photographs because they forced his readers to confront every crack in the plaster and grimy strip of bedding, without exposing them, as he once explained, to "the vulgar sounds and odious scents."

Because they worked so often in dark alleys and sunless rooming houses, Riis and his colleagues became pioneers of flash-lighted photography, a delicate undertaking in the days before flashbulbs. They made some of the earliest use of the newly invented magnesium flash powder, a volatile substance that had to be poured into an open pan, then ignited with a flaming bang. "Twice I set fire to the house with my apparatus," he later recorded. "And once to myself."

Riis was not a delicate intruder; tenderness was not his style. In his pictures gimlet-eyed thugs and homeless old ladies are put before us as coldly as laboratory specimens in a display case. They are not objects of sympathy but examples of degradation, testimony to the effect of squalid conditions. He thought nothing of startling a group of sleepers with an explosion of flash and had no patience for anyone who tried to straighten himself up for the camera. It's no surprise that in one neighborhood a crowd of women drove him away in a shower of rocks.

Riis was by no means a radical. His own solution for the slums was model housing with the landlord's profit held to five percent. He made his appeals to middle-class conscience, not working-class consciousness. Yet his unflinching portraits of tenement life marked a turning point between the Victorian idea that poverty was a stigma of personal failure and the emerging conviction that it was a condition that ought to be remedied. He was typical of turn-of-the-century reformers whose message was that poverty was at the root of disease, vice and ignorance. The solutions were schooling, jobs at decent wages, adequate housing and health care. It was assumed that the middle classes would provide these things (through government or private action), either from a sense of class duty or enlightened self-interest. "The sea of a mighty population, held in galling fetters, heaves uneasily in the tenements," he warned. "If it rise once more, no human power may avail to check it."

There were few precedents for Riis' work. The British, who had felt the effects of industrialism first, had tried to come to terms with it through photography. Henry Mayhew's *London Labour and London Poor*, a pioneering study that was accompanied by wood engravings drawn from daguerreotypes, was published in serial form in 1851, the year in which England and Wales recorded as many people living in its cities as in the countryside. Twenty-six years later, John Thomson contributed 37 photographs to *Street Life in London*, a compendium of case histories he wrote with the journalist Adolphe Smith. As would Riis, Thomson and Smith saw the camera's reputation for truthfulness as its advantage for their work: "The unquestionable accuracy of this testimony will enable us to present true types," they wrote, "and shield us from the accusation of either underrating or exaggerating individual peculiarities of appearance."

Thomson was a forerunner of Riis in still another sense. Thomson spent years photographing in China. Though Riis rarely ventured far from New York, his work owes something to the 19th century travel photographers like Thomson, who brought back images of foreign lands and exotic ways of life. Riis was an emissary to his middle-class readers from a world that was geographically close—Mulberry Bend was not much more than a mile from the mansions of lower Fifth Avenue—but no less foreign or unnerving than Shanghai. He spoke to his readers in the language of their own prejudices and fears. It's an attitude implicit in the title of his famous examination of the Lower East Side, *How the Other Half Lives*, published in 1890. When his pictures appeared as a dozen pen and ink drawings in the *Sun,* they ran under the headline: FLASHES FROM THE SLUMS...THE POOR, THE IDLE, AND THE VICIOUS.

Riis was a paradox: outraged by the squalor of the tenements but deeply suspicious of the people who were forced to live in them. Though he was more sensitive than most white

Climbing into America *Lewis Hine, 1908*

A Russian family on Ellis Island *Lewis Hine, 1905*

Americans to the mistreatment of blacks, he shared the prevailing attitudes of his time in his observations on Italians, Jews and Orientals. "The Chinaman," he says in one typical passage, "is by nature as clean as the cat, which he resembles in his traits of cruel cunning and savage fury when aroused." An offhand bigotry was the rhetorical norm of the 1880s, an era steeped in social Darwinism and racial theorizing. It probably offered Riis a way to distance himself from the poverty he had narrowly escaped. Photojournalism served him the same way. Having once lived in the same flophouses he now photographed, Riis used the camera to master conditions that not long before had threatened to engulf him. It must have been a comfort for him to be on the other side of the lens.

Whatever his failure to rise above racist stereotyping, no one can doubt Riis' wholehearted determination to eradicate the slums. That was why it displeased him to see his pictures reproduced as wood engravings, which softened the harsh detail of his scenes. Though Riis was always willing to play on the sentiment of his middle-class audience, he also wanted to poke, prod and shock. In addition to his published work, Riis showed his pictures in a dramatic slide show in rented public halls. With himself as narrator, the slide lectures were spectacles, a sort of predecessor of the documentary film, with light-

ing effects and music to underline the message that the tenements must go.

Riis achieved satisfaction in a narrow sense. His newspaper pieces led to the appointment in 1884 of a Tenement House Commission to remedy the conditions he had exposed. During Theodore Roosevelt's years as New York's reform-minded police commissioner, the future Governor and President became a friend, admirer and ally. In later years, he offered government positions to Riis several times, but the photographer always refused them. Riis made the Mulberry Bend slums such an embarrassment to the city that they were torn down shortly after. A park now stands in their place. But a century later, the city is still riddled with substandard housing, and the homeless still sleep on sidewalk grates.

While Riis was pointing his lens at squalor in the slums, a host of publications sprang up to expose the larger injustices of monopoly capitalism—"muckraking" was Theodore Roosevelt's derisive term. *McClure's* magazine, established in 1893, became famous for the attacks on urban political machines by Lincoln Steffens and the exposés of The Standard Oil Company by Ida Tarbell, work that was frequently accompanied by photographs. But there was no single photojournalist of Riis' stature and humanitarianism until the emergence of Lewis Hine, a teacher who turned photographer in the first years of the 20th century. If Riis had shown that the camera could achieve rough justice, it was Hine's achievement to show that poetic justice was also within its reach. Riis' pictures were raw; Hine's were frank but tender, with none of Riis' occasional nose-holding attitude toward the poor. He possessed both a reformer's sense of mission and an artist's eye.

Hine's best-known subjects were the immigrants arriving at Ellis Island and the ranks of American workers, especially child laborers. Like Riis, Hine knew something about the world he photographed. At 18 he had gone to work in an upholstery factory near his home in Oshkosh, Wisconsin, earning $4 for a six-day week of 13-hour days. Eight years later, he was somehow able to leave for the University of Chicago, where he studied sociology and education. From there he went to New York City to continue his studies at Columbia University.

Hine was past 30 when he took up the camera in a serious way. By that time he was teaching science and photography at New York's Ethical Culture School, a Manhattan redoubt of dedicated progressives, whose principles and aims were to guide Hine's career. Progressivism was a middle-class reform movement, a self-conscious alternative to the revolutionary socialism that was gaining ground among the working class. Progressives were intent upon ameliorating the hardships of capitalism through legislative action, not class warfare. Hine

saw his pictures as elements in a process that began with aroused public opinion and culminated in government action.

Publications were an essential component of the progressive program. Hine came to regard his photographic work as virtually unfinished until it was published, preferably as a group of images printed together to develop a coherent argument and collective punch. In 1908 he went to work for *Charities and the Commons,* a journal published by two brothers, Paul and Arthur Kellogg. It says much about the way in which the progressives perceived themselves that in the following year the magazine changed its name to the *Survey,* discarding the word "charity" (with its whiff of Victorian philanthropy) in favor of a title that spoke of a scientific and systematic approach to social problems.

Yet for all the progressives' emphasis on dispassionate science, the chief impression left by Hine's pictures is not their efficient delivery of the facts but their deep feeling. His work seems to argue that compassion is an essential complement of intellect; that without it, reason fails. It was a recognition that helped him avoid representing his subjects as stereotypes. In Hine's 1904 portraits of immigrant arrivals, there are no clichés of ethnicity or occupation. Subjects cannot be dismissed or assigned some narrow conceptual slot: peasant or butcher or Slav. Deprived of easy signposts, we encounter these people on their own terms. Hine resisted the temptation to dramatize. He let the gravity of a young woman's face bear the full weight of his intentions. Even if people could not speak the language of their new home, they could state themselves plainly to the lens.

Later, Hine worked for over a decade taking pictures of child laborers. He began in 1906 as a free lance photographer for the National Child Labor Committee, a private body dedicated to surveying and publicizing the hidden world of underage workers in America. There were as many as 2 million children under 16 in the work force at that time, picking cotton and vegetables, working the looms in textile mills, stitching in sweatshops, prying open shellfish at docksides, separating rocks from ore in coal mines. Hine's work took him throughout the Northeast, up and down the Atlantic and Gulf coasts, into the South and the Midwest. To gain access to the workplaces, he sometimes gulled suspicious mill owners into thinking that he was there to photograph their machinery. Then he would move in with his equipment, all the while keeping one hand in his pocket for clandestine note taking on the ages and number of child workers. To get a rough measure of their heights, he compared them against the buttons of his jacket.

Hine went on to do significant work in Europe during World War I, but just as the energies of progressivism ebbed and flowed in the postwar years, Hine fell into obscurity during the '20s, only to be rediscovered just before he died—in poverty—in 1940. By that time a new generation of critics and photographers had been led back to concerned photography by the economic calamities of the Depression. They looked upon Hine's pictures of 30 years earlier as ancestors of their own work. In a sense, Riis and Hine established between them the poles of photojournalism: Riis' work, blunt and rough-edged; Hine's, gentler and more ambiguous. Some combination of their temperaments is detectable in much of the photojournalism that followed.

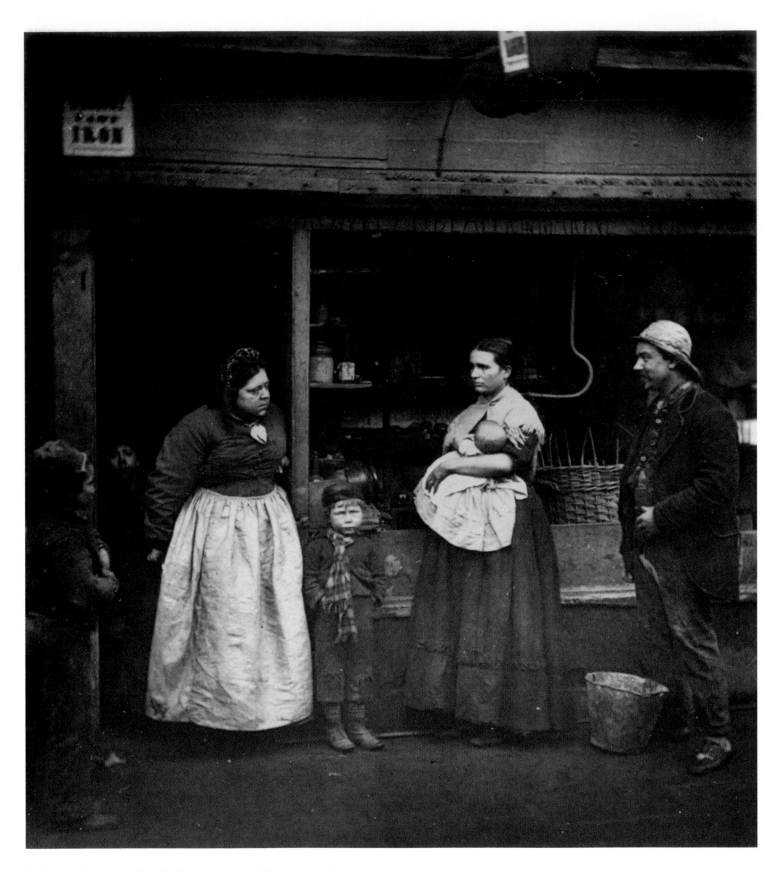

Sufferers from the floods in London *John Thomson, c. 1876–77*

Thomson described the aftermath of flooding on the poor of London's Lambeth district: *"The effects of disasters,"* he wrote, *"are still pressing heavily upon a hard-working, underfed section of the community."*

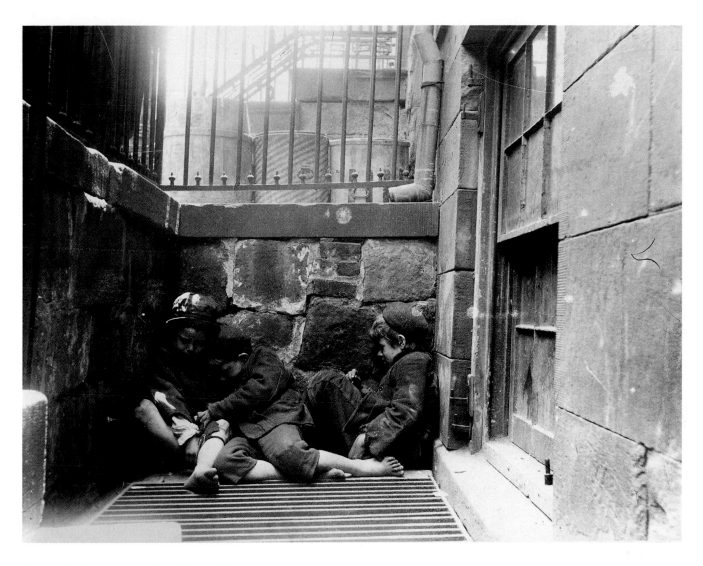

Street Arabs at night *Jacob Riis, c. 1889*

Some of Riis' angriest and most affecting work was done among the poor and homeless children of the Mulberry Street slum district in Lower Manhattan. In his book *How the Other Half Lives*, he described the boys he saw every winter *"when snow is on the streets, fighting for warm spots around the grated vent-holes."*

The crawlers *John Thomson, c. 1876-77*

Thomson made his pictures to accompany a pioneering sociological study, *Street Life in London.* It was one of the earliest attempts to bring to bear the new discipline of sociology on the problems of London's fast-growing population of poor. "Crawlers" were poor people so malnourished they would literally crawl to fetch water for the hot tea on which they chiefly subsisted. This woman held a small child all day for its mother, who had found a job in a coffee shop.

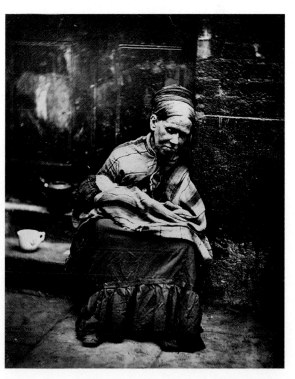

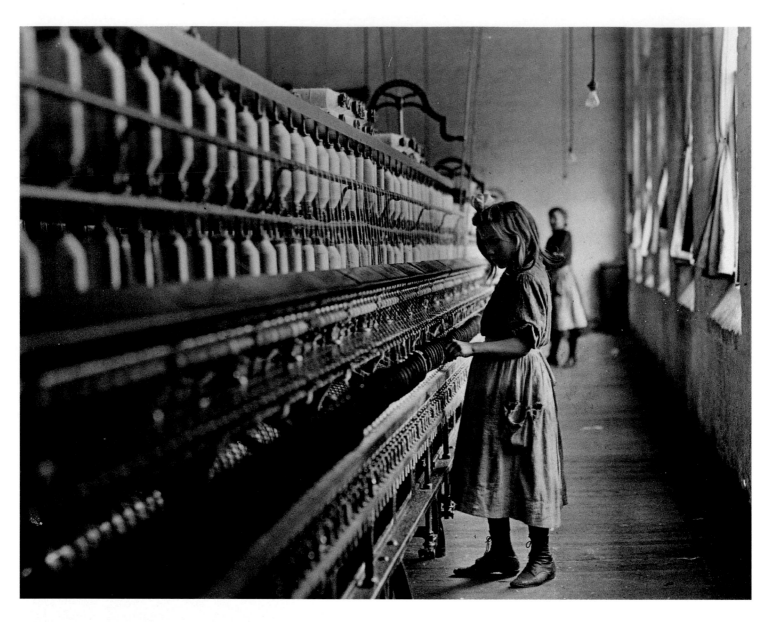

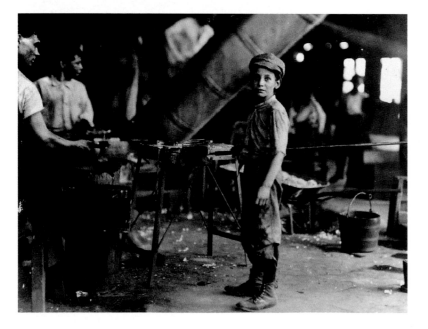

Child spinner
Lewis Hine, 1909

Hine kept detailed notes on the child laborers he photographed, like this one in North Carolina. *"Sadie Pfeifer, 48 inches tall, age not known, has worked half a year. She is one of the many small children at work in the Lancaster cotton mills."*

A carrying boy in a Virginia glass factory
Lewis Hine, 1911

Hine believed in the camera and used it masterfully, but he did not count on it to convey all the hardship of child labor. He was careful to add to the title of this picture the fact that the boy *"works in day shift one week and night shift next. He works all night every other week."*

"Breaker boys" at a coal mine in South Pittston, Pennsylvania *Lewis Hine, 1911*

The primary purpose of the photographs Hine took for the National Child Labor Committee, an organization committed to the regulation of child labor, was simply to prove that there were millions of youngsters working in factories, a fact widely denied by employers. Among the most exploited were "breaker boys," whose job it was to separate rocks from chunks of coal. Like the men they worked beside, the boys endured foul air, dangerous conditions and 12-hour days. In such circumstances, wrote one miner, life *"is scarcely worth having."*

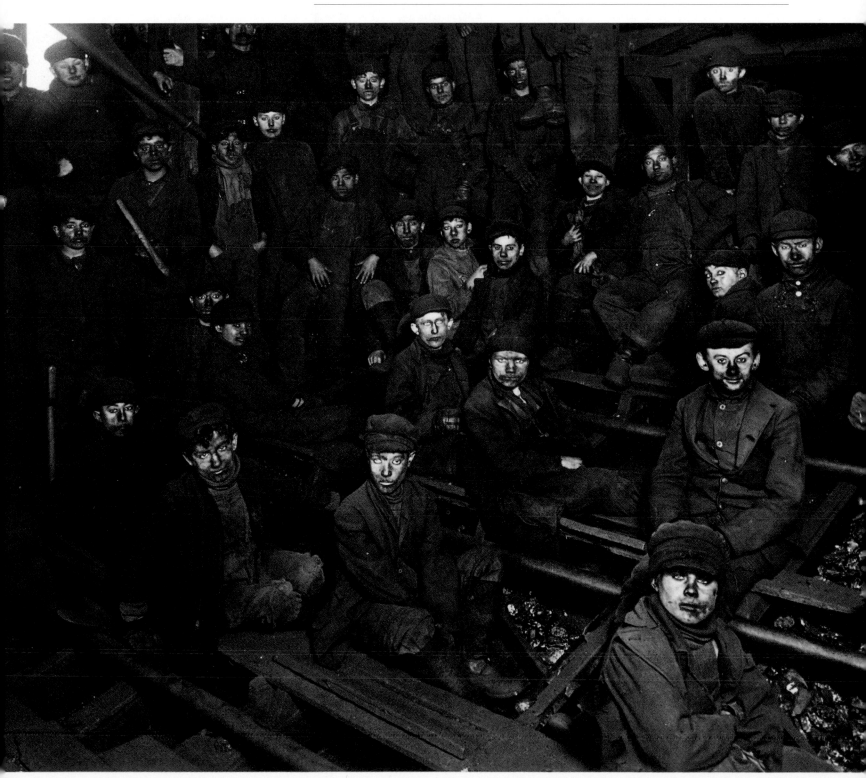

"Breaker boys" at a coal mine in South Pittston, Pennsylvania *Lewis Hine, 1911*

A girl at work in a cotton mill
Lewis Hine, 1911

To gain access to workplaces, Hine sometimes gulled suspicious mill owners into thinking he was there to photograph their machinery. Then he would move in with his equipment, keeping one hand in his pocket for clandestine note-taking.

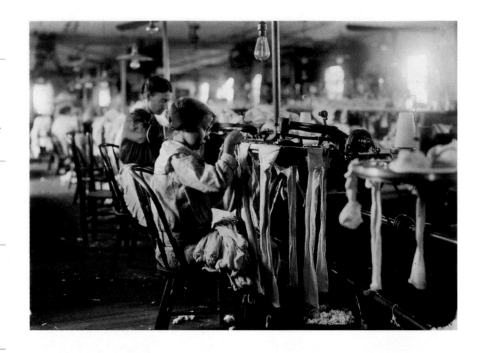

Five cents a spot, Bayard Street
Jacob Riis, c. 1889

Riis aimed to prod the conscience of a middle-class audience with images of poverty, but his raw approach sometimes made his subjects appear alien and sinister. Photojournalism still navigates between the poles of Riis' stark encounters and Hine's gentler presentations.

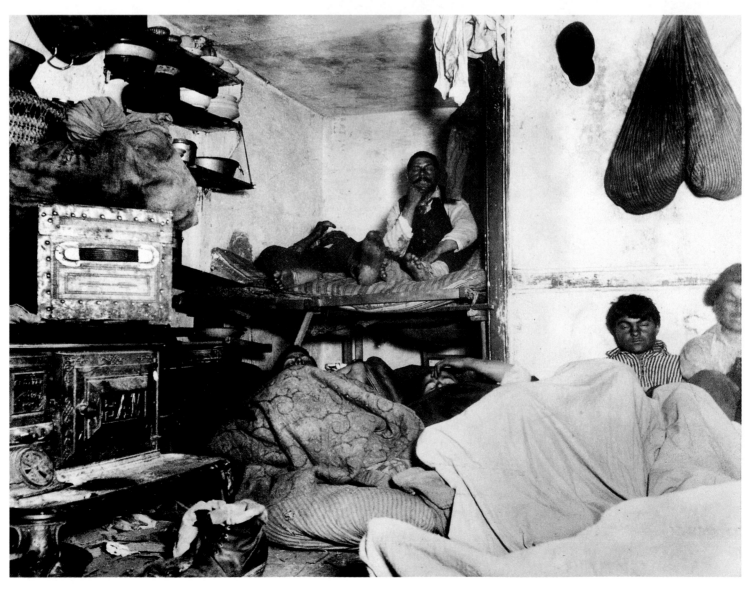

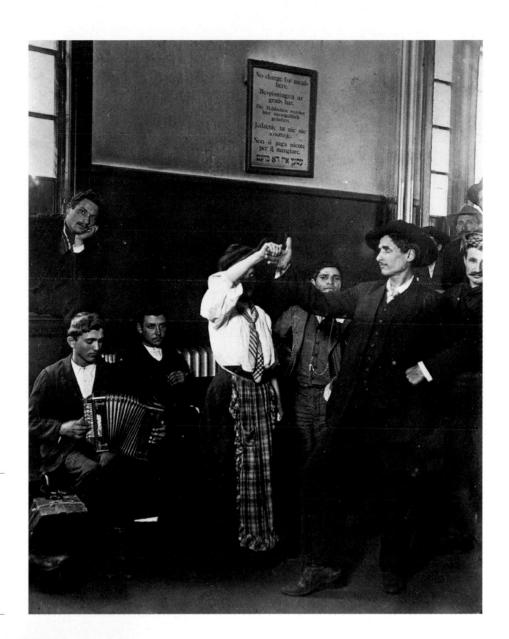

Immigrants waiting at Ellis Island
Lewis Hine, c. 1905

Hine tried to use photography to humanize his subjects for the Middle American audience he hoped would see his pictures. Immigrants were often presented to the public as strange and threatening; Hine showed them enjoying the simple pleasures of life, even in the holding pens of Ellis Island.

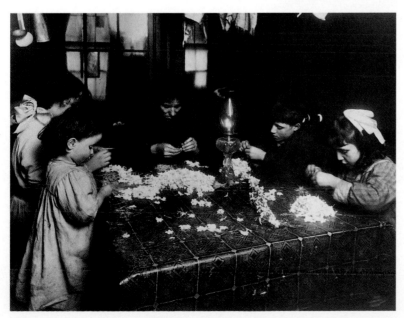

A family works at home making flower wreaths
Lewis Hine, 1912

"It is 8 p.m. and the Mortaria family are making flower wreaths," Hine wrote. *"The little three-year-old on the left is actually helping, putting the center of the flower into the petal. The family said she often works irregularly until 8 p.m. The other children, 9, 11 and 14 years old, work much later—until 10 p.m. The oldest girl said her father is a soapmaker and has been making three dollars a day."*

IV: MAGAZINE DAYS 1920-1950

After the bloodiest war in history, people withdrew into private pursuits. But the postwar public craved to *know*, and to an increasing degree, knowing meant seeing. Much of the craving was satisfied by mundane images of disaster, crime and ribbon cutting. In a world now extensively served by a competitive and sophisticated press, the public sense of curiosity burgeoned. Along with the set pieces of public life and tragedy, photography trained an analytic eye on everyday reality.

In the Roaring Twenties, news photography, like Wall Street, began another era of expansion. The photographic industry responded to the challenge of peace with a broader definition of news—and a corresponding boom in publication. Pictorial magazines and photographic journalism entered a period of creative magnificence.

The flood of picture taking brought profound changes to magazine illustration. Photography began to break away from the static, formal traditions of composition that it had borrowed from the other visual arts. Picture takers armed themselves with small, ultra-sensitive equipment that could operate in less than normal light, with rapid shutter speeds and sensitive film that allowed for multiple "takes" of a subject in a compressed period of time. Photography assumed a narrative life of its own.

If one piece of equipment spurred the capabilities and ambitions of the new medium, it was the Leica. The small, hand-held camera eventually became as firmly associated with the photojournalist as the battered portable typewriter was with the war correspondent. The Leica was never intended for use by professional photographers. It was invented in 1913 by Oskar Barnack, a designer at the Leitz optical works in Wetzlar, Germany, who was also an amateur cinematographic buff. He originally conceived of the Leica as a small, relatively uncomplicated device for testing 35-mm movie film, but he soon realized it had greater potential. World War I interrupted the camera's development, but in the 1920s Barnack returned to his innovation. Loaded with a spool of 35-mm film that was linked mechanically with the camera shutter, the Leica allowed a photographer to shoot rapidly and repeatedly from eye level. The images captured on film could then be magnified in the developing process and ordered in a sequence resembling action. The Leica was introduced in 1924 and spawned a host of imitators and improvements, all based on the notion that photography, particularly action photography, could be expressed as an extension of the photographer's own act of seeing.

The other development that made the Leica the victor in news photography was the perfection of increasingly "fast" film, which allowed sequences of images to be captured in hundredths, then thousandths of a second. By 1930 the best rolled film was as sensitive as the best coated glass plate. The act of picture taking became ever more intuitive, a matter of inspired opportunism.

A complementary breakthrough, in its effect on spontaneity, was the 1925 invention of the flashbulb. (The dangers of magnesium flash powder were well documented. William Randolph Hearst banned its use at his newspapers in 1929 after a photographer lost two fingers in a freak explosion.) The problem was solved when Paul Vierkötter, a German, found a method of sealing magnesium wire in a vacuum bulb. The wire was replaced by foil in 1929, and the resulting product was marketed in Germany as *Vacu-Blitz*. The flashbulb eliminated much of the fume and gloom from lighted photographs, and speeded up the picture-taking process. Photographers were forced to come in closer to their subjects, framing action with figures dramatically heightened against a foreshortened backdrop. The results were inherently melodramatic, a characteristic thoroughly exploited by the best press photographers of the age. The effectiveness and speed of artificial illumination were extended again in 1931, with the invention of stroboscopic lighting.

Possessed of new capabilities, photographers began to take inspiration from the analytical vision of abstract art and, even more, from the cinema, with its restless cutting techniques, multiple perspectives and ruthless editing to achieve a seamless whole. Photography moved from the contemplation of objects

Zeppelin report, May Day, march of the masses *Willi Ruge, May 1, 1933.* The Nazi government gulled workers and labor leaders by co-opting May Day, the traditional day of celebration for European workers. Proclaiming it the "Day of National Labor," the Nazis flew banners affirming solidarity with workers, and Joseph Goebbels staged Germany's biggest mass demonstration. A radio report on the "march of the masses" was broadcast to the whole country from this Zeppelin. The next day trade unions were dissolved and their leaders arrested.

"Parachute Jump" *Berliner Illustrirte Zeitung* Willi Ruge, May 24, 1931

to a subtle emphasis on the process of vision itself. In Germany critics summed up the rapid evolution in capability and technique with the term *Foto-auge* (photo-eye), photography as mechanical seeing.

Germany was one of the great innovative fonts of photojournalism. The *Berliner Illustrirte Zeitung,* or *BIZ,* was founded in 1890. Unlike many competitors, it survived, to be increasingly transformed in the late 1920s by its visionary editor, Kurt Korff, and its publishing director, Kurt Safranski. *BIZ* boosted its circulation to 2 million with essays by such writers as Arnold Zweig and Bertolt Brecht, and even more by its arresting photo coverage. Two to five pages of *BIZ*, heavily loaded with photos, would be devoted to a single topic: in 1929 *BIZ* published what is considered to be its first true photo story—the silent existence of the holy men at the monastery of Notre Dame de la Grande Trappe. That feature showcased the work of an enigmatic Hungarian named André Kertész. He was one of a special breed of independent artist-photographers, with a talent for eliciting drama from everyday images.

Kertész and his peers were forerunners of a new species, the photographer vagabond. Their mobility mirrored the condition

sweeping across Europe: people uprooted by revolution, the redrawing of national borders and, with the advent of the Great Depression, economic desperation. The photographer was, quite literally, the man in the street. If the prewar expansion of press photography transformed the photographer from a small businessman into a proletarian, the rise of the postwar magazine press restored emphasis on the picture taker as a free-lancer.

The chief competitor of *BIZ* in Germany was the *Münchner Illustrierte Press—MIP—*but the allure of photography transformed a number of publications. German newspapers sported rotogravure weekend supplements. (The rotary press process that produced them was first installed commercially in 1910.) New magazines devoted to sports, society and consumption—inconceivable without current photography—suddenly became staples.

From its beginnings, photography possessed an enormous power of factuality. In the postwar era, with the Western world seemingly in a state of moral decline, the "scientific socialism" of the fledgling Soviet Union appeared to offer a rational vision for society and, as a byproduct, elevated scientism and realism to aesthetic heights. The past, burdened with elaborate aesthetic

21. Juli 1929
Nummer 29
38. Jahrgang

Berliner

Preis
des Heftes
20 Pfennig

Illustrirte Zeitung

Verlag Ullstein

Berlin SW 68

Ferienfreude.

Aufnahme Munkacsy.

Cover of *BIZ* **July 21, 1929** *Martin Munkacsi.* Munkacsi began his professional career as a sports reporter, but a chance encounter in a Jewish coffeehouse in Budapest changed all that. Munkacsi happened to be carrying a camera when a brawl broke out between soldiers and some Jews. Less than a year later, Munkacsi had become the highest paid photographer in Hungary.

"Political Portraits" *Münchner Illustrierte Presse* René Kraus, 1929

conventions, no longer mattered. Hope was transferred to the future. Science and industry were seen as the basis for a new world that would replace the bankrupt traditions and systems that had collapsed in 1914. What better expression of the "new objectivity," to a world dominated by science and rationalism, than photography, which captured the dynamism of society with technology and gave a new freedom to personal vision.

Europe, and especially Germany, was deeply riven by ideology in the postwar interlude. Willi Ruge helped build his reputation as one of Germany's first great photojournalists with images of communist, monarchist and fascist bands battling in the streets. Unsurprisingly, photojournalism grew ideological as every variety of political credo was cranked out of the printing presses. Lenin himself declared photography and cinema revolutionary arts. In Germany the communist viewpoint was brilliantly marshaled in the *Arbeiter Illustrierte Zeitung,* where John Heartfield transformed news photography into a new weapon, the political photomontage. The rising National Socialist party,

masters of the mass spectacle, used *Die Illustrierte Beobachter.*

The sense that photojournalism had a mission, however ill defined, was deeply imbedded in the illustrated press. The elegant French photomagazine *Vu* announced its birth in 1928 with a statement by its director, Lucien Vogel, that the publication was "at once a form of expression and a means of action." To show—or to suppress—was to advocate.

Vogel's founding declaration rested on another axiom: behind every great photographer was a great and strong-willed editor—the photographer's boss. The photographer had given up immediate control of his work when he ceased to be an impresario-entrepreneur. In the new photomagazines, the editor became a creative partner. He was often responsible for the choice of subject, and certainly had more say about the final display. Perhaps the most creative editor of the day was Stefan Lorant, a Hungarian who started his career as a film cameraman and scriptwriter. He became editor of *MIP*, then the *Weekly Illustrated* in London and then a new magazine, *Picture*

Post. Lorant's imaginative sense of display and confidence in the talents of his photographers created the modern photo-journalistic showcase, with the editor as producer and the photographer as director of an enterprise not unlike cinema.

In a brief time of peace, photojournalism launched a war against privacy. Before the Leica became the weapon of choice, the Ermanox, a miniature glass-plate camera with a wide-aperture lens, appeared in 1924. The camera could operate in dim light and without being intrusive. Erich Salomon, a German-Jewish banking scion with a talent for discretion, stalked diplomatic salons, courtrooms and private railway cars with his tripod-held model to produce extraordinary documents of the closed worlds of diplomacy and justice. In the United States a New York *Daily News* photographer, Tom Howard, strapped a miniature camera to his ankle and penetrated the scene of Ruth Snyder's electrocution for murder in 1928. On the back streets of London, Paris and Hamburg, Alfred Eisenstaedt, Gyula Halasz (known as Brassei) and Tim Gidal peeled back the night to show the demimonde with an intimacy and artistic sympathy that went well beyond the earnest researches of Jacob Riis and Lewis Hine.

European news photographers had empires to chronicle and, as the '30s wore on, imperialists and anti-imperialists to announce in India, Ethiopia and Palestine. The photographer became a self-contained mobile observer, whose lines of communication were greatly extended when, starting in the 1920s, press syndicates began to experiment with techniques for transmitting photographs by wire.

As Europe's picture-magazine domain flourished, Henry R. Luce took notes. After the success of TIME, he wanted to add new territories to his newsmagazine empire. FORTUNE was launched in 1930 to celebrate American business (at a time when that activity was in a somewhat stricken condition). No consumer magazine had as great an influence on the course of American news photography at the start of the '30s as FORTUNE. Luce, who wanted to hire the best writers of the day (regardless of whether they knew anything about business), also wanted to give space to the best photographers. He found his first talent in Cleveland, a young woman named Margaret Bourke-White, who channeled into FORTUNE a fascination with industrial beauty and power that had flowered in Germany as the "new objectivity." Bourke-White's timing, as it was throughout her life, was impeccable. The Depression was taking a heartbreaking toll in America, but amid the wreckage of economic collapse, American foundries and blast furnaces were extruding the world's greatest industrial society. Bourke-White paid it monumental homage.

In politics, Luce was a confirmed Republican, in religion a Presbyterian; as a publisher, his tastes were catholic. He cared more about his photographers' originality than about their politics. The result was that FORTUNE, with its expansive format, heavy paper stock and gravure, sheet-fed press, drew some of the world's best documentary photographers, many of whom claimed to despise themselves. The most celebrated—by everyone but himself—was surely Walker Evans. Now hailed as one of America's greatest photographers, he was the producer of rich, meditative images of decaying factories, auto junkyards, abandoned railway locomotives and peeling warehouses—what he called the American "vernacular." A former TIME writer, Evans was given unprecedented freedom at FORTUNE to pursue what interested him and even did his own layouts. That did not prevent him from systematically deprecating the value of his work, which appeared intermittently from 1934 until 1965.

"I am fascinated by man's work, and the civilization he's built," Evans subsequently declared in the *New Republic*. The notion of society as an object for contemplation, as news, was one that FORTUNE went far to establish. In the '30s, that included the invisible yet pervasive disaster known as the economy. If the press had had to depend on its own enterprise to establish the contours of that catastrophe, it probably would have failed. Like so many other institutions, the press fell back on the government assistance of the New Deal, in the form of a remarkable social-documentary archive: the historical unit of the Resettlement Administration, later known as the Farm Security Administration, established in 1935 under the autocratic hand of Roy Stryker. FORTUNE drew on the archive, as did countless other publications, since its products were handed out free of charge. Stryker, an economist who had taught at Columbia University, knew the work of Riis and Hine and realized that photography could be a powerful tool in mobilizing the support of the American public to help the growing army of agricultural poor. He hired some of the most talented photographers of the era to collect 288,775 prints, negatives and transparencies for the FSA archive: Dorothea Lange, Carl Mydans, Arthur Rothstein and the irascible Evans (whom Stryker soon fired).

Meantime, the restless Harry Luce, inspired by the outburst of magazine creativity in Europe, was studying how to create a picture magazine. He had the unwitting help of Adolf Hitler. In 1933, when Hitler took power, he single-handedly enriched the photographic tradition in the rest of Europe and America by forcing countless artists and journalists to flee. Those who stayed behind in the Third Reich were required to become members of the Association of the German Press of the Reich. Hitler and his Minister of Propaganda, Joseph Goebbels, declared themselves to be the nation's paramount picture editors. All photographs of the two men had to be personally

inspected by them before publication: Hitler would snip the corners off any he did not like.

The totalitarian surge in Germany pushed the best photographers of Central Europe (with the exception of a few talented sycophants) toward Paris, London and eventually New York. The same held true for editing talent. Stefan Lorant was arrested by the Reich and freed only after Hungarian government intervention. He emigrated to Britain, where he eventually edited the *Picture Post* and, starting in 1937, *Lilliput*. Korff and Safranski of *BIZ* fled into the arms of Luce. They taught his staff technique and recommended photographers to him, including the durable "Eisie," Eisenstaedt. For more than three years Luce and his aides tinkered, until in November 1936, the first issue of LIFE appeared on newsstands. It was a runaway success that almost destroyed itself when the huge demand for the maiden issue far outstripped the press run. Luce took a deep breath and printed more copies than his advertising rates would support.

Today, saturated as we are with photographic and electronic images, it is difficult to recapture the immense impact of LIFE upon the American public. Like the railroads, the telegraph and, later, television, the magazine gave the nation a more immediate sense of itself. It treated America as news. Insulated from the political calamities of Europe, and from the sharp ideological sensibilities that defined so many European publications, the tenor of LIFE was inherently celebratory, even when the images it bore were tragic or horrifying. From its first issue, when the magazine—for lack of anything better—celebrated a Saturday-night wingding near the Fort Peck Dam in Montana, LIFE reinforced the American sense that large news events are often writ small—a distinctive feature of American journalism. The magazine spawned a gush of imitators: *Look, See, Photo History, Focus, Pic, Click.*

As the magazines extended their scrutiny inward to unexplored aspects of America and outward to nations around the world, they increasingly covered war: in China, Spain, Europe, then the Pacific. A generation of *engagé* photojournalists, led by Henri Cartier-Bresson, Robert Capa and David Douglas Duncan, marched alongside the cataclysm. The sensibilities they had forged in peacetime would bring a powerful dimension to the recording of atrocity: a sense of intimacy with the intersection where individuals create and suffer history.

At work *Boris Ignatovich, 1929.* Twelve years after the revolution, Soviet leaders were extolling the workers' new relationship to labor, calling them "masters of technology" or "socialist heroes." The magazine *Sovetskoye foto* urged photographers to create a "proletarian photography" that would concentrate on the heroic worker, emphasizing his dominance over the machine. To convey this, photographers had to reverse the size ratio between man and machine. Shot from underneath, instead of straight on, the worker became the giant he was expected to be.

Summit conference *Erich Salomon, 1928*. French statesman Aristide Briand and German Minister of Foreign Affairs Gustav Stresemann met with British Foreign Minister Sir Austen Chamberlain, August Zaleski of Poland, Mineichiro Adachi of Japan and Vittorio Scialoja of Italy in Lugano before the signing of the Kellogg-Briand Peace Pact renouncing war.

Erich Salomon came to photography late; he began taking photographs at age 41. Within a year, the impeccably tailored Salomon was on his way to becoming one of the foremost photographers of Europe. He had an uncanny knack for penetrating the innermost councils of European diplomacy. His shots of European statesmen and diplomats at their secretive labors brought a new term to the lexicon when a London *Graphic* editor labeled Salomon the "candid camera." Salomon's achievement, however, went beyond bringing new territory within the range of photojournalism's inquisitiveness. Salomon helped cement the notion that news photography was a privileged form of seeing, a record of events that brought the viewer together with the event. In his chosen field, Salomon was the equivalent of the greatest war photographers, and in his ingeniousness, surpassed most of them.

Born in Berlin in 1886, Salomon studied law, engineering and zoology. After World War I, when the family fortune was lost, he found a job in the promotion department of the Ullstein publishing empire, publisher of the *Berliner Illustrirte Zeitung*. Salomon was placed in charge of the company's billboard ads.

Erich Salomon

His first photographs were made in 1927 to document some legal disputes. Eventually he came upon the camera that was to make his career: the Ermanox, a small, glass-plate camera combined with a large f/2 lens that made it usable in dim light. His initial successes came in Berlin criminal courtrooms, where cameras were banned. By hiding his Ermanox in a bowler hat and cutting a hole for the lens, Salomon caused a sensation with his pictures of a police killer on

trial in 1928. At another murder trial, he put the camera in an attaché case and rigged a lever to trip the shutter. His reputation soared.

The great institutions of politics, justice and diplomacy fascinated Salomon, and he had a remarkable ability to penetrate them. Fastidious and multilingual, Salomon blended in easily with the great men who were, in a sense, his more successful peers. At the signing of the Kellogg-Briand Pact in Paris in 1928, Salomon simply walked into the signing room and took the vacant seat of the Polish delegate. Eventually, the statesmen whom Salomon stalked bestowed on him their ultimate accolade: they came to believe his presence was a necessary part of their deliberations. Salomon had managed to convince them that photojournalism was part of the historical record. The "photo opportunity" was born.

When Adolf Hitler came to power, Salomon fled to Holland with his Dutch-born wife and continued his career at the Hague. LIFE offered to bring him to the United States, but he refused. In May 1940 Hitler invaded the Low Countries, and Salomon was trapped. He and his family were betrayed to the Nazis and died in Auschwitz in July 1944.

Joseph Goebbels
Alfred Eisenstaedt, 1933

Joseph Goebbels, Adolf Hitler's Minister of Propaganda, with his private secretary and Hitler's interpreter at a League of Nations Assembly in Geneva. *"When I went up to him in the garden of the hotel,"* Eisenstaedt later recalled, *"he looked at me with hateful eyes and waited for me to wither. But I didn't wither. If I have a camera in my hand, I don't know fear."*

Private jazz concert in a Berlin villa *Felix H. Man, 1929*

Man, who worked with Dephot, the German photographic service, was in great demand because of his talent for covering the widest possible range of subjects. Man left Germany during the great exodus of artists in the mid-'30s.

Piazza del Campidoglio
Carl Mydans, 1940

This picture of the famous 16th century Roman square was shot during an assignment for LIFE on Fascist Italy. *"When I arrived in Rome in May 1940,"* Mydans wrote, *"I was repeatedly prevented from taking pictures by Black-shirts who blocked my cameras. On May 9, Mussolini appeared at the Victor Emmanuel II monument to celebrate the fourth anniversary of the founding of the Italian Empire. A circle of security men barred me from the ceremony. But as Mussolini was departing, he strutted right past me. The security men were compelled to applaud as he went by, and I was able to make one quick frame between their shoulders. The picture appeared across a page of LIFE several weeks later with the caption, 'The elderly Butcher Boy of Fascism, Benito Mussolini, steps out...' The TIME and LIFE staffs were immediately expelled from Italy."*

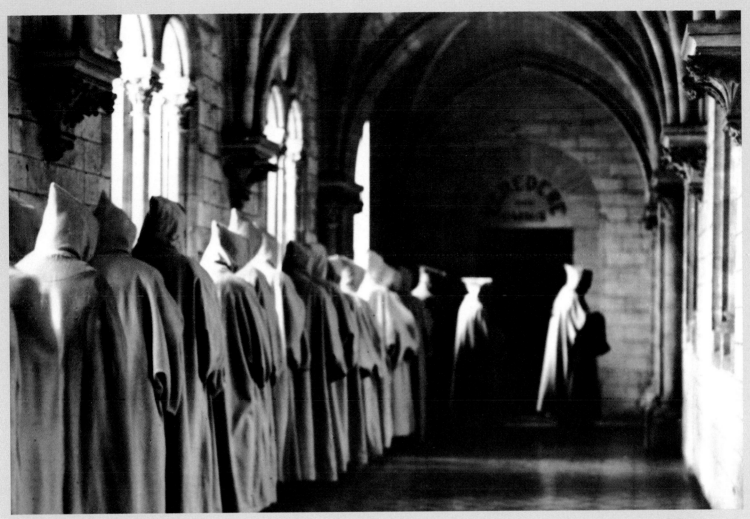

The house of silence *André Kertész, 1929.* Monks at the motherhouse of the Trappist order, Notre Dame de la Grande Trappe, in Soligny.

André Kertész

To the European publishers of photojournalism's golden age and to his peers, Hungarian emigré André Kertész was one of the most interesting and provocative photographers of his day. His haunting sense of composition inspired generations of succeeding photographers: a dadaist dubbed Kertész "Brother Seeing Eye," for his angular vision of reality, in which nothing was quite as it appeared. The photo-essay format was virtually invented for him. Yet in America—where he immigrated because of Hitler—Kertész was a virtual unknown.

Born in Budapest in 1894, Kertész was a self-taught photographer who picked up his first camera when he was 18. He was drafted into the Austro-Hungarian army in 1914, and had his first photographs published while he was still in uniform. In the desolate years following World War I, Kertész joined the great intellectual migration to Paris, where he ensconced himself in 1925. Kertész was the quintessential bohemian; his friends included the artists Piet Mondrian and Marc Chagall. Cinematic photography shaped his tastes for unorthodox camera angles and carefully framed, geometric shots of Paris streets and monuments in which human figures appeared as if by accident.

For Kertész, photography was an act of organization. His sense of the extraordinary made him a hypnotic chronicler of everyday events. Kertész's greatest journalistic collaborator was the French editor Lucien Vogel, who ran his photographs without explanatory prose; the haunting images made text redundant.

When Kertész came to the U.S., he discovered that his new audience was more interested in straightforward narrative photography, not one of his strong points. He was never published by LIFE. Appreciation of his work was left to the Condé Nast fashion empire, which signed him to a long-term contract. Ultimately, Kertész's reputation was rehabilitated by the Museum of Modern Art. At the time of his death in 1985, Kertész was widely recognized as one of the seminal figures of photojournalism.

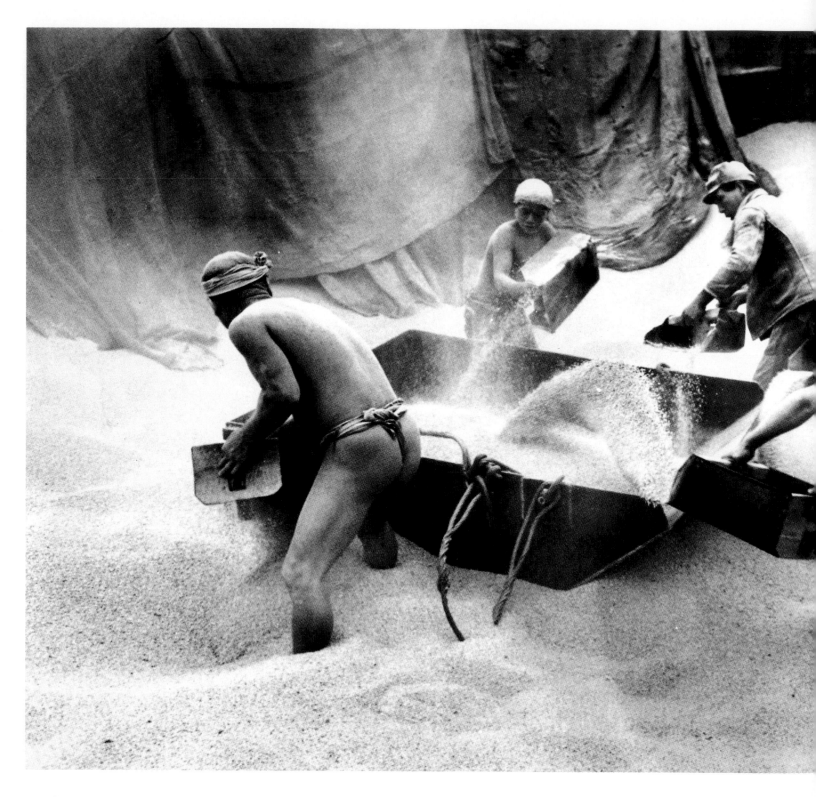

Relief rice for starving Japan
Carl Mydans, 1949

Rice being unloaded from a ship in Kobe's
harbor during the American occupation.

Mother and child at Hiroshima
Alfred Eisenstaedt, 1945

"When I had gone to Hiroshima hardly a building was standing, but the people had cleared all the rubble from the streets. A mother and child were wandering near a ruined site where once they had lived. When I asked the woman if I could take her picture, she bowed deeply and posed for me."

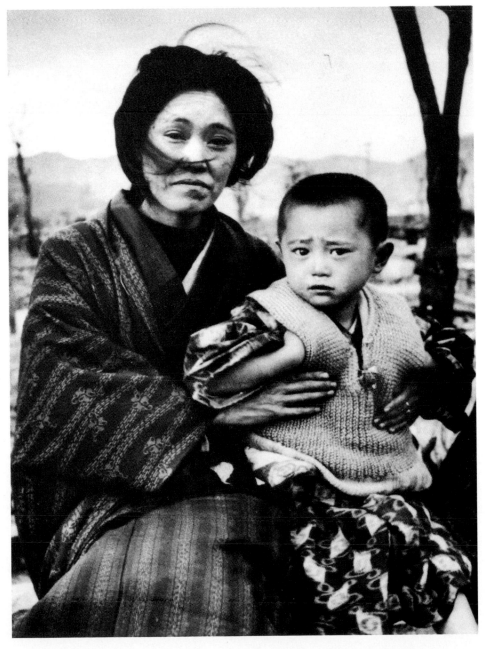

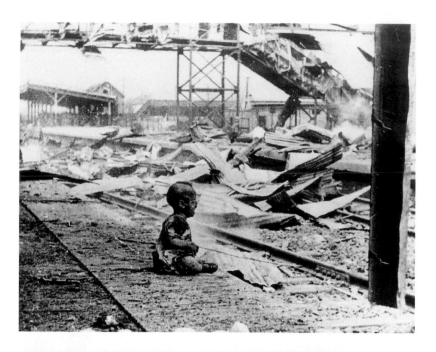

Wounded by a bomb, a Chinese baby howls pitifully in Shanghai's railroad station
H.S. ("Newsreel") Wong, August 28, 1937

With Chinese Nationalist troops in retreat, 1,800 people stood on the platform at the railroad station in Shanghai waiting to be evacuated to the mainland. Japanese airmen mistook the crowd for a troop movement and bombed the station. Wong, a cameraman for Hearst Metrotone News, waded through the wreckage and photographed this tiny survivor. His film was sent by U.S. Navy ship from Shanghai to Manila, then flown to New York. Two weeks later, the photo was seen in Hearst newsreels and newspapers. The October 14, 1937, issue of LIFE estimated that 135 million people had seen Wong's "Chinese Baby."

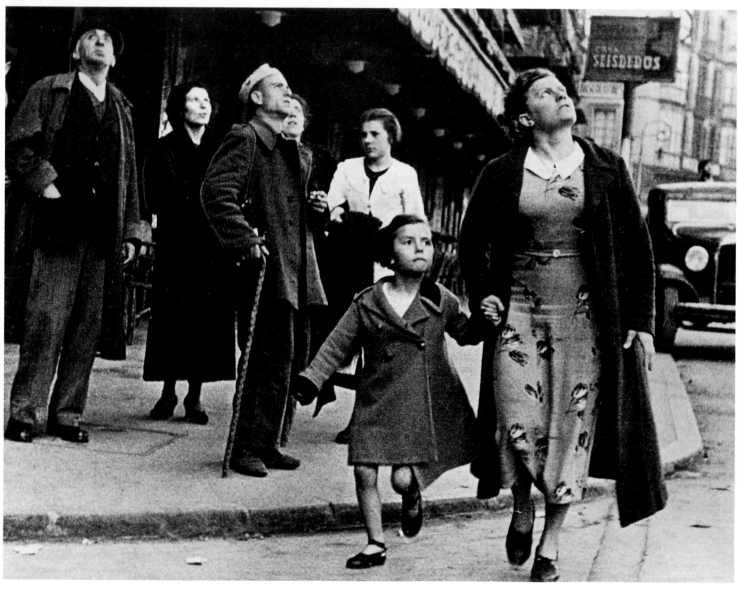

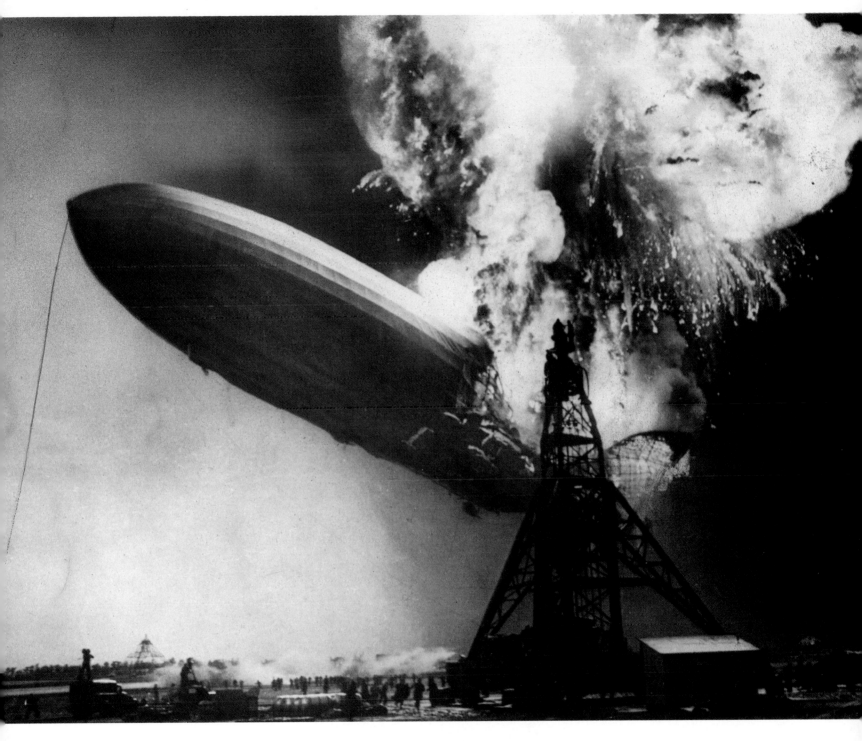

The *Hindenburg* disaster *Sam Shere, May 6, 1937*

Passengers paid $400 to cross the Atlantic in luxury aboard the
Hindenburg. The magnificent 804-foot-long dirigible boasted a dining
room, a library and a lounge with a grand piano. While attempting to
land at Lakehurst, New Jersey, after its 37th ocean crossing, the airship
suddenly burst into flames. Of its 97 passengers and crew, 36 perished
as the era of lighter-than-air commercial flight came to a tragic end.
Though 22 newsreel and still photographers were on hand, this frame
by Shere, of International News Photos, is perhaps best remembered.

Air-raid alarm
Robert Capa, May 1936

Civilians during the Spanish Civil War
look up toward German Luftwaffe bombers
flying over the Gran Via in Bilbao.

Auto thief arrested, car crashed, one killed *Arthur Fellig ("Weegee")*

Weegee

"Crime was my oyster, and I liked it," claimed Arthur Fellig, the diminutive, streetwise master of the Speed Graphic press camera, who won fame, modest fortune and artistic esteem as a result. Under the sobriquet Weegee (or, as he always stamped his work, Weegee the Famous), Fellig was the Damon Runyon of photojournalism. His up-close, flash-bulb-lighted view of New York City's violent, late-night streets provided the lurid images tabloid journalism craved. Fellig was a police-blotter photographer, perhaps the ultimate of his kind. "I belong to the world," he declaimed, in his celebrated hard-boiled style. "And I work only for kicks and for money."

Fellig demonstrated how the brutal factuality of press photography could be distilled into a form of melodrama. Nothing summed up his approach better than the title of his most famous collection of work, *Naked City*.

Fellig was literally a child of Manhattan's streets. Born in Austria, he came to the United States with his parents at age 10 and grew up on the Lower East Side. He dropped out of school in the seventh grade and became a photographer's apprentice as a way of earning money. He graduated from the darkrooms of Acme Newspictures, a photo agency, to become a free-lance photographer operating out of police headquarters. Contrary and combative, Fellig led a gypsy life, an insomniac *Front Page* existence as hit-and-run as the gangster rubouts and auto smashups he covered. Rushing to crime scenes, developing pictures in a frenzy, then flogging them to the daily newspapers for $5 each, Fellig developed a premonitory sense of where to be, and when, to beat out his rivals. The name Weegee was bestowed by admiring peers; it referred to the popular Ouija board it was said Fellig must use to arrive on crime scenes so promptly. Fellig, with a genius for self-promotion, immediately seized on the name.

Fellig's premonitions were eventually supplanted by a police radio in his 1938 maroon Chevrolet coupe. The trunk held a primitive darkroom, so that Fellig could process his film on the spot. What gave his photography its power, however, was not so much its immediacy as its narrative sense. For Fellig, each crime or tragedy was a social event, in which observers crowded around the scene of calamity, giving it a past and a future. He died in 1968, but his reputation continued to grow. In 1977 his work won a retrospective showing at the International Center of Photography.

Suicide *I. Russell Sorgi, 1942*

The woman was described as a despondent divorcée.
Sorgi's camera caught her as she plunged to her death.

Fred Astaire
Martin Munkacsi, 1936

About his photography, Munkacsi once wrote: *"I have never taken pains to establish myself as a specialist, nor to settle exclusively at one or another branch of photography. It was never my desire to be called as 'the most outstanding landscape photographer' or as 'the most outstanding news photographer' or as 'the most outstanding portrait-photographer'; I was content to be known as a 'good photographer.'*

"He, whose aim is the genre photographs, must be somewhat of a poet in order to lend his pictures a dash of poetry and imagination. And the portrait-photographer must be a bit of a psychologist, the landscaper, a bit of an artist...and they all must draw well, to arrive at a perfect composition with each of their subjects.

"And finally, the top of all: news photography—which requires beyond all these qualities the quality of a journalist, with an instinct for the news, the knowledge of an all-round sportsman who runs, jumps, climbs, plus the tact and the wit of a diplomat, that is, to be able to emerge from the most embarrassing situations with the best possible shot already bagged."

A study of the impact of a golf ball
Harold Edgerton, 1939

Stroboscopic devices, which made action appear to stand still, were harnessed to photography in 1931. This photo shows the impact on a telephone book of a golf ball traveling 225 feet per second.

Joe DiMaggio *Hy Peskin, 1949*

DiMaggio strokes a double in the 1949 All-Star Game.

Waiters, St. Moritz *Alfred Eisenstaedt, 1932*

Eisenstaedt, a pioneer of photojournalism, was forced to leave Europe once the Nazis came to power. He became one of LIFE's four original staff photographers.

Exchange Place
Berenice Abbott, 1934

Berenice Abbott left the United States for Europe in the early 1920s and worked in the studio of the legendary Surrealist artist and photographer Man Ray. She returned permanently to the United States in 1929. There was little private patronage for the arts or for artists, so Abbott turned to the Federal Arts Projects of the Works Progress Administration for support. They wrote of her in the '30s: *"Berenice Abbott does not wish to be called artistic. She hates everything that is sentimental, tricky, or devious. Her photographs are not dressed up with trailing clouds nor dramatized with superficial tricks or angle shots, soft lighting or oversimplification. This is 'straight photography.' Amid traffic, haste, vibration, crowds, confusion, she has set up her 8 x 10 camera, leveled it off with a tiny carpenter's spirit level, composed the image on the ground glass, focused it, calculated exposure, and taken the picture. But the layman must not think for an instant that these photographs were made by merely pressing a button. They are the work of a master artist who is a master craftsman as well."*

What are all these people so worried about?
Barney Cowherd, 1949

This somewhat enigmatic picture by a photographer from the Louis-ville *Courier-Journal* won top awards at the University of Missouri's School of Journalism and a great deal of attention whenever it was exhibited. People were disturbed by the worry that pervaded it. Photographer Barney Cowherd could offer no enlightenment. *"It was a warm day,"* he recalled, *"and people were waiting for the lights to change."*

Death of a Loyalist soldier *Robert Capa, September 5, 1936.* Taken near Cerro Muriano during the Spanish Civil War, this photo first appeared in the French magazine *Vu*. Capa said he snapped it just as this Loyalist fighter was struck in the head by a bullet after emerging from a trench, though some critics later disputed that account. It is nonetheless considered one of the greatest war pictures of all time.

Robert Capa

Endre Ernö Friedmann—better known as Robert Capa—was a rebellious young socialist from Budapest, Hungary, who rose from the darkroom of a German photo agency to become the foremost war photographer of the age. Along the way he created a persona to go with the name he had invented for himself: the daring, debonair, itinerant chronicler of street politics; lover of beautiful women; partisan of left-wing causes.

Capa's self-image and his extraordinary talent under fire were fused during the Spanish Civil War, a conflict he covered passionately from the Loyalist side. He later developed the definitive yardstick of the war photographer's trade: "If your pictures aren't good enough, you're not close enough." Following his own dictum, Capa swam ashore with the first U.S. wave to hit the Normandy beaches and was present for the liberation of his beloved Paris.

Still, Capa's most lasting contribution to photography may have been sealed over lunch in the penthouse restaurant of New York City's Museum of Modern Art in 1947. Together with his longtime friends and colleagues David ("Chim") Seymour, Henri Cartier-Bresson, William and Rita Vandivert and the great war photographer George Rodger, Capa founded the photography collective Magnum, an organization of, by and for photographers.

The cooperative was intended to free them from business concerns, sell their work and promote photography in general. Members would retain copyrights to their photographs rather than passing them along to the publications that retained their services. Capa had dreamed of such an agency since 1938, but war had stalled his plans. Finally he achieved his ambition: to free the working photographer from the whims of editors who had the power to choose the assignments and select which images would be published. The founding of Magnum amounted to an emancipation proclamation.

The original group soon dwindled. The Vandiverts left in 1948. Capa died in Indochina in 1954. Seymour was killed at the Suez Canal in 1956. An extraordinary array of talents replaced the giants: Capa's brother Cornell (1954), Marc Riboud (1955), Bruce Davidson (1959), Leonard Freed (1972), Gilles Peress (1974). Magnum's members continue to uphold two founding traditions: uncompromising quality of work and a passionate sense of commitment to the subjects they record.

Santa Lucia Mountain Range between Carmel and San Simeon, California
Nina Leen, 1945

Russian-born Nina Leen was brought up in Europe and educated in Dresden. She came to the United States in 1939 at the outbreak of the war and began working for LIFE shortly after. She is best known for her photographs of animals.

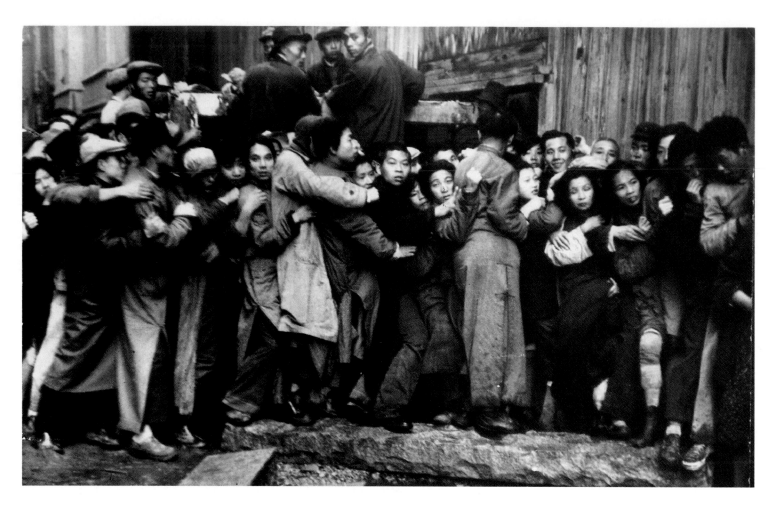

Trying to buy gold before the Red Army enters Shanghai
Henri Cartier-Bresson, 1948

This picture was taken in December 1948, when the Kuomintang announced it would exchange paper money for gold at half the black-market rate. Cartier-Bresson defined photography as composition: that is, the single picture constructed to serve *"as a whole story in itself."*

Girl and movie poster
John Vachon, October 1938

Vachon began his work for the FSA Historical Section as a $90-a-month assistant messenger; the bulk of his work involved copying caption material. Despite this inauspicious beginning, Vachon's interest in cataloging the country overcame his lack of photographic expertise. He was promoted from assistant messenger to roving photographic file clerk (with camera) and, after some advice from FSA co-workers like Dorothea Lange, Ben Shahn, Arthur Rothstein and Walker Evans, he began making field trips for the FSA.

Ford plant, River Rouge, Michigan
Milton Brooks, 1941

For 38 years no strike had ever closed any of the Ford plants in Detroit. This picture of the violence outside the River Rouge plant won the first Pulitzer Prize awarded for news photography.

Bushmen children *N.R. Farbman, 1947*

Bushmen children of the southern Kalahari Desert in central-southern Africa sit around a campfire with their elders. Their chief acts out each event of the story he tells his band. The struggle of these nomadic people to eke out an existence in the barren wastelands of southern Africa was documented pictorially for the first time by LIFE photographer N.R. Farbman.

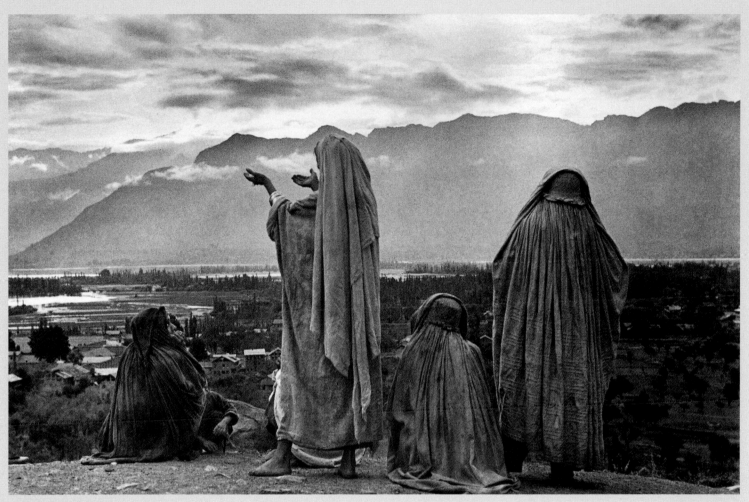

Kashmir *Henri Cartier-Bresson, 1948.* After the 1947 partition of India, the question of jurisdiction over Kashmir helped precipitate the first of the India-Pakistan wars. This photograph was taken during a two-year period when Cartier-Bresson was working and living in the Far East.

Henri Cartier-Bresson

The debate still rages in aesthetic circles about the achievement of Henri Cartier-Bresson, the quiet, cerebral French bourgeois who is considered by many to be the best photojournalist of all time. Was he an artist whose work was often perceived as photojournalism, or a photojournalist who elevated the métier to the perfection of art? Cartier-Bresson called his Leica a "sketch book" and insisted that the essence of picture taking lay in the spontaneous organization of reality as it occurred. A painter by training, a surrealist, a rebel and a communist by early inclination, Cartier-Bresson was born in 1908 near Paris, the son of a wealthy textile family. As soon as he could, he left behind the middle-class life to mingle with the Parisian avant-garde: Salvador Dali, Max Ernst, Jean Cocteau. By 1931 he had abandoned painting for the camera.

Cartier-Bresson was prone to wanderlust, and he brought a pared-down, strangely dislocated sensibility to his views of street life. What he later called the "rhythm in the world of real things" quickly established him as a visual poet of the ordinary. In 1935 he became intrigued by cinema and later worked as an assistant to Jean Renoir. During World War II, he fought with French forces, was captured and escaped after 36 months as a prisoner of war.

Two years after the war ended, Cartier-Bresson was given an exhibition by the Museum of Modern Art and became a principal founder of the photographers' collective Magnum. In 1952 he published *The Decisive Moment*, his discourse on photography as a product of intuition, intellect and spontaneity. The work became a bible for ensuing generations.

True to his surrealist heritage, Cartier-Bresson always claimed that he was not primarily interested in the particulars of the social and political events he photographed; it was the universality they represented that he sought to capture. After the war, he produced masterly contemplations of China, the Soviet Union and the stormy Third World. Cartier-Bresson, now in his late 80s, lives quietly in Paris, painting.

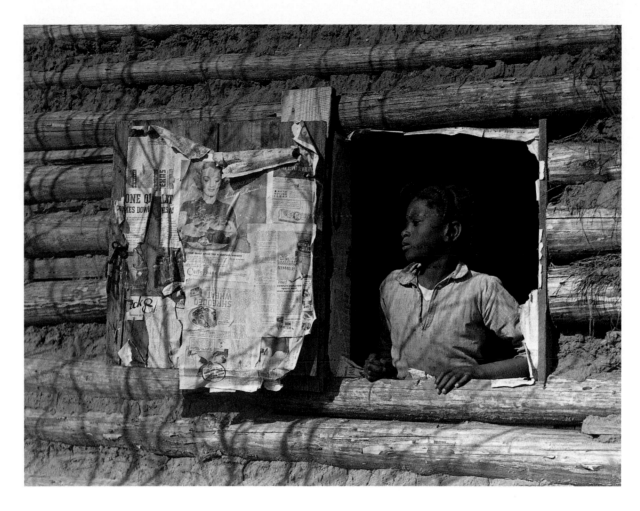

Girl at Gee's Bend, Alabama
Arthur Rothstein, April 1937

Rothstein was the first photographer hired by Roy Stryker for the Historical Section of the Resettlement Administration. A former student of Stryker's at Columbia University, Rothstein was 21 years old and only a month out of school when he began work on July 1, 1935. This picture was part of a series he took when assigned to photograph conditions in and around Birmingham, Alabama.

A week's housework
Nina Leen, 1947

Marjorie McWeeney of Rye, New York, surrounded by a typical week's load of housework and supplies. The photo was part of a story on the American woman.

Taxi dancers, Fort Peck, Montana *Margaret Bourke-White, 1936.* In LIFE's debut issue, Bourke-White presented America's first photo essay. She took the pictures while on assignment to photograph the nearby Fort Peck Dam. After she shot the taxi dancers, a brawl broke out among some of her more unwilling subjects. LIFE's editors, meanwhile, were desperate for a lead story for their intended new showcase of photojournalism. HAVE YOU GOT GOOD FORT PECK NIGHTLIFE PICS, they cabled. She did; the story ran for nine pages.

Margaret Bourke-White

She was the best-known woman photojournalist in history, but that was only one of the distinctions of Margaret Bourke-White. The daughter of an inventor and amateur photographer, she studied with the great American art photographer Clarence White, then became an architectural photographer in Cleveland. She gravitated to advertising work, which led to a fascination with industrial society—a basic motif of European photographic aesthetics.

Bourke-White's big break came with a commission to photograph the Otis Steel Company in Cleveland. Among those impressed with the resulting images was publisher Henry R. Luce, who offered her a ticket to New York in 1929. He had a job for her, working on a new magazine he was founding, named FORTUNE. It would, he assured her, have "the most dramatic photographs of industry that had ever been taken."

It would and did; many of them hers. Bourke-White's Otis Steel photographs adorned the dummy issue, and helped sell advertisers on Luce's brainchild. She had the magazine's first photo credit. Bourke-White went on to define the image of '30s industry with her richly detailed, almost abstract homages to the building of America.

Fort Peck Dam *Margaret Bourke-White, 1936.* In this study of the construction of the giant pipes used to divert a section of the Missouri River during the building of the Fort Peck Dam in Montana, human figures lend perspective to the abstract geometries.

Then Bourke-White discovered her social conscience. She made frequent trips to the Soviet Union to observe the new socialist society, with the blessings of the Bolshevik government. At home, with her future husband, author Erskine Caldwell, she produced a powerful social document, *You Have Seen Their Faces,* on the plight of the Southern poor.

Her greatest accomplishment, undoubtedly, was helping launch LIFE. She started work for the magazine two months before it hit the stands, with Luce himself setting her first assignment. Bourke-White's photo of the new Fort Peck Dam in Montana ran on the cover of the first issue; her extended photo essay on the workers and local townsmen at play was the main picture story inside. For the next 21 years she was the premier picture magazine's premier photographer. She witnessed the first German air raids on Moscow, was the first woman to fly on a U.S. military combat mission in 1943, and was part of the press contingent that uncovered the horrors of Buchenwald. She photographed Gandhi in 1948 six hours before he was assassinated, and later covered the war in Korea. In the early 1950s, Bourke-White discovered that she had Parkinson's disease. She ceased working for LIFE in 1957 and died in 1971.

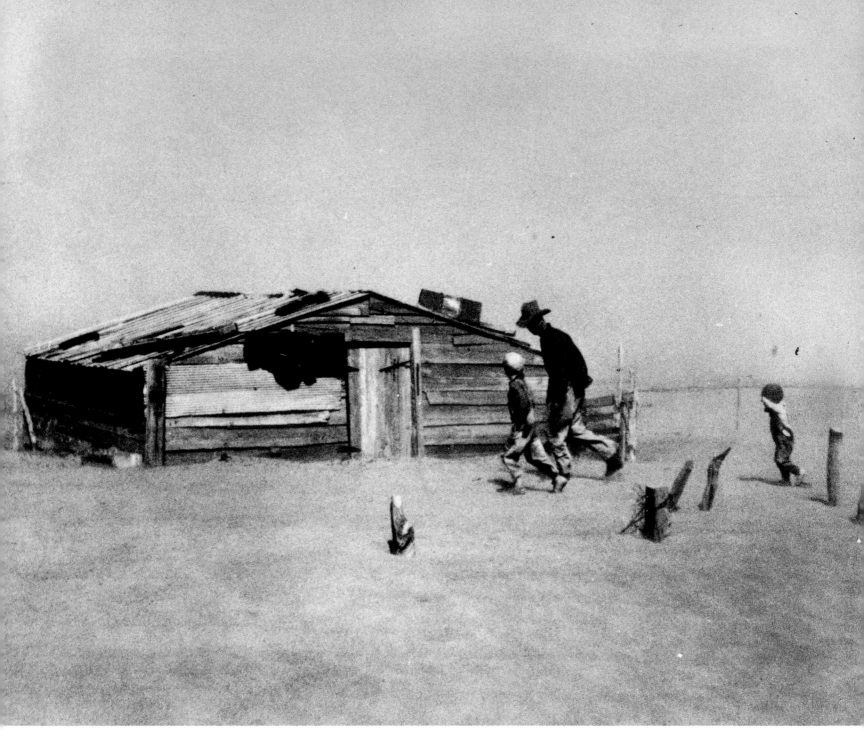

**Father and sons walking in the face of a dust storm,
Cimarron County, Oklahoma**

Arthur Rothstein, 1936

Sometimes known as "Dust Bowl," this image is one of the most famous
of the Great Depression and the drought-worsened collapse of farming
on the Great Plains. At first the effects of the Depression and the Dust
Bowl crisis were ignored by the government and the press. Then the
desperation of the times made economic misery into news. As poet
Archibald MacLeish put it, *"The Depression was one thing you had to know
about."* On the trip on which he took this picture, Rothstein covered more
than 1,000 miles. The dust eventually destroyed his camera.

Negro barbershop, Atlanta, Georgia
Walker Evans, March 1936

Evans joined the Historical Section of the FSA in 1935 and was fired by Roy Stryker two years later. According to Evans, *"Stryker did not understand that a photograph might be something more than just an item to file away. He missed the point of the eye…Stryker did not have any idea what an artist was, and it was unfortunate that he had one like me around. I was excessively independent by temperament and had a hard time with him because of this. Stryker was shrewd enough to make use of the talent I had, but we were born to clash."*

Child of migrant worker in car, Oklahoma *Russell Lee, 1939*

Russell Lee joined the Historical Section in 1936, taking Carl Mydans' place when he left to work for LIFE. Lee stayed with the section longer than any other photographer and produced the greatest number of photographs.

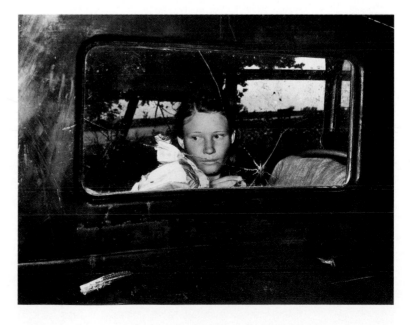

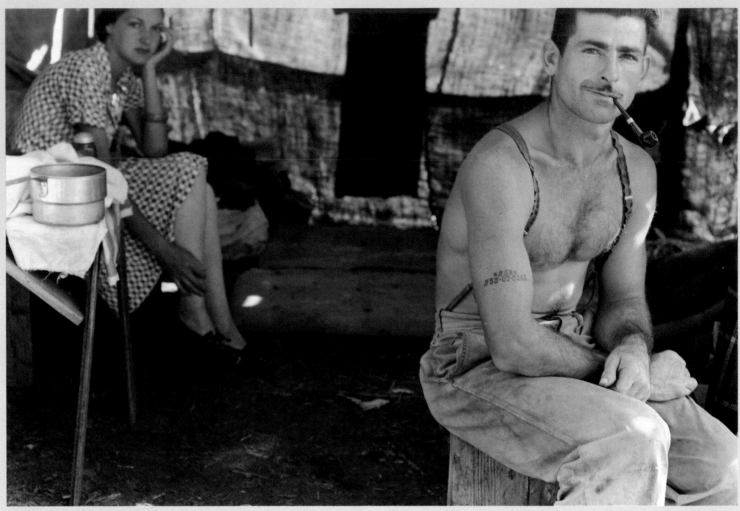

Migrant farm worker, Klamath County, Oregon *Dorothea Lange, August 1939*

Dorothea Lange

As a rule, great photojournalists combine talent, fortitude, determination and luck. Dorothea Lange had more than her share of all four. During her career, she took some of the most memorable photographs ever made of America's working poor.

Born Dorothea Nutzhorn, she was a childhood polio victim whose father abandoned his family. Lange declared her interest in photography by the time she was 17. Eventually she managed to study under the legendary Clarence White and work with German-born photographer Arnold Genthe (famed, among other things, for his San Francisco earthquake photographs). She migrated to the West Coast, where she established a photo studio.

Lange's social conscience pushed her in the direction of agitation for reform. With economist Paul Taylor, her future husband, she documented the lives of migrants in "the factories of the fields," work that eventually brought her to the attention of the Resettlement Administration, later known as the Farm Security Administration. Before that happened, however, Lange had already taken one of the great images of the Depression, a 1932 photograph of despairing men at a soup kitchen, known as the *White Angel Breadline.*

At the FSA, where she worked from 1935 to 1940, Lange became a photojournalist despite herself, since FSA material was disseminated free of charge to any newspaper that would use it. Lange's great talent lay in humanizing the dimensions of the Depression tragedy; she traveled thousands of miles across the country to capture her searing portraits of poverty. Lange's humanistic bent was best exemplified in her *Migrant Mother, Nipomo, California:* a lambent, sympathetic portrait of a destitute pea picker and her family that is perhaps the most widely recognized icon of the '30s. After the war, Lange continued to photograph the strong, work-etched faces of the American people, and particularly those of women, until she succumbed to cancer in 1965.

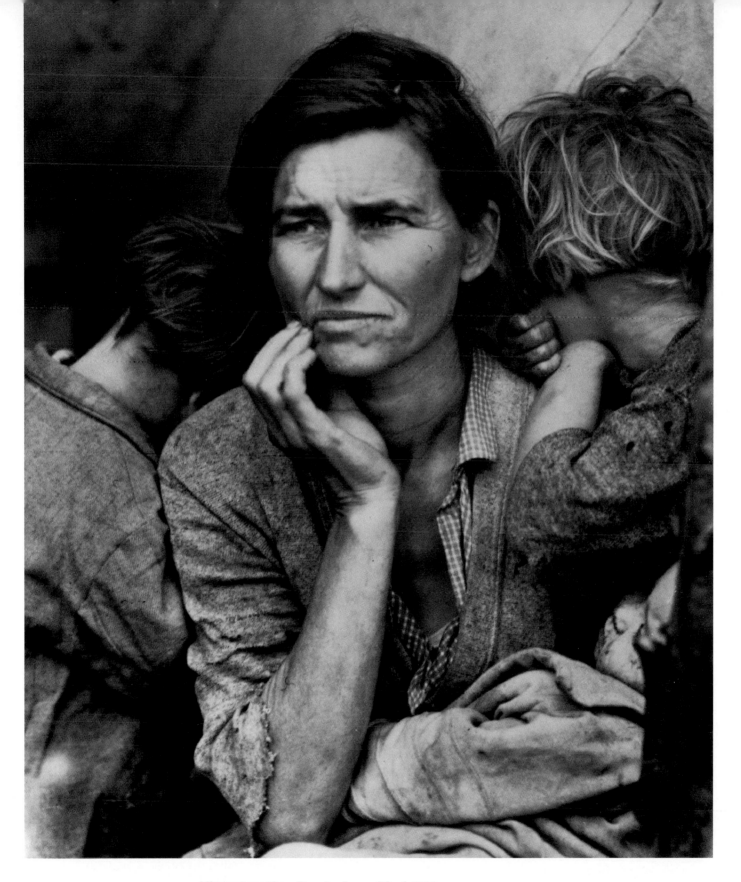

Migrant mother *Dorothea Lange, March 1936*

"I saw and approached the hungry and desperate mother, as if drawn by a magnet," Lange said. *"I do not remember how I explained my presence or camera to her, but I do remember she asked me no questions. I did not ask her name or history. She told me her age, that she was 32."* The face of this woman in a California migrant workers' camp is one of the best-known icons of the Dust Bowl era.

The battleship *Arizona*
Anonymous, December 7, 1941

When the bombs dropped, the *Arizona* exploded and sank, carrying more than 1,100 crew members to their deaths.

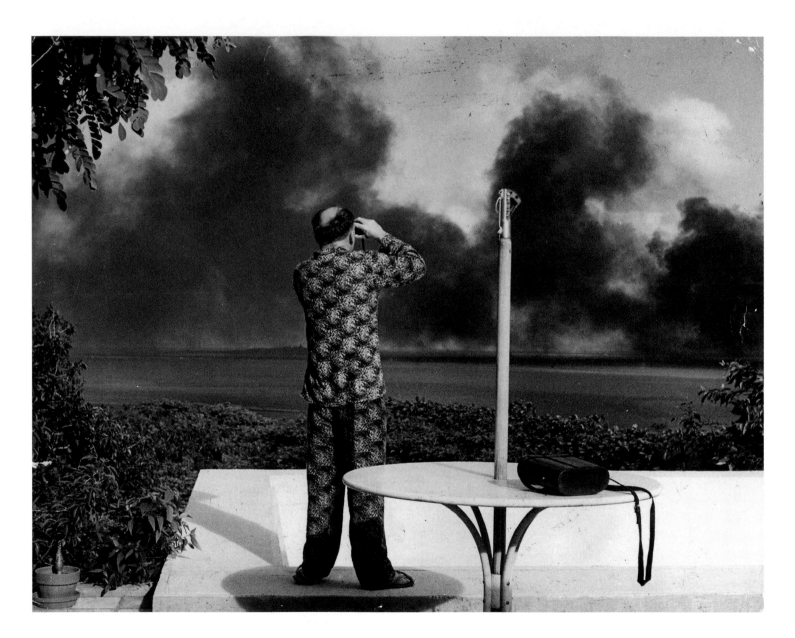

**Pearl Harbor inhabitant watches
bombing by Japanese planes**
Kelso Daly, 1941

The attack by more than 350 planes and some midget submarines severely damaged a number of the battleships anchored that Sunday in Pearl Harbor's Battleship Row.

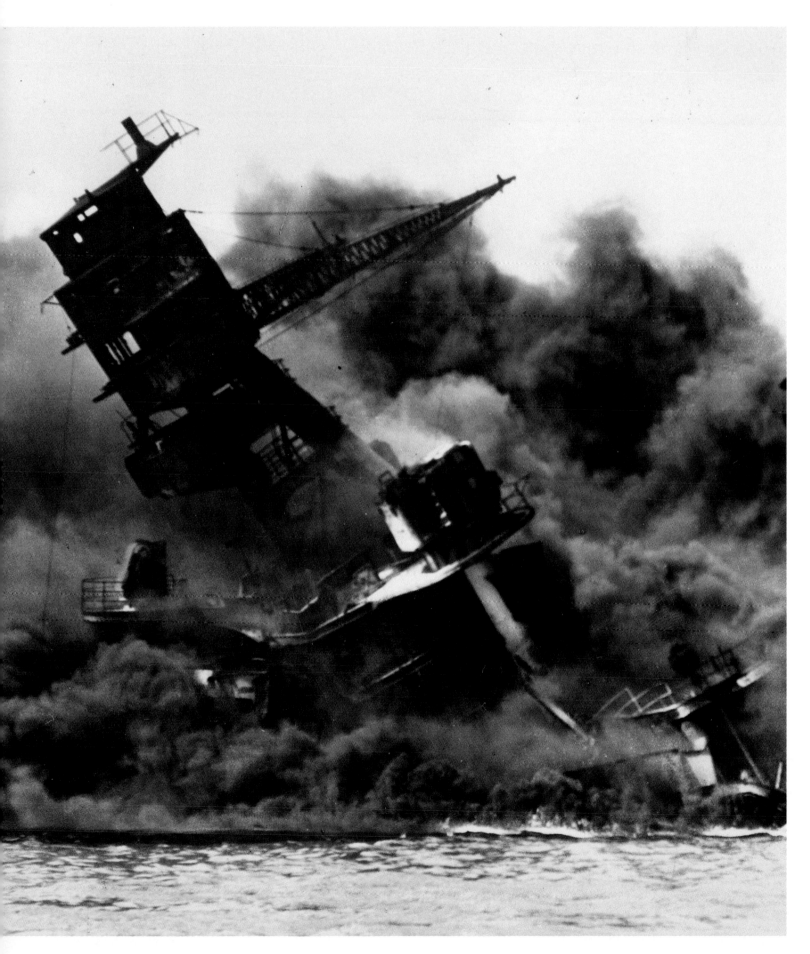

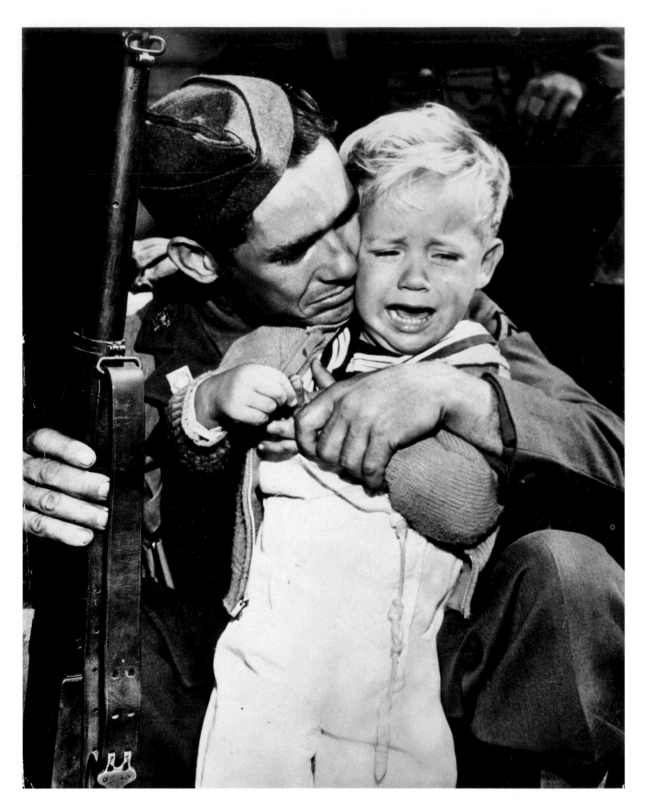

Private John Winbury says goodbye to his son
Robert Jakobsen, 1940

Some of the more poignant war images were not battlefield
pictures but partings, such as this National Guardsman saying
goodbye to his son before leaving for Hawaii.

Soldier's skull on a destroyed tank
Ralph Morse, February 1943

The charred head of a Japanese soldier was propped up on the
tank after it was destroyed by U.S. Marines on Guadalcanal.

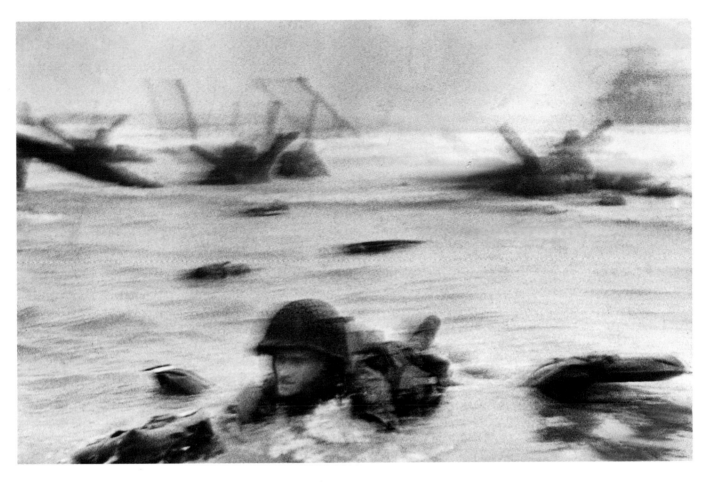

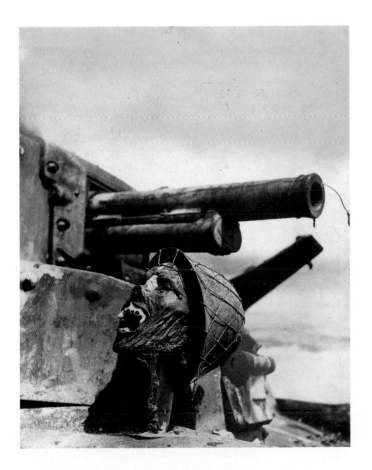

Normandy invasion on D-Day *Robert Capa, June 6, 1944*

This picture is one of Capa's few images of the Allied invasion that was saved. Most of the others were destroyed in a darkroom accident. Capa sent a brief account of his D-Day landing experiences to LIFE: *"I was going to Normandy on this nice, clean transport ship with a unit of the First Division. The food was good and we played poker. Once I filled an inside straight but I had four nines against me. Then just before six o'clock we were lowered in our* LCVP *and we started for the beach. It was rough and some of the boys were politely puking into paper bags. I always said this was a civilized invasion. We heard something popping around our boat but nobody paid any attention. We got out of the boat and started wading and then I saw men falling and had to push past their bodies. I said to myself, 'This is not so good.' I hid behind some tanks that were firing on the beach. After 20 minutes I suddenly realized that the tanks were what the Germans were shooting at, so I made for the beach. I fell down next to a guy who looked at me and said, 'You know what I see up there? I see my old mother sitting on the porch waving my insurance policy at me.'"*

A Douglas SBD Dauntless dive bomber over Wake Island
Charles Kerlee, 1943

Kerlee worked for the Naval Aviation Photographic Unit, created by Rear Admiral Arthur W. Radford for Edward Steichen after the already famous photographer tried to enlist in the U.S. Navy in 1942. Despite some general misgivings—Steichen was 62 at the time—his potential contribution as a photographer was undeniable. The unit's mission was to document the activities of the aircraft carriers, and for the next four years Steichen and his crew of hand-picked professionals did just that, focusing on the sailors and showing the war in close-up. Steichen edited all the work, oversaw its printing and released it to major magazines and newspapers.

London bomb damage
Cecil Beaton, 1940

Beaton was in his mid-30s when Britain declared war on Germany in 1939. With his contemporaries signing up for various regiments, Beaton felt—as he wrote in his diary—both frustrated and ashamed. *"This war, as far as I can see, is something specifically designed to show up my inadequacy in every possible capacity. I am too incompetent to enlist as a private in the army. In any case my repeated requests to join have met with, 'You'll be called if you're wanted.' I have tried all sorts of voluntary jobs in the neighborhood, helping organize food control, and the distribution of trainloads of refugee children from Whitechapel. I failed in a first-aid examination after attending a course given by a humourous and kindly doctor in Salisbury."*

Eventually Beaton was assigned to the Ministry of Information and given orders to take photographs of "everything." The pictures were used for news and propaganda purposes. The wax head in this photograph was part of the debris of a hairdressing establishment.

St. Paul's Cathedral
John Topham, December 1940

Topham's photo of the Great Dome of St. Paul's
Cathedral during an incendiary bomb attack shows the
Cathedral surrounded by the burning city of London.

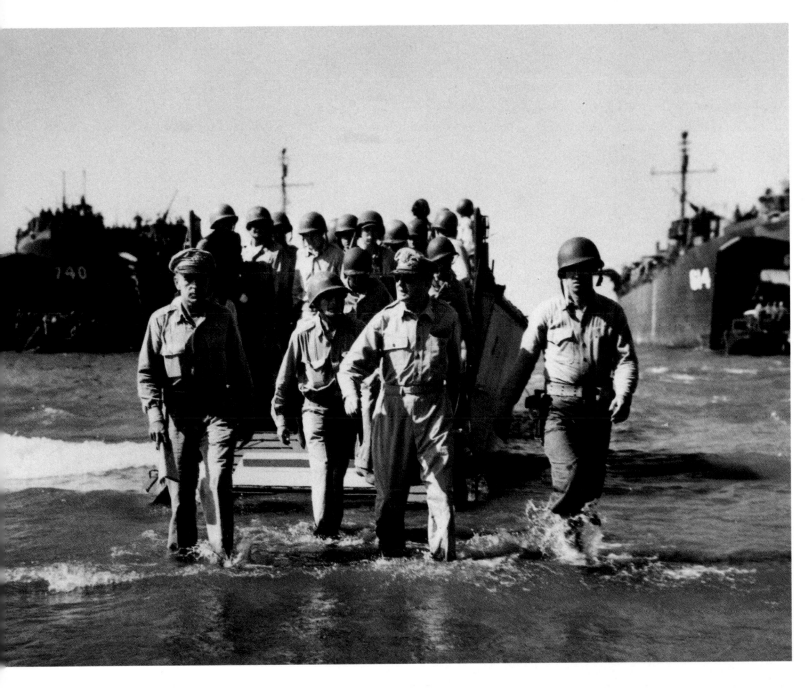

MacArthur landing in the Philippines
Carl Mydans, 1945

"In January 1945 I was the only press photographer aboard General Douglas MacArthur's command ship as he prepared to invade Luzon, in the Philippines," said Mydans. *"I was invited to go ashore with him. As our landing craft neared the beach, I saw that the Seabees had got there before us and had laid a pontoon walkway out from the beach. As we headed for it, I climbed the boat's ramp and jumped onto the pontoons so that I could photograph MacArthur as he stepped ashore. But I suddenly heard the boat's engines reversing and saw the boat rapidly backing away. I raced to the beach, ran some hundred yards along it and stood waiting for the boat to come to me. When it did, it dropped its ramp in knee-deep water, and I photographed MacArthur wading ashore. No one I have ever known in public life had a better understanding of the drama and power of a picture."*

Adolf Hitler and companions
Tim Gidal, 1929

Gidal was one of the European founders of the style of photojournalism that blossomed in the heyday of pictorial magazines. His earliest images chronicled the tempo of life throughout an increasingly unstable prewar Europe.

Coney Island
Henri Cartier-Bresson, 1946

Cartier-Bresson traveled in the United States during 1946 and '47, photographing primarily for *Harper's Bazaar*.

Soviet soldier, off duty
Dmitri Kessel, 1948

An off-duty Soviet soldier amusing himself in Vienna's Prater Park. Kessel, who was born in Ukraine, served in the Red Army before immigrating to the United States in 1923. Kessel studied photography in New York and specialized in industrial photography before becoming a photojournalist.

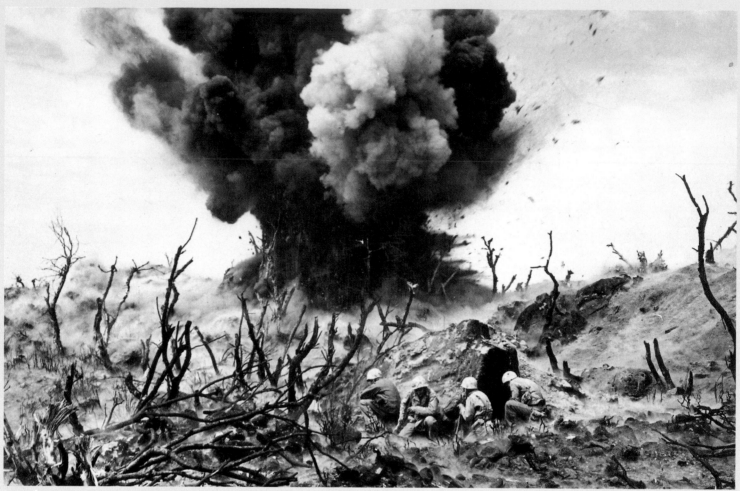

Marines blow up a cave connected to a Japanese blockhouse on Iwo Jima *W. Eugene Smith, 1945.* Smith's caption sheet was marked with the bitter words, *"Sticks and stones, bits of human bones . . . a blasting out on Iwo Jima."*

W. Eugene Smith

From the beginning, photojournalism and human suffering have been linked, but no photographer embraced the connection with more fervor than W. Eugene Smith: his empathy with human pain was rivaled only by his personal embrace of it. He epitomized the photojournalist as suffering artist, unwilling to compromise with anyone over his work. Relentlessly critical of photojournalism's commercial roots and of his own achievements, he was obsessed with the notion of imprinting another human's experience directly into the consciousness of his audience.

Born in Wichita, Kansas, in 1918, the son of a grain merchant who committed suicide during the Depression, Smith started taking pictures for the Wichita *Eagle* and *Beacon*, then gravitated to New York City and landed a job with *Newsweek*. He quickly gained a reputation for incessant perfectionism and a thorny personality. Smith was fired for refusing to use the type of camera ordained by his boss. He joined LIFE in 1939, then resigned, and in 1942 was injured while simulating battle conditions for *Parade*, keeping him out of the naval aviation photography unit formed by Edward Steichen. Eventually, Smith wangled his way to the Pacific as a correspondent for Ziff-Davis Publishing. On the ground he displayed the same reckless courage as his Marine subjects at Saipan, Guam and Iwo Jima; his images were unequaled in their proximity to violence and their human intimacy. Smith was hit by mortar fire on Okinawa in 1945; his recovery took two years.

In 1947 Smith rejoined the staff of LIFE, and over the next seven years perfected his form of the LIFE photo essay, in which he strove to invest individual lives with iconic significance. Despite his talent, he possessed a masochistic critical streak and absolutely refused to take direction. After breaking with LIFE over the use of his photographs of Albert Schweitzer, Smith began a round of book-length projects in which he strove for complete control of his subject matter. Bedeviled for years by drugs and alcohol, he died in 1978 after a massive stroke.

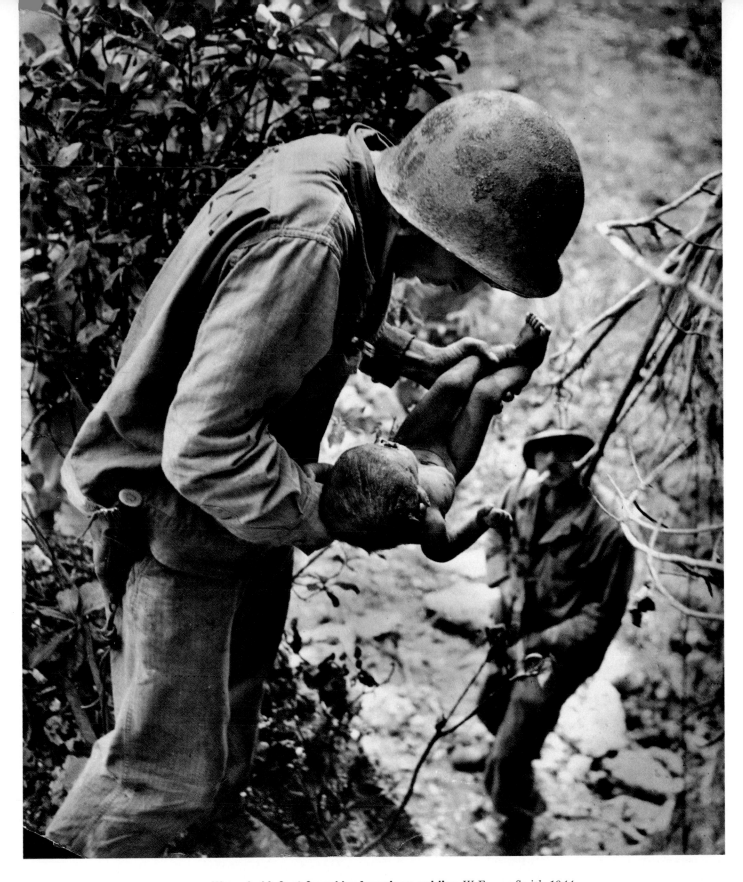

Wounded infant found by American soldier *W. Eugene Smith, 1944*

The Marines were clearing out caves on Saipan where hundreds of Japanese were hiding. Smith's caption on this photo: *"The first live person that we found was a 'living-dead' tiny infant that had somehow become lodged with face straight down into the dirt and head almost concealed by being wedged under the edge of a rock...We had heard the tiny muffled cry and then had seen the bony body writhing, with its head as pivot."*

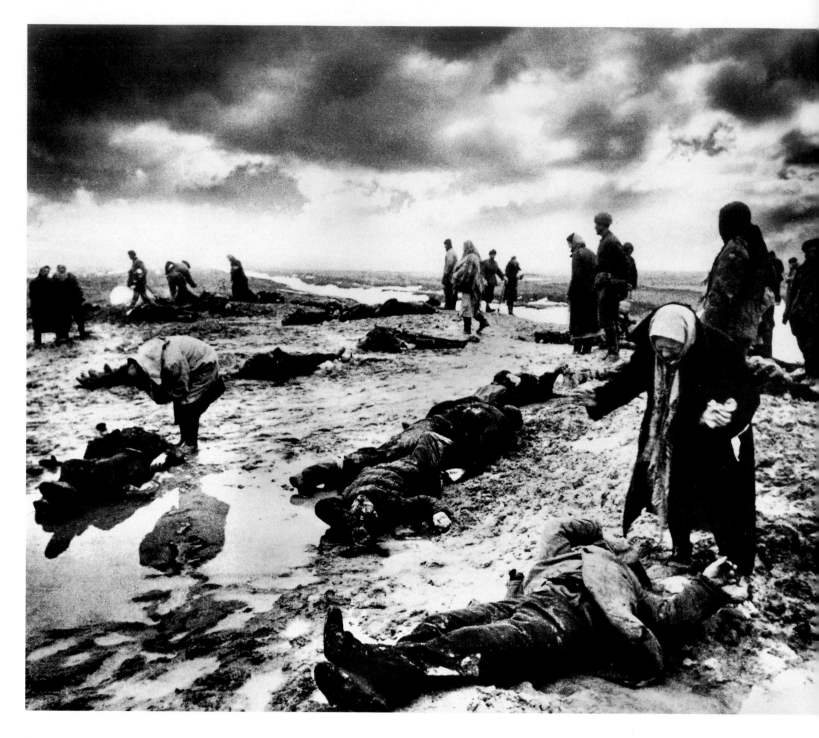

The eastern front: Searching for loved ones at Kerch
Dmitri Baltermants, 1942

Also known as "Grief," this haunting scene of the aftermath of a
Nazi retreat in the Crimea is one of the Soviet Union's most
famous modern images, by one of its leading photojournalists.
As a correspondent for *Izvestia,* Baltermants photographed the
battles of Moscow and Stalingrad and the liberation of Poland.
He won recognition abroad only after a 1965 traveling
exhibition. Baltermants died in Moscow in 1990.

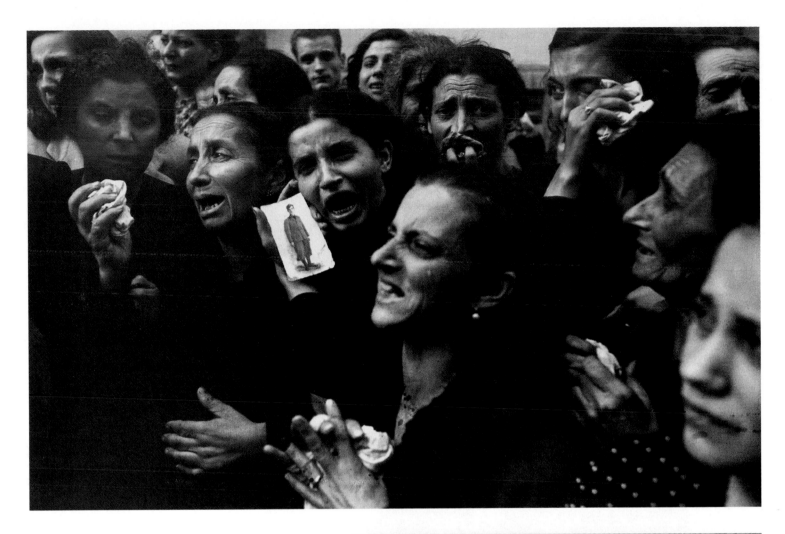

Naples
Robert Capa, October 2, 1943

Crying mothers and other relatives hold up photographs of 20 teenage partisans of the Liceo Sannazaro in the Vomero district. The boys, who were all killed, fought the Germans during the four days before the Allies arrived in the city.

Murdered prison guard, Dachau
Lee Miller, 1945

Miller, who began her career as a fashion model for *Vogue*, became a protégé of Man Ray in 1929. In 1942, when she was working in England as a fashion photographer, she became an accredited U.S. war correspondent. Miller covered the siege of St. Malo and the liberation of Paris. Her photographs from Dachau, the German concentration camp, were accompanied by a cable to the editor of British *Vogue:* I IMPLORE YOU TO BELIEVE THIS IS TRUE.

European child
David ("Chim") Seymour, 1948

David Seymour was one of the co-founders of Magnum. During the war he served in the U.S. Army in photo reconnaissance; he received a medal for his work in American intelligence, but lost both his parents to the Nazis. Afterward Seymour spent two years working for the United Nations Educational, Scientific and Cultural Organization (UNESCO), photographing the children who had suffered through the war in Europe. This image of a disturbed girl in a Polish institution, standing before the frantic scribbles she made when asked to draw a picture of her home, attests to the devastation of war.

The liberation of Buchenwald
Margaret Bourke-White, 1945

U.S. forces reached Buchenwald on April 11, two hours after the Nazis left. Margaret Bourke-White came right behind. She later wrote that using a camera *"was almost a relief. It interposed a slight barrier between myself and the horror in front of me."*

Returning prisoner of war *Ernst Haas, 1945*

In 1947 Haas' photos of returning POWs were exhibited at American
Red Cross headquarters in Vienna. The photos were published in
Heute magazine two years later and were subsequently run in LIFE.

Iwo Jima *Joe Rosenthal, February 23, 1945*

This Pulitzer Prize-winning shot of Marines atop Mount Suribachi was originally rejected by LIFE editors, who thought it looked posed. TIME and others used it, however, and LIFE eventually followed suit, even though it was believed by then that Rosenthal had restaged the event. Rosenthal denied that he used an 8-foot by 4-foot flag to replace the smaller one that was planted first.

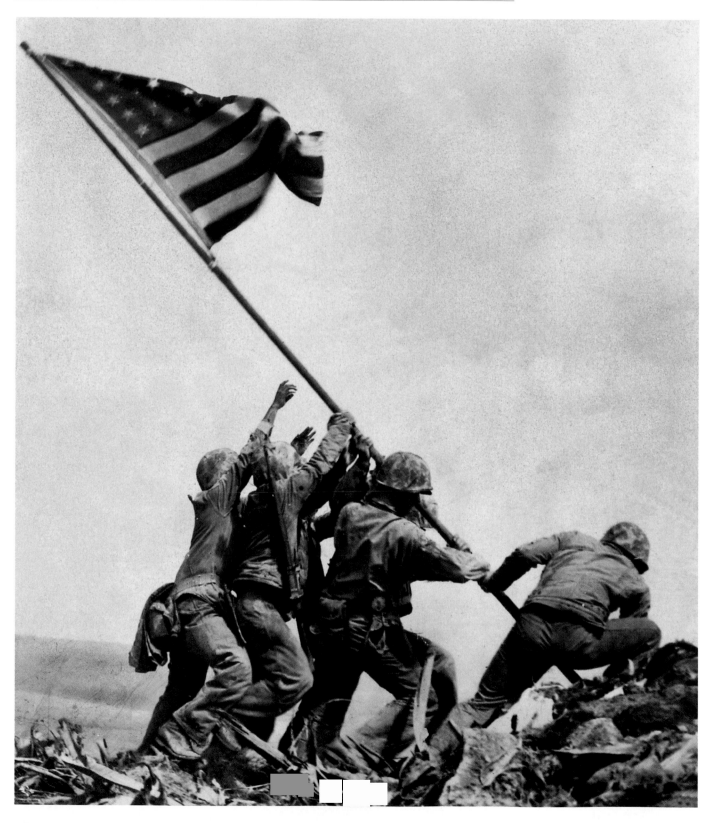

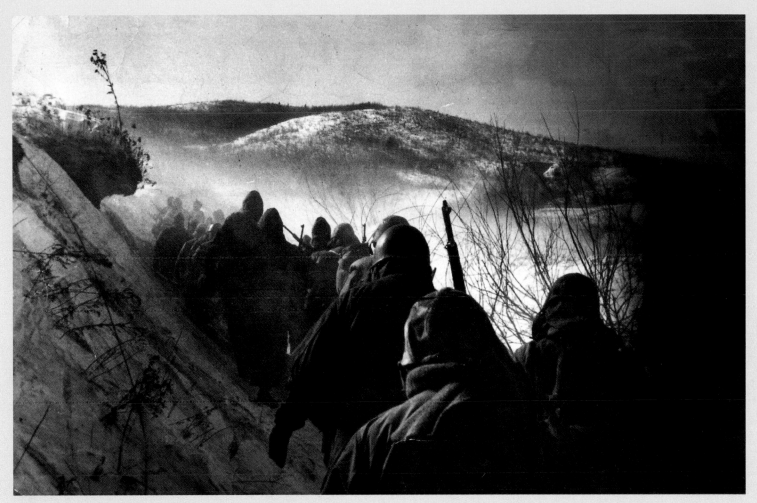

U.S. Marines in Korea *David Douglas Duncan, 1950.* Duncan shared the burdens of this column of Marines as they retreated from the frigid Changjin Reservoir in December 1950. The decorated combat photographer chronicled the face of conflict from World War II to Vietnam.

David Douglas Duncan

For sheer physical courage and devotion to the subject of war, David Douglas Duncan has few peers. His photos of the Pacific front in World War II are among the finest taken, and his pictures of the Korean "police action" are considered to be the definitive images of that frustrating struggle. But Duncan was more than one of the world's pre-eminent war photographers. His search for broader scope and control over his work helped define the direction of postwar photography.

Born in Kansas City, Missouri, in 1916, Duncan studied archaeology at the University of Arizona. As an amateur photographer at college, he snapped a photo one day in 1934 that accidentally included the famed gangster John Dillinger. His news career was launched. He soon became a roving photographer, but he found his true métier after joining the Marines in 1943. He invented a special device to take

aerial photographs on raids, as he hung under the wing of a P-38 fighter bomber in a special tank with a transparent, Plexiglas nose. Among his many wartime decorations were two Distinguished Flying Crosses and the Purple Heart. He brought the same degree of dedication and

bravery to Korea, the agonizing cold war conflict that he captured powerfully in the book *This Is War!*

Duncan's obsessive perfectionism—and his distress at the way photographs were treated by magazine editors—led him increasingly toward book work, where he had more autonomy. He resigned from LIFE in 1955 to become a freelancer, and soon after struck up an acquaintance with Pablo Picasso. The friendship generated tens of thousands of images and numerous books. Throughout it all, Duncan remained a war photographer. His LIFE essay, *Indochina: All but Lost,* rang down the curtain on French involvement in Vietnam. He was soon to chronicle the U.S. escalation in the same futile war. His blending of photographic artistry and art was recognized in 1972, when the Whitney Museum of American Art gave Duncan its first-ever one-man show for a photographer.

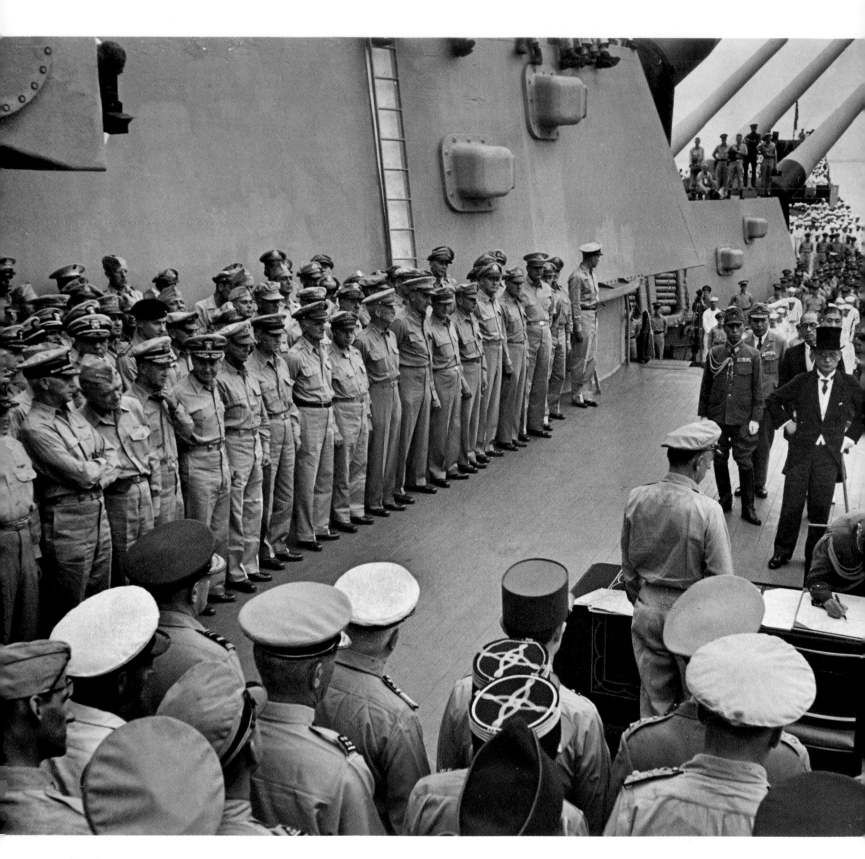

The Japanese surrender *Carl Mydans, September 2, 1945*

Japanese General Yoshijiro Umezu signs the surrender
document onboard the U.S.S. *Missouri* in Tokyo Bay while
General Douglas MacArthur looks on.

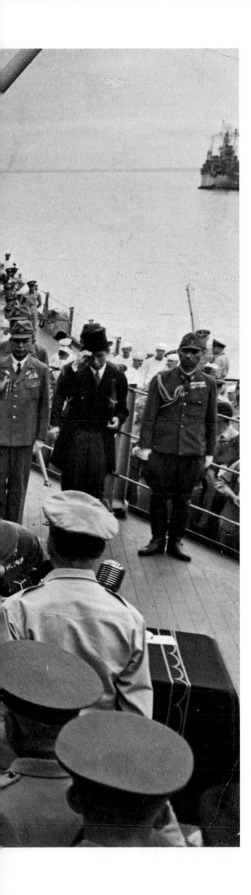

V–J Day in Times Square
Alfred Eisenstaedt, August 14, 1945

A jubilant sailor grabs and kisses a pretty nurse as thousands jam the streets of New York City to celebrate the long-awaited victory over Japan. This classic photo, which originally appeared in LIFE, has come to embody America's joy and relief at the end of World War II. Recalls Eisenstaedt: *"People tell me that when I'm in heaven, they will remember this picture."*

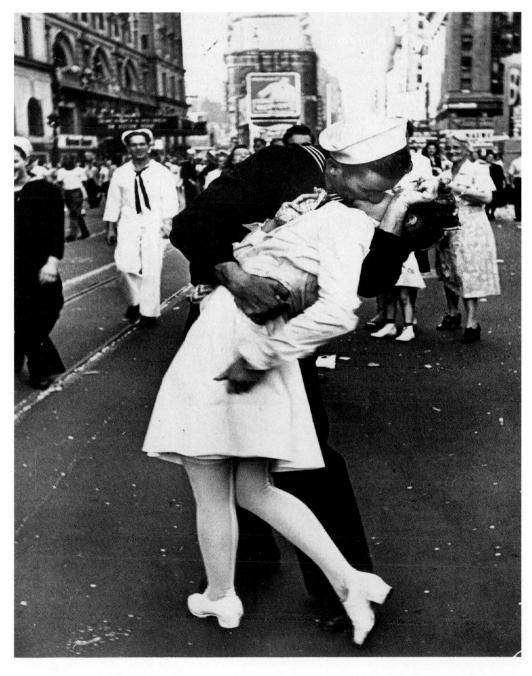

Atomic bomb test, Bikini *Fritz Goro, 1947*

Sailors shield their eyes during an atomic-bomb test on Bikini atoll.

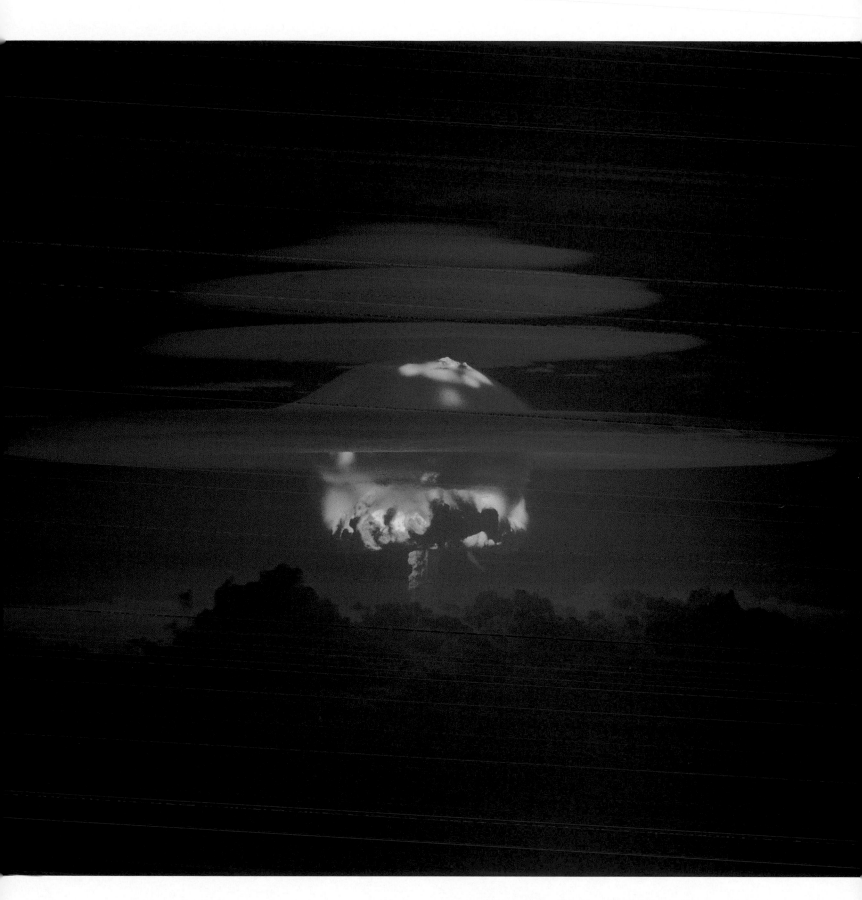

The world's first hydrogen-fusion blast at Eniwetok
U.S. Air Force, 1952

V: NEW DIRECTIONS 1950-1980

The best photojournalists to emerge from World War II and the Korean conflict were acknowledged giants of the craft, and their status was enhanced by the intimacy of their experience in combat. No commander could dream for long of excluding photojournalists from the battlefront (as commanders routinely managed to do during World War I). Modern war demanded an enormous industrial effort from the civilians at home. The surest way to drum up popular support was to maintain a steady flow of images from the battlefield to the builders of Sherman tanks and the buyers of war bonds. The result: photographers became participants en masse in battle, an experience that took its toll. It was during the war that the guardians of the Pulitzer Prizes—daily journalism's highest self-appointed honors—recognized the importance of the news photograph to their business by adding the photo category to their awards. (The first award actually did not go to a combat photograph, but to a Detroit *News* picture of a picket-line battle at Henry Ford's River Rouge plant, the first-ever shutdown at the huge factory.)

By the dawn of the 1950s, the photojournalist was monarch of all he surveyed. No other medium challenged the status of the great picture magazines such as LIFE and *Look*. The public thirsted for their contents. The economic status of the photojournalist also began to shift for the better. The majority of news photographers remained the employees of countless newspapers and major press organizations, but the 1947 founding of the photographers' cooperative, Magnum, established the revolutionary principle that picture takers should own the rights to their work. (Previously, rights belonged to whoever had commissioned a project.) The idea amounted to an emancipation that ironically returned photojournalists to their 19th century roots as independent businessmen. They were free to pursue projects and were beyond the immediate beck and call of editors. They were also aware that their long-term work might produce long-term income.

Photojournalism could even claim a theoretical foundation, which had its most cogent expression in the French photographer Henri Cartier-Bresson's ideal of the photographer as an instant organizer of reality. Cartier-Bresson's meditation on the subject, *The Decisive Moment*, published in 1952, exerted a profound influence on his peers and on the growing critical community that acknowledged photojournalism—or at least the best of it—as a special category of photographic art. (In the case of Cartier-Bresson, one argument was that he was no photojournalist at all, but a special case: an artist in his own right.) To Cartier-Bresson, photojournalism was something of a Zen act of perception: "To me photography is the simultaneous recognition in a fraction of a second . . . both the fact itself and the rigorous organization of visually perceived forms that give it meaning. It is putting one's head, one's eyes and one's heart on the same axis."

Within the decade, the postwar glow faded. Tensions, always latent, erupted between editors—who were text-oriented, even at picture magazines—and some of the more deeply committed photojournalists over what to cover, and why, and how. Eugene Smith, one of the masters of the LIFE photo essay, broke away from the magazine in 1954 to seek what he felt were more profound forms of expression. At the center of his dissatisfaction was the crux of the relationship between the photographer and the picture magazine: the power of editors over the cropping and selection of pictures. Smith, whose perfectionism was legendary—as was his dark, obsessively critical streak—finally exploded over the editors' handling of a photo essay he had produced on the humanitarian doctor Albert Schweitzer at his hospital mission in Lambaréné, French Equatorial Africa. After Smith quit, he spent nearly 20 years in obscure poverty, composing lengthy, obsessive meditations on subjects like the cityscape of Pittsburgh, before regaining popular acclaim with *Minamata*, his exposé of industrial mercury poisoning in Japan.

David Douglas Duncan was a much decorated hero of the Pacific front in World War II. His photographs of Korea, published in book form as *This Is War!*, virtually defined that ugly conflict. He took his leave of LIFE in 1955 to become a free-lancer. Some of Duncan's most widely hailed work thereafter—a long, intimate look at the life of Picasso at home in Vauvenargues, a ground-breaking tour of the Kremlin—appeared in magazines like the *Saturday Evening Post* and *Look*, but was intended from the beginning to appear in book format. The increasing recourse to books was the photographer's attempt to capitalize on work that had attained an independent value in the cultural marketplace. Above all, the book format offered the photojournalist an increase in scope, per-

Aerial view of suburban Los Angeles *Loomis Dean, 1949*

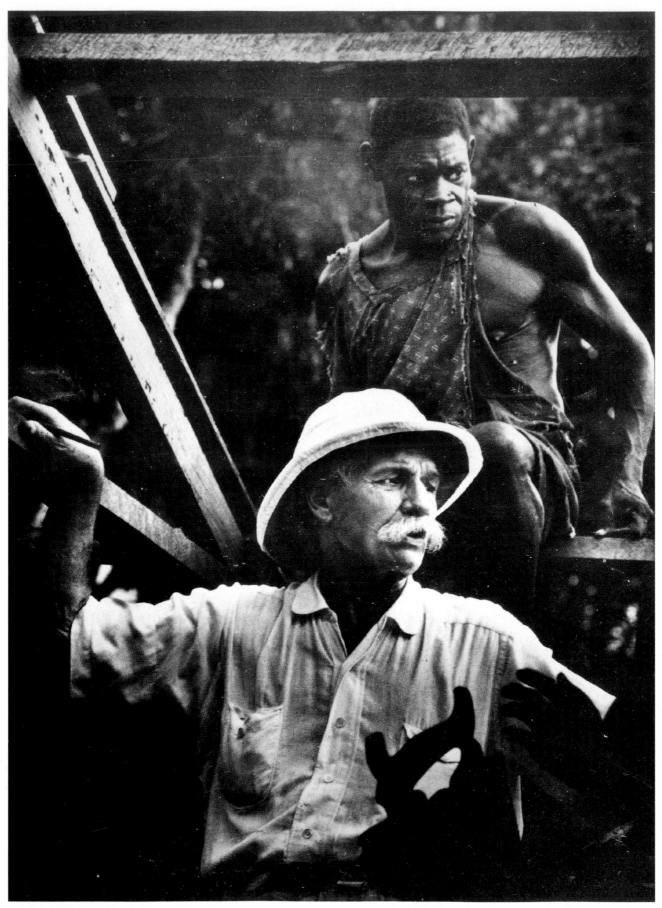

Albert Schweitzer *W. Eugene Smith, 1954*

sonal control and intensity of emotional tone that magazine publication could not match.

As a vanguard minority began to flee from the mass press, they threw up a wave of criticism about the failures of news photography in general. The power of photojournalism had always derived from its aura of factuality, which from the very beginning, in the days of Brady and O'Sullivan, had been a slightly embroidered truth. In the view of postwar dissidents like Eugene Smith, the factual impact of photography had been undermined by overproduction and by the sheer banality of what was overproduced.

Continuous wire-service transmission, the insatiable appetite of the daily press for repetitive images of meaningless local events, the peacetime return to managed news events (political campaigns being then as now the paramount example) and the triumph of consumer culture, accompanied by the relentless photo advertising of its wares, covered the world with photographs leached of their expressiveness and meaning. As Smith bleakly said, "We are deluged with photography at its worst—until the drone of superficiality threatens to numb our sensitivity to image." One of Smith's admirers, Lincoln Kirstein, put an even sharper edge on the condemnation. "Dominated by a condign conspiracy between mass media, coffee-table publishing, luxury advertising and competitive curators," he wrote, "photography since the Korean War has declined into ferocious overexposure."

The outrage in the dissident camp was based on the conviction that the factuality of picture taking and the truth the picture was intended to represent—the meaning of the event—had become separate in the world of mass images. This was, without doubt, an élitist view: the private vision of the photographer versus the view of the world he was forced to depict. In essence it was an artist's position (which made it doubly appealing to many photographers, whose mechanical means of expression were still viewed with suspicion in the art world). But the idea that photojournalism represented a kind of higher truth remained questionable, because in fact the medium was reaching some of its more obvious limits. John Szarkowski, curator of photography at New York City's Museum of Modern Art, has noted that the very repetitiveness that Smith decried is part of the nature of photojournalism. As Szarkowski expressed it, "We might look at it not merely for what it tells us that is new, but for the ways that it describes for us over and over again, with subtle but constant variation, those few simple and enduring human issues that the medium of photography has learned to cope with."

Nonetheless, the frustration of the photographic vanguard was real. Thus perhaps it was unavoidable, and even necessary, that the most influential figure in news photography in subsequent decades was a man who essentially spurned the medium, creating what might be called anti-photojournalism. Swiss-born Robert Frank said of his own work that he wanted to produce images that would make "all explanations unnecessary." In other words, abolish the necessity for text.

Frank knew photojournalism from the inside. He worked for *Harper's Bazaar* in the 1940s, for LIFE and FORTUNE in the '50s. At FORTUNE, he occasionally worked in close collaboration with the cantankerous Walker Evans, who shared his antipathy to the great industry of press photography. (Evans wrote the text for one Frank portfolio in FORTUNE, a railway study called *The Congressional*.) Liberated from commercial work by a Guggenheim fellowship, Frank toured the United States for two years, assembling the images that eventually appeared in Europe in his 1958 book, *The Americans.*

Frank later described his journey: "I had never traveled through the country. I saw something that was hidden and threatening . . . you felt no tenderness." That sensibility was captured in the work. The dark, harsh, enigmatic images presented a vision of the United States populated with hardened, wary, bored and enervated individuals, caught in deliberately enigmatic fashion while contemplating the aspects of everyday living that held them captive. They were the antithesis of the country's optimistic self-image. Frank's subversive photographs had no point beyond themselves; they were the point. They flew in the face of a canon of news photography: the primacy of events. Frank carefully composed his photographs to avoid the kind of clarity espoused by Cartier-Bresson; he made his statement by photographic indirection. *The Americans* created a furor, and it took another year for the book to find a publisher in the United States. Frank had achieved his aim: after *The Americans* he was never taken for a photojournalist again, but by the 1960s, his influences began to dominate the medium.

At the same time that Frank was working to undermine the notion of the event, and even the individual, as a focus for news, photojournalism continued to expand its frontiers. In the blandness of the postwar years, photographers turned their vision on the corporation and the suburb. No magazine was more prolific or more adept in exploring that realm than FORTUNE, and no photographer more skillfully bared the soul of the consumer society than Dan Weiner. A veteran of the left-wing New York Photo League, Weiner had a talent for reducing the complexities and contradictions of consumerism to jarring human portraits taken with candid naturalness: the predatory face of a detergent salesman waging supermarket shelf wars; a fashion show on a commuter train. Weiner captured the stratagems, martial discipline and artifice that underpinned mass-produced America. Before he died in a 1959 plane crash, Weiner spread the news of the United States

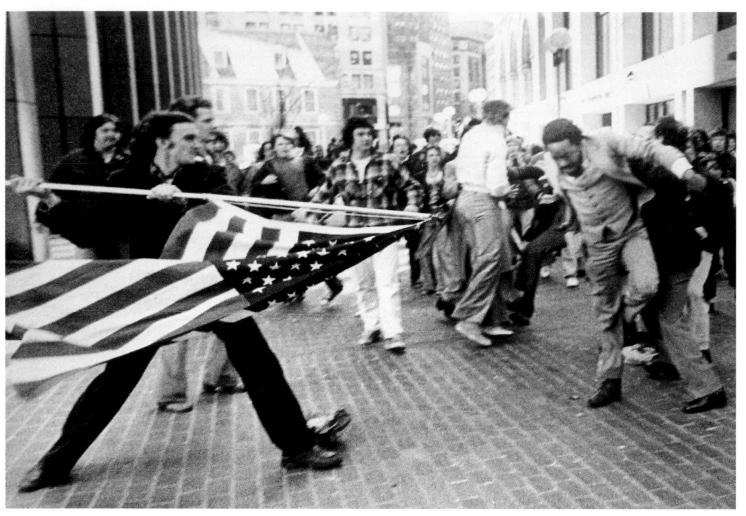

Anti-busing demonstration in Boston *Stanley Forman, 1976*

transforming itself no less dramatically than in the great era of dam- and waterway-building in the '30s.

Another reality of the '50s was more difficult to bring to light: the plight of black America. As the civil rights movement gestated in Southern black churches, most U.S. publications took little notice. There were, of course, exceptions. The blatantly contradictory nature of segregation did not escape the attention of Magnum's Elliot Erwitt, more renowned for his puckish snapshots of the human comedy. Other white photographers, like Flip Schulke, persevered by contracting with black-owned *Ebony* and *Jet* magazines. With the deployment of troops in Little Rock in 1957 and the rise of civil disobedience, the work of Schulke, Leonard Freed and others, including Weiner, received wider exposure. Some of the most haunting photographs of youthful black nihilism and despair in the North—an ulcer that would not perforate for another decade—were taken by a young black photographer named Gordon Parks, a last protégé of the redoubtable Roy Stryker. Parks hired on with LIFE and was dispatched to Paris. He returned to follow a street gang through the Harlem ghetto and intro-

duced LIFE readers to Malcolm X, Elijah Muhammad and the Nation of Islam.

In 1954 Robert Capa was killed by a land mine at Thai Binh, as one Indochina war ended and another began. The event marked the end of an age: Europe entered the era of decolonization, and the United States emerged as a kind of global policeman. With the enthralling arrival of the Kennedys, American journalism finally decided that the White House was worthy of full-time coverage: with Camelot came the court photographer. In 1963, as events darkened for the United States at home and abroad, it seemed that photojournalism had regained some of its tragic power, a power based more than ever on the accurate reflection of somber events. The A.P.'s Malcolm Browne methodically photographed a Buddhist monk burning himself to death in a Saigon protest. A Dallas *Times-Herald* photographer caught the instant of Lee Harvey Oswald's death.

So did television. A latent threat to the press since its first practical demonstration in 1929, the electronic medium had, by the '60s, systematically undercut the prosperity of the picture

magazines. *Collier's* expired in 1957; the *Picture Post* in the following year. *Look* vanished in 1972. Life suspended publication that same year. Television took away the national advertising markets that the picture magazines, as mass-circulation media, had enjoyed. At the same time, television news robbed the picture press of its monopoly on presence and immediacy. With its mobile images and soundtrack, television was simply able to provide a more vivid sense of news events.

News photography surrendered its pre-eminent place as a mover of mass public opinion in Vietnam. It also discovered—or rediscovered—a different kind of emotional intensity, based on what television could not do. Television did not linger well, nor could it amplify an emotional effect by passing and repassing across the same subject from subtly differing angles. That kind of television news was simply boring. In Vietnam, therefore, photography took on a kind of meditative authority, in lengthy, often ferociously pointed essays on the devastation and senselessness of the conflict. No photographer was more

savage in his critique of the American involvement than Phillip Jones Griffiths, the Welsh-born Magnum photographer whose book, *Vietnam Inc.,* was published in 1971. No one was less squeamish or more meticulous in recording the conflict's physical horror than Don McCullin of the *Sunday Times* of London, and perhaps no one managed to catch as many of the war's individual moments of heroism and despair as Larry Burrows of Life, who died in a 1971 helicopter crash while covering the South Vietnamese invasion of Laos.

Vietnam was an immense drain on the nation's military, political, economic and journalistic resources. As the war progressed in Asia and at home, U.S. publications ceded coverage elsewhere in the world to newly formed, predominantly French news agencies: Gamma, Sygma, Contact Press Images. Once again, Paris emerged as a great center of photojournalism, as it had been before World War II. With the death of the American picture magazines, the new, fast-moving agencies sold their wares to the publications that filled the void: the Amer-

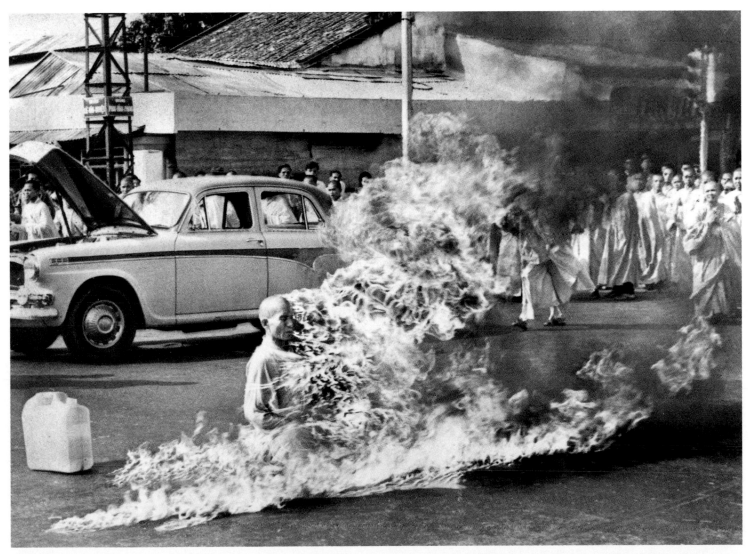

A Buddhist monk burns himself to death to protest the Diem government in South Vietnam *Malcolm Browne, Associated Press, 1963*

ican newsweeklies. Led by TIME and *Newsweek,* news-magazines gradually shifted the balance in their coverage from a heavy reliance on text toward greater illustration. It was only toward the end of the decade, however, that the news-magazines developed the technology for printing color photos as quickly as black-and-white, bringing the magazines into the same fast-moving visual realm as television.

Television, which had killed off one generation of pictorial magazines, became the sponsor of another. In moving to greater pictorial coverage, the newsweeklies were following the lead of the magazine that had fattened most off the rise of television: SPORTS ILLUSTRATED. Henry Luce's weekly sports magazine—sometimes referred to ironically as "Harry's yacht" in the profitless years after its 1954 founding—showed that television could create interest in news photography as well as kill it. In a subtle but far-reaching change in their philosophy, newsweekly editors came to agree that news photography, piggybacking on the interest created by television, gave added luster to their sacrosanct text. News photography got a renewed lease on life, but one in which the presentation of reality was increasingly conditioned by the electronic medium. Most dramatically, the new symbiosis with video forced photographers to adapt to the world of color television by using high-speed color film as a standard practice. For many traditionalists, color marked a final capitulation to the superficial values of "the Tube." If anything, the task of news photography became more demanding. For a younger generation of photojournalists, the raw immediacy of the news now demanded color—not to make their images conform to television but to stand out against its visual cacophony.

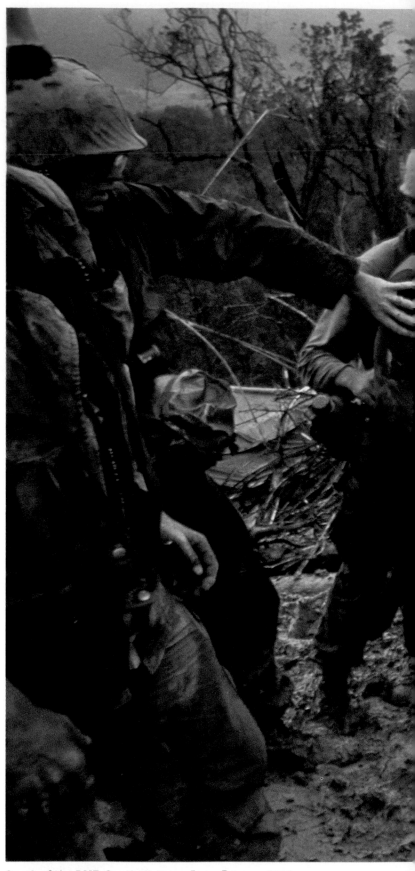

South of the DMZ, South Vietnam *Larry Burrows, 1966*

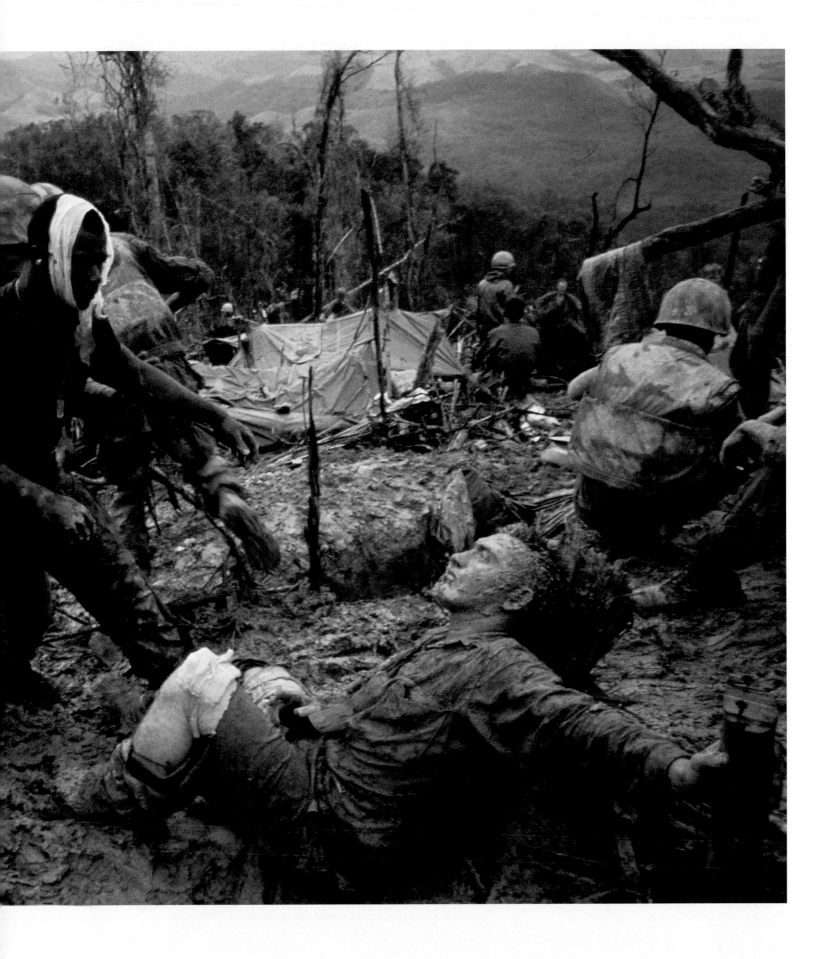

A radiation shelter in Garden City, Long Island
Walter Sanders, 1954

So powerful was the ethos of normalcy in the 1950s that every effort was made to convey the impression that an undisturbed family life could be pursued in an atom bomb shelter.

Test mannequins at an atom bomb site
Loomis Dean, 1955

A constant preoccupation of the early atomic years was imagining the effects of a nuclear blast. These dummies at a test site in Yucca Flat, Nevada, were used to gauge what was only too easy to imagine: the impact a blast might have on the human body.

Opposite page:

Fashion show aboard a New York commuter train *Dan Weiner, 1949*

After the grim war years, photographers like Weiner turned their cameras on the battlefields of business and marketing as the nation happily transformed itself into a consumer society.

Albert Einstein
Philippe Halsman, c. 1955

Throughout his long career, Halsman devoted himself almost entirely to portraiture. Occasionally he resorted to elaborate scenes, as in his famous portrait of Salvador Dali in the midst of flying cats and a spray of water. He often asked his subjects to allow him to take one picture of them jumping in the air. Mostly he was satisfied to let the face alone be the focus of attention.

A Japanese industrialist in repose *Bill Ray, 1964*

As Japan emerged from the war, interest in its personalities and institutions grew among Americans. Konosuke Matsushita was a businessman, publisher and author. He liked to take daily walks in the garden of a philosophical institute he had founded in Kyoto.

General Douglas MacArthur in Korea
Carl Mydans, 1950

MacArthur was a soldier with a showman's sense of how to cultivate his own celebrity. Mydans made a number of memorable pictures of the general; particularly famous was the shot of his return to the Philippines. This tough-guy portrait appeared not long before MacArthur's downfall, when President Truman recalled him for his unwillingness to follow Truman's orders to restrict the war to Korea.

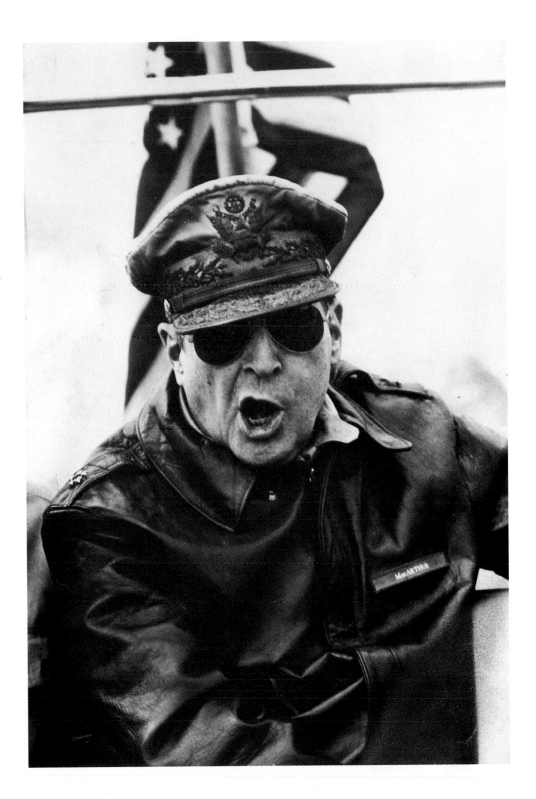

Christmas in Korea *David Douglas Duncan, 1950*

Along with Mydans, Duncan became the great chronicler of the Korean War. He made this picture as part of a classic photo essay on the suffering of a column of Marines that appeared in a holiday issue of LIFE. The men fought their way from the Changjin Reservoir to a haven on the Sea of Japan, much of the time under heavy fire from the nearby hills.

Picasso in his studio
David Douglas Duncan, 1960

Picasso became one of the most recognizable artists of the century, partly because of the many pictures of him published in the press. For a number of years Duncan was, in effect, Picasso's court photographer, following him constantly with a camera.

Alberto Giacometti at work in his Paris studio
Henri Cartier-Bresson, 1960

Cartier-Bresson's great strength in his many portraits of artists and writers was his gift for conveying some quality of the subject's work in the likeness. Here he has photographed the lean, serious Giacometti looking much like one of his own sculptures.

Sammy Davis Jr. in New York City
Burt Glinn, 1959

In this portrait of Davis, Magnum photographer Glinn set the emerging star in an atmosphere drawn from downbeat photography of city life. It was a style common to the '50s.

James Dean in Times Square
Dennis Stock, 1955

By the mid-1950s, the traditional Hollywood glamour shot began to give way somewhat to a moodier style that reflected the influence of postwar urban social documentary. It also suited the image of a new generation of actors like Marlon Brando, Paul Newman and James Dean. Inevitably, the darker kind of portraiture produced a new category of glamour: the glamour of alienation.

Illegal immigrants await deportation
Loomis Dean, 1951

Dean took this picture at the border patrol jail at
Calexico, California, as part of an essay on Mexicans
who traveled illegally into the United States to find
work. The group here, some of whom had walked 50
miles across the desert with little food and inadequate
shoes, was to be sent home.

Mexican woman and her daughter making tortillas
Leonard McCombe, 1950

Until he retired in 1972, McCombe was one of Life's great
photographers and photo essayists. He uses the shaft of light
falling from the left in the same way the 17th century Dutch
painter Vermeer used it when painting domestic interiors.

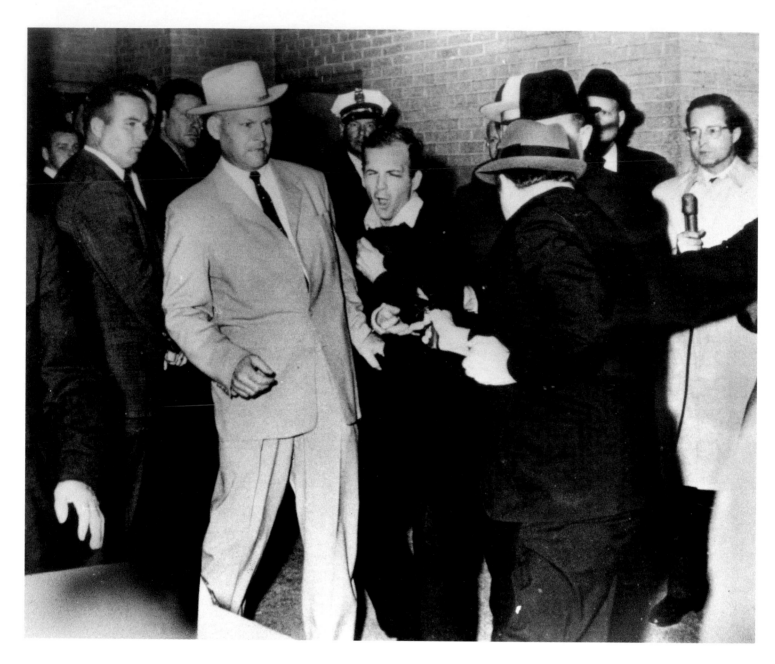

The murder of Lee Harvey Oswald
Robert Jackson, 1963

On the day before President John F. Kennedy's funeral,
just two days after he was gunned down, Dallas
night-club operator Jack Ruby shot and killed Kennedy's
accused assassin as he was being transferred to the county
jail from the Dallas city jail. Jackson, a photographer for
the Dallas *Times-Herald,* tried for a second picture
immediately after this one (which won the 1964 Pulitzer
Prize), but his electronic flashgun failed.

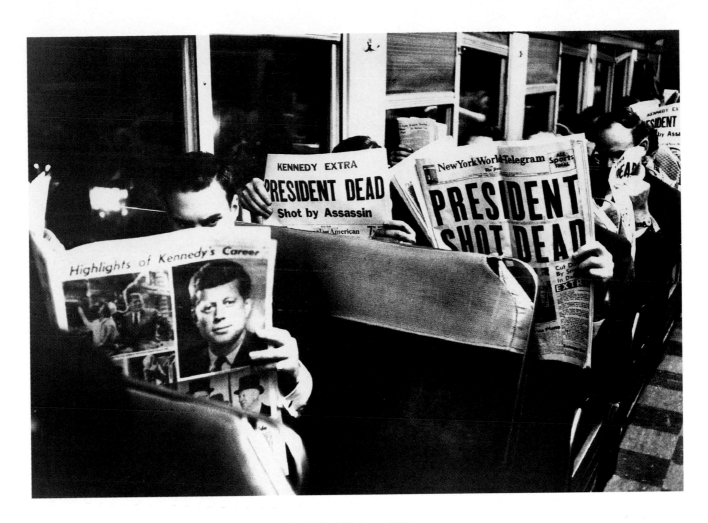

Commuters on a train to Stamford, Connecticut *Carl Mydans, 1963*

Mydans' picture of the nation absorbed by the news of the Kennedy assassination captures a truth about the climate of that event. For a few days, the news was everything.

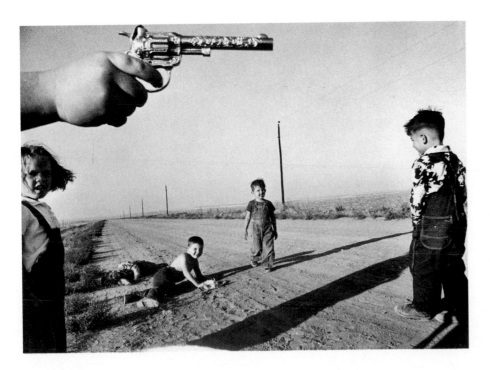

Children with toy gun
Howard Sochurek, 1952

Sochurek's picture, from a photo essay called "Prairie Country," anticipated the skewed composition, fragmented elements and disconcerting moods that photographers like Garry Winogrand and Lee Friedlander were to carry into the art world during the following decade.

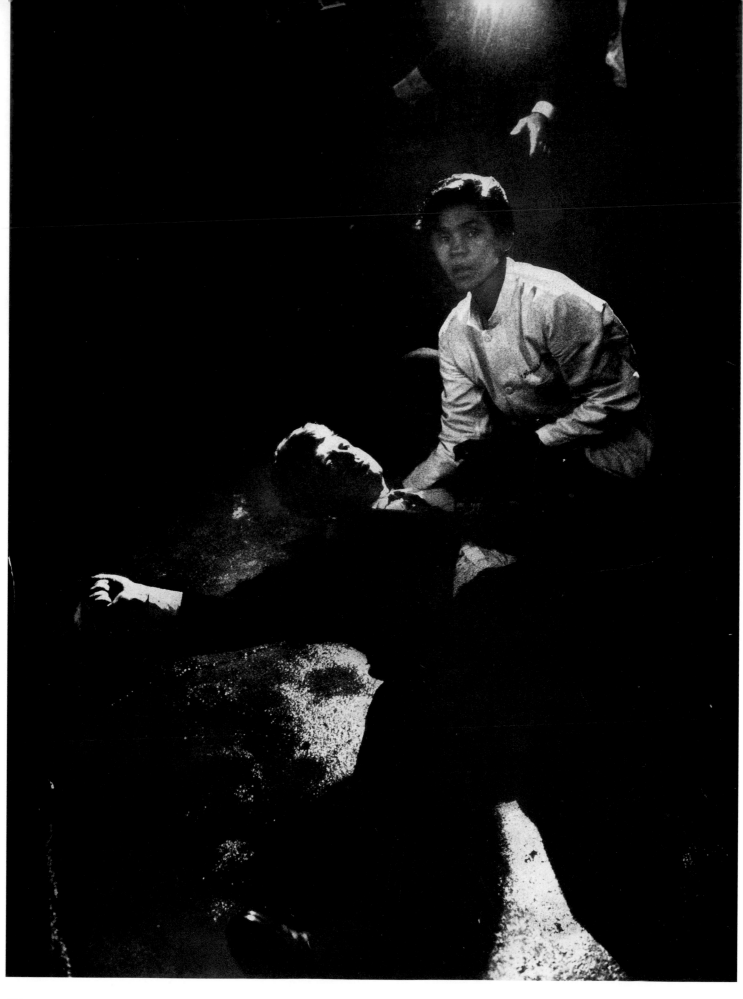

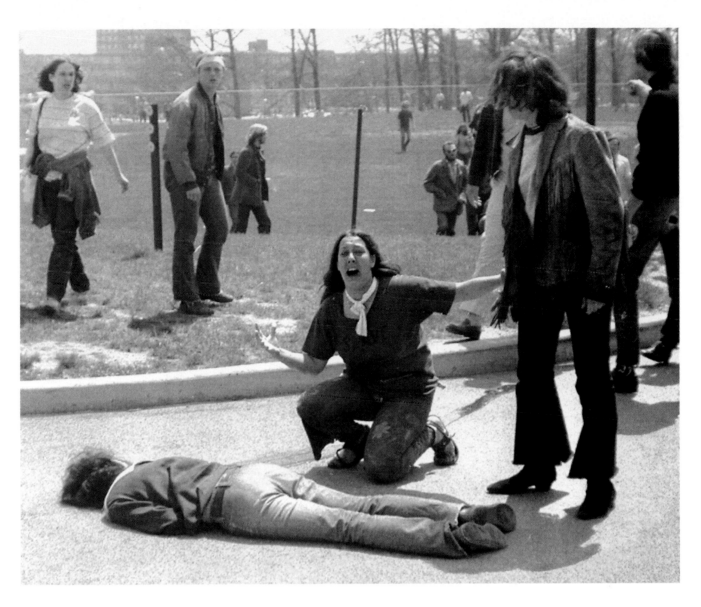

After the massacre of students at Kent State University
John Paul Filo, 1970

This Pulitzer Prize-winning picture is another of the quintessential images from the years of student protest. A young woman kneels beside the body of one of four students killed in a 13-second barrage of bullets fired by troops of the Ohio National Guard. During demonstrations to protest the U.S. invasion of Cambodia, troops armed with live ammunition were sent to the campus by Ohio Governor James Rhodes. Because no one expected the demonstration to become a major story, no publications had assigned photographers to cover it. Filo was a student photographer on the campus yearbook staff. He took this picture to a local newspaper, which sent it out nationally over the AP wire.

Robert F. Kennedy after he was shot
Bill Eppridge, 1968

Kennedy was shot twice in the head by Sirhan Sirhan within minutes of claiming victory in the crucial California primary. After giving a triumphant speech in the ballroom of the Ambassador Hotel in Los Angeles, Kennedy cut through the kitchen on the way to meet the press. Sirhan was waiting for him there. Eppridge's picture of Kennedy being supported by a busboy whose hand he had just shaken became the pietà of the late 1960s.

"*When I got to the kitchen, I heard a series of shots,*" Eppridge said. "*The crowd parted for a second, and I saw Kennedy lying on the floor, and I went to work.*"

Harlem
Leonard Freed, 1963

Another veteran of the civil rights movement, Freed, a Magnum photographer, was drawn to coverage of the American black community. In 1964 and 1965, he traveled the country for a photo study of race relations, which he published in 1969 under the title *Black in White America.*

Muhammad Ali
Gordon Parks, 1966

Gordon Parks has had one of the most varied careers of any photojournalist. After contributing to the Farm Securities Administration project of the 1940s, he served as a staff photographer for LIFE. An author and composer as well, Parks became a film director in the 1970s and is best known for his movie *Shaft.*

A tenement in New York City
Bruce Davidson, 1970

Davidson chronicled the life of a single block in Harlem in his book *East 100th Street.* His later pictures relied even more on mood and psychology, rather than on the depiction of specific events, to give a sense of life in the city.

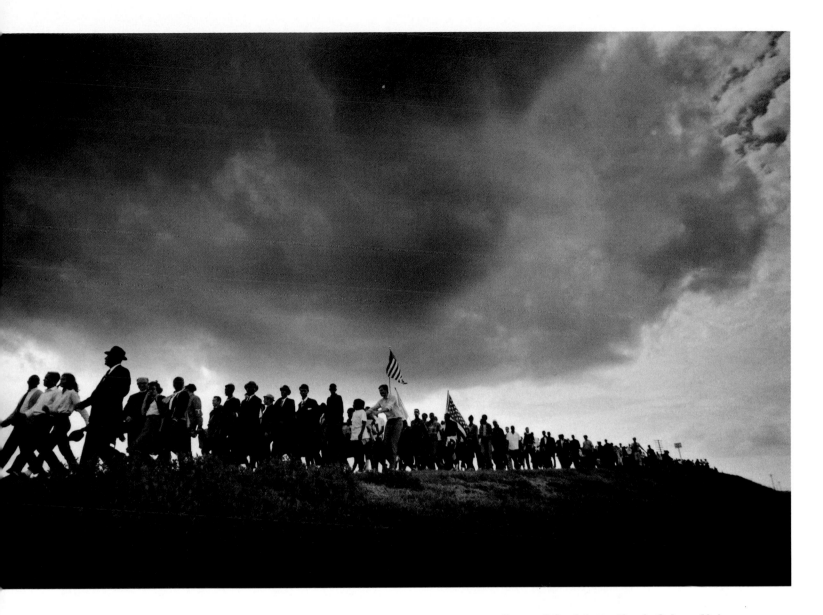

A march for integration in Selma, Alabama
James H. Karales, 1968

Coverage of the civil rights movement was similar in many respects to the coverage of war, not merely because so many of the photographers who followed the movement were veterans of World War II and Korea. The civil rights struggle offered scenes of carnage, but also moments of courage, victory and jubilation.

South Carolina
Bruce Davidson, 1962

Davidson came to prominence as a chronicler of the civil rights movement. Later he turned to book-length projects, including his study of Harlem, *East 100th Street*. Books allowed Davidson to explore a subject in greater depth than was possible on a magazine assignment.

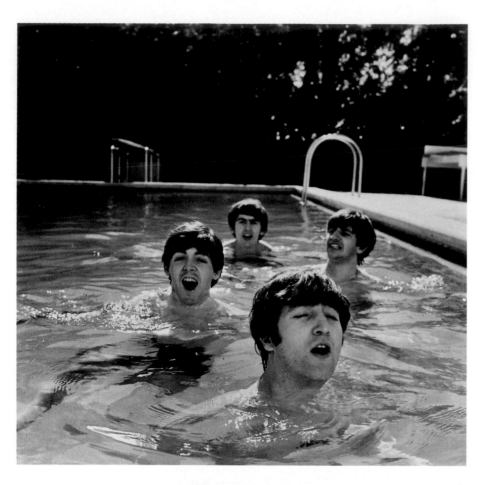

The Beatles in the swimming pool of a Miami Beach Hotel
John Loengard, 1964

The Beatles first arrived in the United States early in 1964, where they found a public grateful for the opportunity to shake off the gloom that had set in after the assassination of John F. Kennedy. The Beatles were witty, spontaneous and eager cutups for the camera.

Clark Gable, Van Heflin, Gary Cooper and Jimmy Stewart
Slim Aarons, 1957

The golden age of Hollywood studios was nearly over, but for a moment one might not realize it looking at this picture of a New Year's Eve celebration at Romanoff's restaurant.

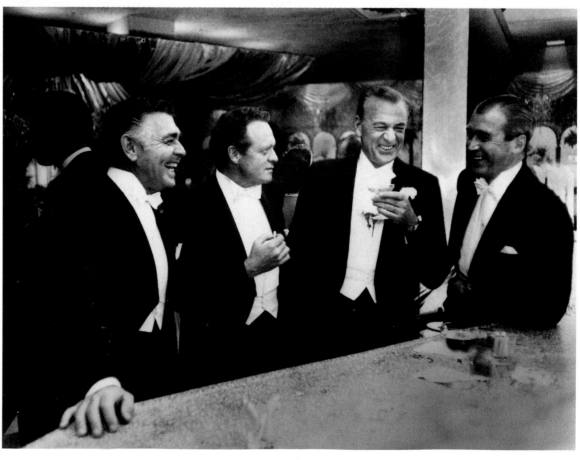

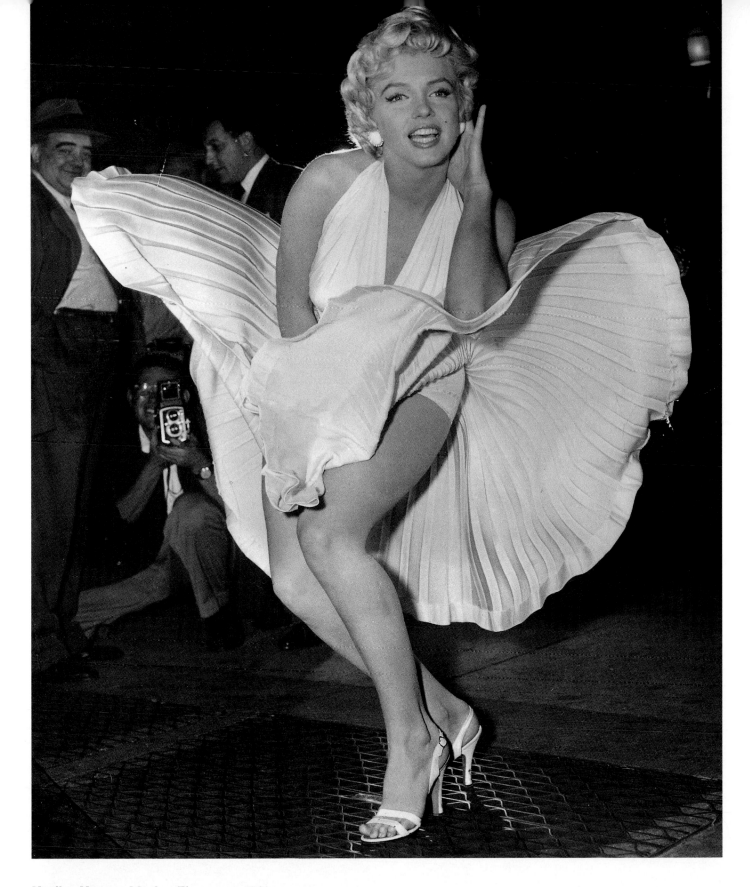

Marilyn Monroe *Matthew Zimmerman, 1954*

Monroe became one of the most photographed women of the 1950s, a magnet who drew all our mixed feelings about the media's depiction of women and the personal price of fame. This famous picture of the star dealing with an updraft from a subway grating—and an electric blower—was made in New York City during the shooting of *The Seven-Year Itch*.

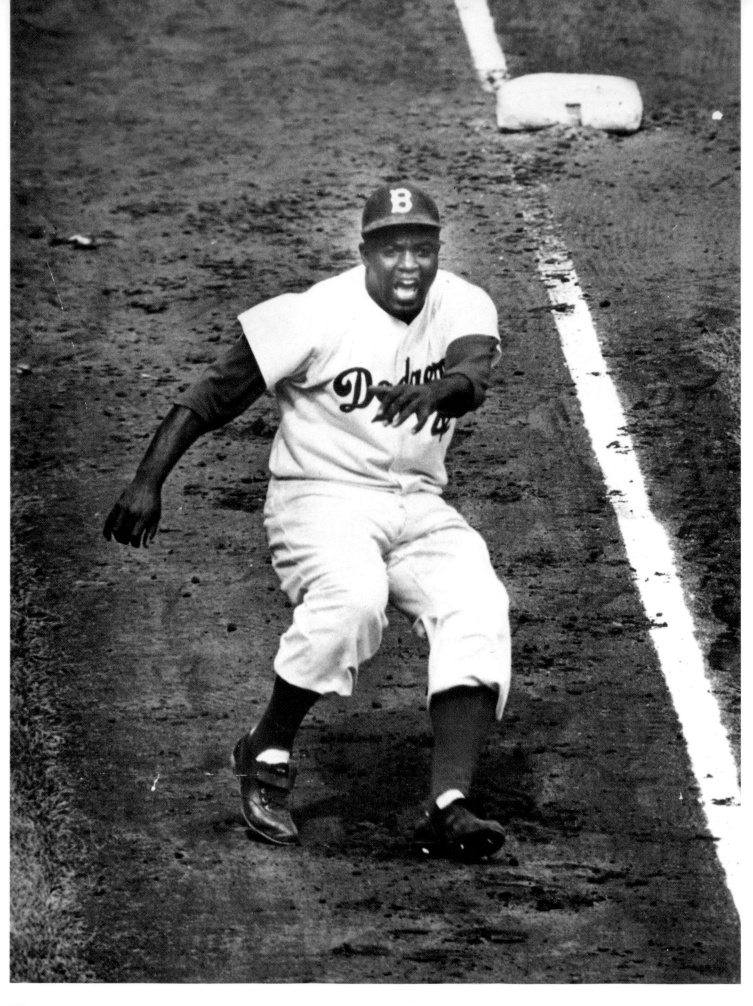

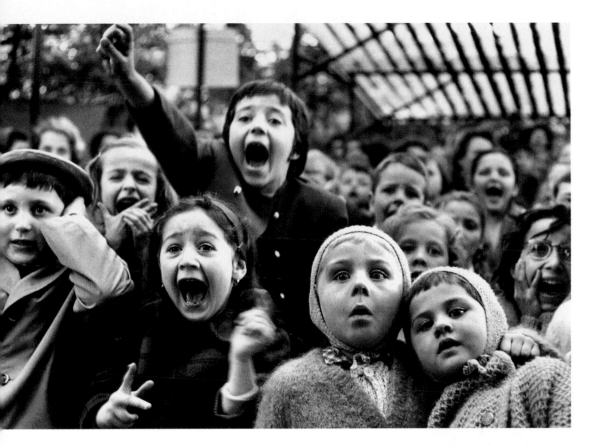

Children watching a puppet show
Alfred Eisenstaedt, 1963

Eisenstaedt was famous for pointing his camera away from the action on center stage to discover the surprises to be found in the unexpected angle. In this picture of children watching the dragon being slain during a puppet show in a Paris park, he made an enduring image that appears to sum up all the pleasures of the act of seeing itself.

Marcel Marceau
Gjon Mili, 1955

Mili's specialty was pictures in which figures of light were rescued from the deepest darkness, like this portrait of the French mime, Marcel Marceau. A former lighting engineer for Westinghouse, Mili made revolutionary use of the strobe light to get motion effects on film. His knowledge of electronic equipment enabled him to produce unique photographs of sport, theater and dance.

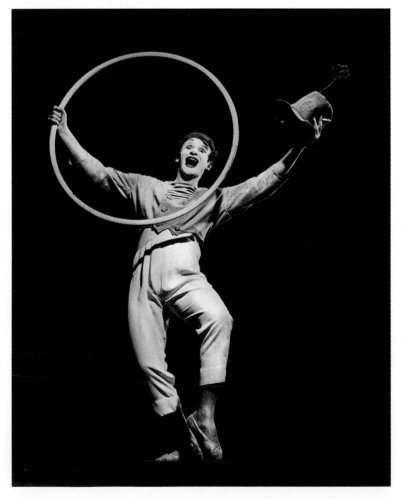

Jackie Robinson steals home base
Ralph Morse, 1955

Robinson's gift for stealing bases was apparent from the time he became the first black player in the major leagues in 1947. To make this picture, taken at Ebbets Field in Brooklyn during the 1955 World Series that pitted the Dodgers against the Yankees, Morse had a camera aimed down the third-base line that he operated with a foot switch. That left his hands free to hold a second camera for shots of other plays.

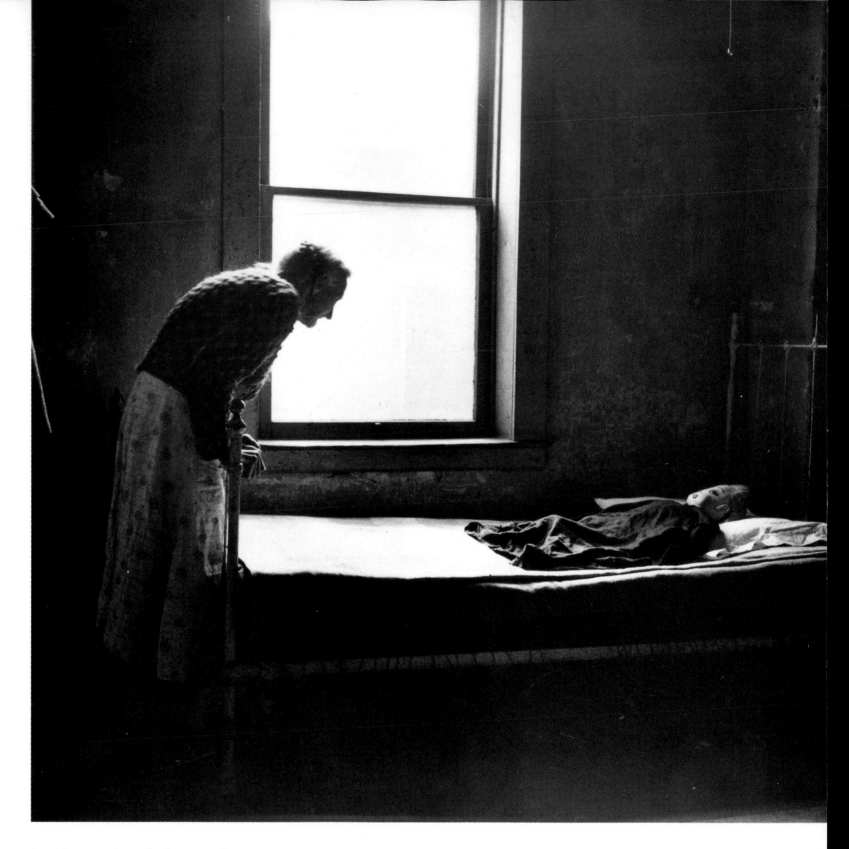

An old woman in an Indiana poorhouse
Wallace Kirkland, 1952

This picture of a woman gazing at the doll that is her
only possession was a departure for Kirkland. He was best
known as a nature photographer with the patience to
spend nearly three weeks hidden under a bale of hay to
get a picture of a barn owl bringing a mouse to its young.

A child imitates the expression of his baby-sitter
Leonard McCombe, 1957

Not all photojournalism consisted of news pictures or celebrity shots. In the 1950s many photographers went after the pleasures of everyday life.

In an insane asylum, Turin, Italy
Raymond Depardon, 1979

Depardon helped revolutionize the idea of a news photo agency when he founded Gamma in the late 1960s. His agency offered photographers a 50 percent commission on their pictures, gave them the copyright and added their name to the agency's on the photo credit. Gamma pictures established a reputation for toughness, political passion and aesthetic daring.

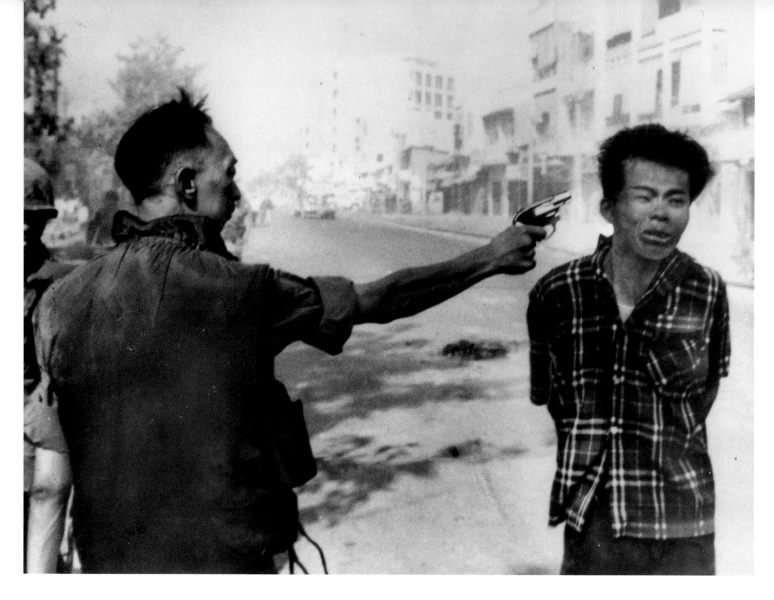

Street execution of a Vietcong prisoner *Eddie Adams, 1968*

For many Americans certain photographs came to symbolize the brutality of the Vietnam War. One was Adams' picture of a South Vietnamese police chief, Colonel Nguyen Ngoc Loan, shooting a Vietcong prisoner in the head at point blank range in the streets of Saigon. It was in the midst of the wild street fighting during the Tet offensive, when the Vietcong were sweeping through the cities of South Vietnam. The picture won a 1969 Pulitzer Prize for Adams, who took it for the Associated Press. Ironically, he later became a friend of Loan's and often attempted to explain the context for the brutal act that the picture alone could not provide: Vietcong guerrillas had recently massacred a South Vietnamese colonel, his wife and six children in their home.

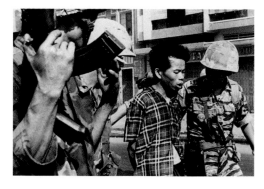
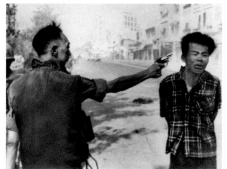
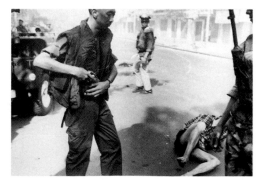

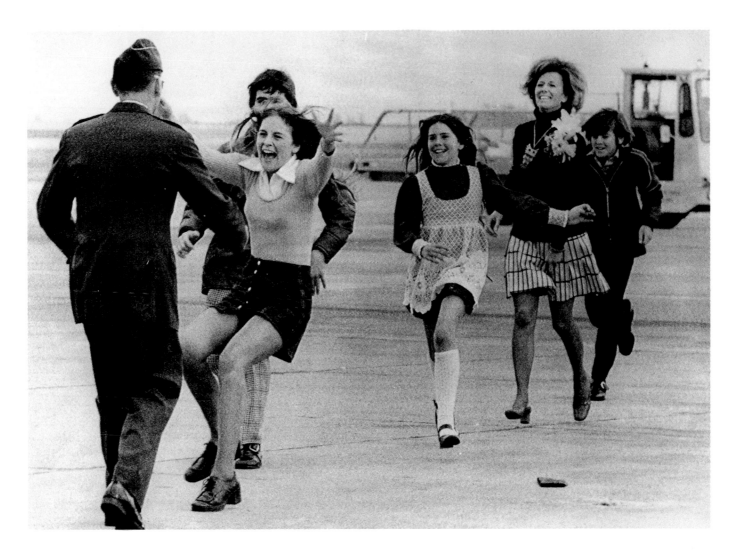

Lieutenant Colonel Robert Stirm
returns home *Sal Veder, 1973*

An Air Force officer, Stirm had been shot down over North Vietnam in 1967. Like many of the most striking photos of the Vietnam War years, this picture was not the result of a lengthy assignment, but rather a quick "grab shot" by an AP photographer. *Burst of Joy,* as it is also known, won a Pulitzer Prize.

Children fleeing an American napalm
strike *Huynh Cong ("Nick") Ut, 1972*

A group of terrified children runs down a highway near Trang Bang. The girl in the middle had ripped off her napalm-burned clothing. This Pulitzer Prize winner was called a fake by U.S. General William Westmoreland, who suggested the girl in the picture had been burned *"in a hibachi accident."*

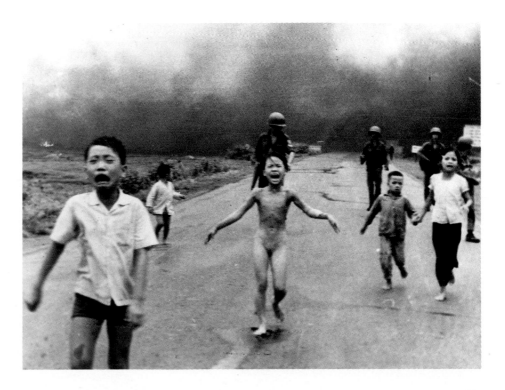

A madwoman in a Haitian clinic
W. Eugene Smith, 1958

Though many photojournalists are uneasy about
darkroom manipulations of the print, Smith felt that such
effects could emphasize psychological truths. For this
photograph he darkened the background and whitened
the woman's eyes *"to indicate the inner emotions that were
going on at that time."* Initially the series of pictures he
took at the clinic were not widely seen. They were not
published until two years after they were taken, and then
only in a small-circulation medical magazine.

Spanish women in mourning *W. Eugene Smith, 1950*

The old man had died of gangrene poisoning; in the foreground are his wife, granddaughter and daughter. Because the room was lit by a single candle, this was one of the rare occasions when Smith used a flash. He paused to make just three exposures, "*never having said a word.*"

A young woman deformed by mercury pollution

W. Eugene Smith, 1971

The deformed and contorted body of 16-year-old Tomoke Uemura was the result of mercury pollution that had also left her blind and mute. The same industrial waste had poisoned many other inhabitants of the Japanese fishing village of Minamata. A few weeks after this picture was taken, Smith was severely beaten by goons working for the polluters, the Chisso company. Uemura died six years later.

Chinese Nationalist recruits massing in Beijing

Henri Cartier-Bresson, 1948

In the waning days of the Chinese revolution, recruits were rounded up to swell the army of Chiang Kai-shek in his fight against the communist forces of Mao Zedong.

A hand rises from the eastern side of the Berlin Wall

Paul Schutzer, 1961

Ten years from now will the Berlin Wall have faded from memory? Will it be necessary to explain this picture in detail? Those who saw the photograph in 1961, when the wall was new, needed no explanation. Schutzer, who did prizewinning work during the Eisenhower era, was killed during the 1967 Six-Day War in the Middle East.

Spanish Civil Guard
W. Eugene Smith, 1950

This wide-angle portrait of Franco's hated Guardia Civil is part of Smith's legendary LIFE photo essay on the Spanish village of Deleitosa (population 2,300). The soldiers were squinting into a bright sunset. Smith persuaded them to stay still, assuring them through his interpreter that "*the lighting makes you look so strong, so powerful.*" That night he wrote to his mother, "*This afternoon . . . I was crouched in horse dung on a street in Spain trying to translate my indictment of the Guardia Civil and powers above.*"

Bangladesh *Don McCullin, 1971*

In the 1960s and '70s, British photgrapher McCullin became one of the best-known
chroniclers of war and misery. His work was an inventory of the endless plague of vio-
lence in such places as Cyprus, the Congo, Cambodia, Biafra and Northern Ireland.

Earthrise from space *William Anders, 1968*

Not every great picture is taken by a professional photographer. This shot was made by one of the astronauts aboard Apollo 8, a lunar orbital mission that preceded the first moon landing by seven months. *"We'd come 240,000 miles to see the moon,"* Anders later wrote, *"and it was the earth that was really worth looking at."*

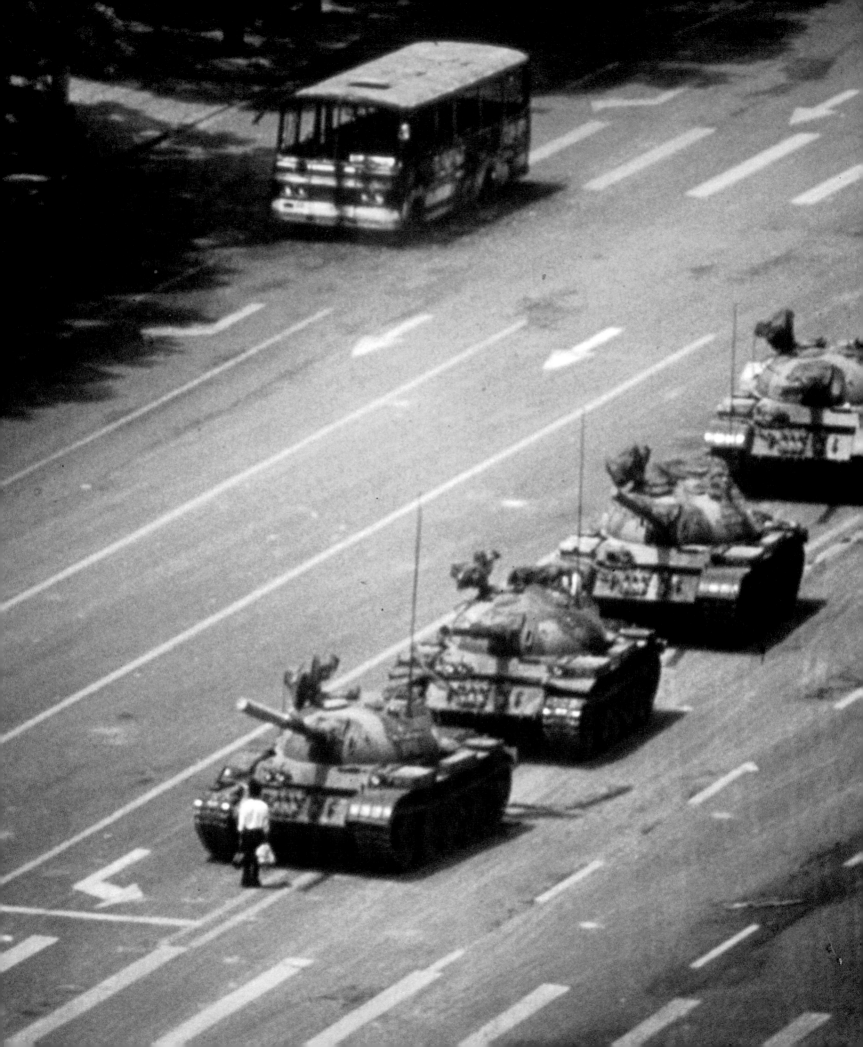

VI: RESURGENCE 1980–1995

By now the dominion of the camera is total. Photography has mapped every inch of creation, every patch of earth, no matter how remote. Cameras are obliged to patrol the solar system to find new sights. Show us the earth from Mars—we've already seen earth from the moon.

In the midst of this abundance, photojournalism has come to a crossroads. In terms of sheer tonnage, the 1980s was a good decade for the profession. Magazines began devoting increased space to pictures, using more of them and giving them bigger play. It may be argued that too many were celebrity portraits and glamour shots; still, the galvanizing news image and the moving photo essay managed to survive being crowded out by sparkle and hype. It was possible to find magazines in the U.S. and abroad that would give space to projects like Sebastião Salgado's global survey of work, Alon Reininger's portrait of the age of AIDS and essays on homelessness by Mary Ellen Mark and Eugene Richards. A few imaginative newspapers, the Detroit *Free Press,* the Boston *Globe,* the Louisville *Courier-Journal* and the Philadelphia *Inquirer* among them, began generating picture stories with the quality and ambition that were once the exclusive domain of magazines.

Nevertheless, the very quantity of photographs has led to an uncomfortable question: Does the power of pictures dwindle when they are so numerous? In the last decade of the 20th century—a bloody and sinister era by any measure—it seems reasonable to ask whether the impact of photojournalism has worn off, leaving only the most sensational images to register on the brain. Now that every kind of grief has been presented to the camera, which has recorded it from every angle, pictures of misery only seem to recall to us other pictures of misery. Look behind the face of a hungry child in Ethiopia, and there is the face of a child in Bangladesh; behind that, there is the face of a child in Somalia. It becomes hard to determine whether the moral sense is sharpened or coarsened by repeated exposure to calamity.

Then comes an image of one man blocking a line of tanks in Beijing, and once again a photograph sends shivers down the spine. So it can be done; a picture can still penetrate the emotional indifference that comes from overexposure. The

One man blocking a line of Chinese government tanks
Stuart Franklin, 1989

question is—as it always has been—how to make that picture. Sebastião Salgado does it with photographs of a world in which one can glimpse the shapes of eternity lurking just beneath the events of the day. For 20 years, Salgado, a Brazilian who was trained as an economist, has documented life and labor in developing nations. Whether photographing a village in Peru, an open-pit gold mine in Brazil or a refugee camp in Ethiopia, he dwells not on suffering alone but on the facets that give life, and even suffering, meaning: tradition, community and especially work.

Eugene Richards and Mary Ellen Mark are two Americans who have brought new life to the old format of concerned photography. When Richards talks about photography, he often sounds like Jacob Riis. He sees it as no more than a means to an end: showing unflinching views of poverty and pain. His black-and-white essays about emergency rooms or crack-heads or panhandlers may look at first like a million other images of mayhem, funk and misery. But, in the manner of Lewis Hine, his work takes on lasting power by its refusal to categorize people. His pictures are not tidy; the people are never defined and dismissed. The frame is hectic, full of loose ends. "Composed shots lie by turning people into archetypes," he once said. "The Hungry Child, the Drug Addict. I feel more comfortable taking fragmentary photographs, so you know that this is not the final, correct answer."

Mark's pictures often cover the same territory, but she infuses them with an extra sprinkle of spirit. Her subjects never fall into the category of victim. Her photo essay about street kids in Seattle is typical. If the kids in her pictures have problems, they also have brains, guile, sass and endurance. They can be shrewd and admirable even when they are not entirely likable. Mark's gifts are apparent in her lighter work too. In the color photographs she produced of Miami, the sheer chromatic punch tells you that Florida is a great setting for the human comedy. The lemony sunlight, the scrumptious blue of the sky, all the elements are in on the joke.

The spread of color photojournalism was one of the signal developments of the '80s. For decades, it was difficult to imagine news pictures in anything less sober than hard and durable blacks and grays. Though many notable photojournalists continue to work primarily in black-and-white, their numbers are dwindling. In the '80s, color photography virtually took over many magazines and even some newspapers. But color is tricky.

It lacks the automatic gravity of black-and-white. It seems frivolous by comparison and awkward to control. Blood throbs and the smallest patch of yellow smacks up against the retina.

This may appear at first to be a strictly aesthetic question, and photojournalists tend to stay aloof from talk about camera aesthetics. There is something about dodging gunfire in Beirut that discourages ruminations on style, understandably enough. More to the point, no one who catalogs bloodshed or poverty wants to be thought of as yet another vendor to the senses. Some news photographers spend half their lives chasing wars; who can blame them if they reach for the door when they hear the word art? The examples of artist-reporters like W. Eugene Smith and Henri Cartier-Bresson prove otherwise, but the stereotype survives: artists have visions; journalists have assignments. They may both think to themselves, "I am a camera," but each means something different.

Yet aesthetic questions have a moral dimension. Color is pretty; misery is not. How does one keep the simple appeal of color from confounding the full range of meanings a photograph may convey? If pictures of genocide come to us in the muted pastels of a Gap ad or the vivid hues of a rock video,

how does a photographer keep atrocity from looking palatable?

The most capable photojournalists of the past 15 years have learned to incorporate the unruliness of color into a deliberate statement. Alex Webb is best known for his work in the tropical nations of the Third World, especially Haiti. The hot pinks and fluorescent limes in his pictures of Haiti don't just sizzle inside the frame. They are the essential elements of a paradox: barbaric rule can operate in the broadest daylight, suffering can happen in sensual settings, a place can be cruel and inviting at the same time. This is quite different from the bass note of tragedy played in black-and-white photography. There is probably no one else working in photojournalism today whose pictures offer so many tangled possibilities. Nearly every one of them resists being pinned down by a caption. They offer too many complexities; contradictory signals and surplus meanings emanate from all parts of the frame.

Webb's pictures clearly take inspiration from the spatially complex work of Cartier-Bresson. Like a number of recent photojournalists, he also owes a debt to such photographers as Garry Winogrand and Lee Friedlander, who used the documentary approach for more personal ends. In the 1960s, they

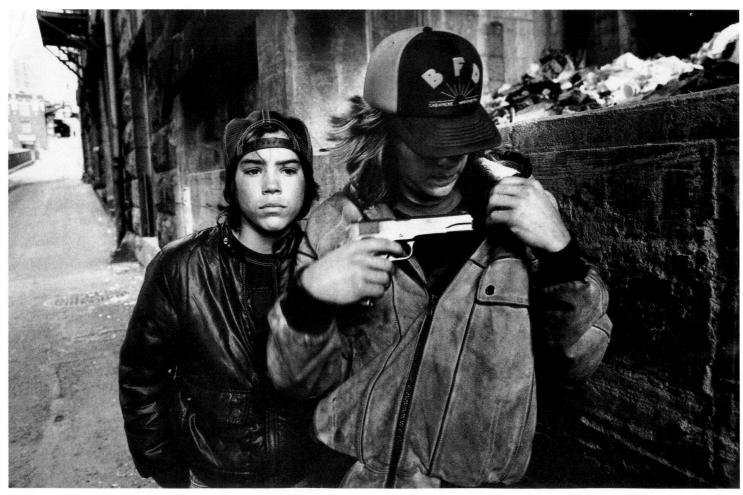

Seattle street kids with gun *Mary Ellen Mark, 1983*

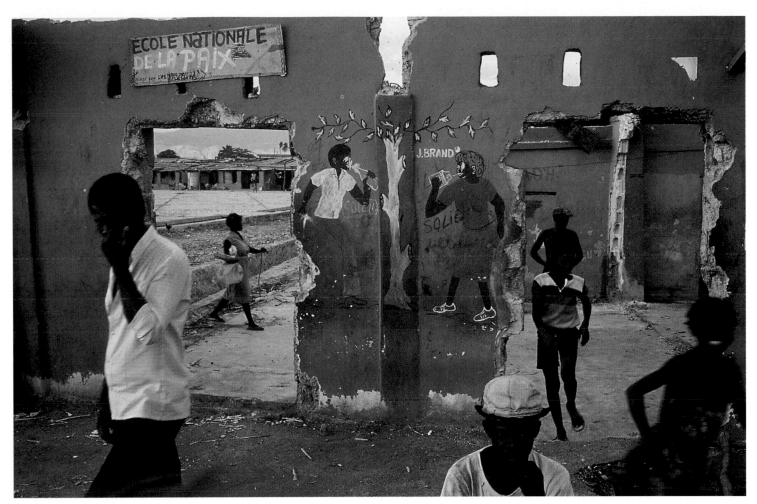

Street scene in Haiti *Alex Webb, 1986*

discovered from snapshots (and from the groundbreaking work of Robert Frank) how the eccentricities of amateur picture taking—the awkward gestures, the uncomposed views—could be a style in itself when adopted deliberately. Eventually their work legitimized photographs in which the scene might be tilted, limbs might be sliced by the edges of the frame and the mood of the main figures might be contradictory, ambiguous or simply impenetrable.

Because photojournalists work in a profession that puts a premium on action shots, they have often turned out scenes with the same laissez-faire approach to composition. It's not easy to get real people to fall neatly into place. But the exemplary pictures of the camera-reporting tradition have bowed more often to conventional expectations of how a picture should be constructed, treating the edges of the frame like a proscenium arch surrounding a quickly readable image. This is the tradition of Dorothea Lange, Carl Mydans and W. Eugene Smith. It does not always work, however, for photographers who find themselves in the midst of the mayhem of Rwanda or Sarajevo, where the composure that marks such earlier work can seem incompatible with the brutality of current events. In

such circumstances the most decent impulse is to use the camera as a branding iron; the right pictures are blunt, scorching and indelible. That they can also look raw and haphazard is merely proof that style can echo the facts. The more coherent images of classic photojournalism carry an implied message: life is comprehensible even in the midst of catastrophe; while events may be terrible, the human dilemma retains a familiar shape. The atrocities of Bosnia or Rwanda can break that faith. In a place like Sarajevo, throwing aside design is not just expediency. It is a moral gesture.

Probably no one has seen more of such places than James Nachtwey. One of the most widely published photojournalists of recent years, he has witnessed the work of the death squads in Central America, the sectarian fighting in Belfast, the steady rain of horrors in Lebanon and most of the weary spectacles the '80s and '90s had to offer. In 1989 he selected some of his work for a book, *Deeds of War,* that consists almost entirely of images of political violence—brutal, dark sequences.

In its seriousness and remarkable globe-trotting scope, Nachtwey's work is of the kind that was under severe pressure from two sides in the past fifteen years. In the private sector,

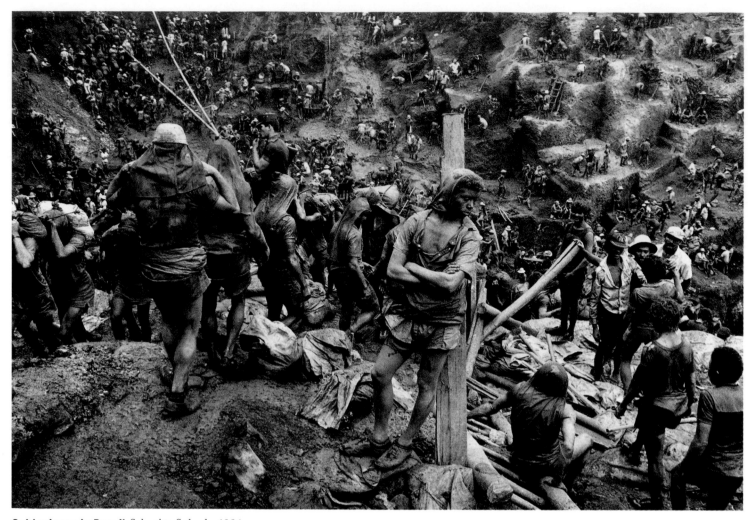

Gold miners in Brazil *Sebastião Salgado, 1986*

the newspapers and magazines where work is published, there was a greater demand for celebrity journalism and "life-style" pictures. A photographer could make a decent living by specializing in swank living rooms, Caribbean resorts and close-ups of Hollywood hopefuls. Complex photo essays and solemn social reporting had a harder time finding page space. And from the government side came a renewed threat of censorship.

In recent years, some places that were long off-limits to photographers became accessible. A few sealed precincts of life in the Soviet Union and Central Europe were at last opened to the press. In the United States, many courtrooms admitted cameras for the first time. (They had been banned in most states in reaction to the swarms of news photographers who covered the 1935 Lindbergh baby-kidnapping trial.) But there were too many other spots where the lens was met by an official hand raised to cover it: the Iran-Iraq war, the West Bank, the black townships of South Africa and the killing ground of Tiananmen Square. News photographers were banned from the U.S. invasion of Grenada. Soviet bombers fractured Afghan villages away from public view. Heeding the

lessons of Vietnam rather than the lessons of World War II, the Pentagon restricted press access to the battlegrounds of the Gulf war, amid widespread criticism of its censorship.

Add to these problems the pressure that the future will bring. The profession now has at its disposal advances in photographic technology that will change what pictures are capable of doing, just as the hand-held camera and the flashbulb once did. New digital equipment that breaks down an image into thousands of electronic impulses has made it possible to store photographs on a computer disk or to transmit them instantly via satellite. The advantage for news coverage is obvious: pictures taken at a summit meeting in Europe or at a demonstration in South Africa can be beamed at once to editorial headquarters elsewhere in the world, instead of being flown in by overnight jet.

With those changes come new problems. The difficulty is that related technologies also allow photographs to be altered electronically, a mixed blessing at best. Photo retouching, a craft that alters pictures subtly with pencil or paste or airbrush, has existed for a long time. Even many of the earliest

A child at play in Nicaragua *James Nachtwey, 1983*

daguerreotype pictures were hand-tinted. But conventional forms of retouching were always detectable by experts; they were often detectable by anyone. The computerized reworkings are different. It is virtually impossible to tell whether such pictures have been altered, leaving open the possibility that photographs will be able to lie in ways unimaginable in the past. In an era of dubious "re-enactments" on network newscasts, the photograph still says, "This happened." Each frame on the contact sheet represents some indisputable moment of contact with the world. The prospect of computer tinkering threatens to bring a day when the whole enterprise of picture taking will be not so subtly compromised.

Technical alteration of photographs penetrates to the heart of the relationship between the viewer and the image. TIME was widely criticized when its cover featured a photo-illustration by artist Matt Mahurin that used computer technology to darken a police mug shot of accused murderer O.J. Simpson; some even perceived racism at work. Critics charged the altered image betrayed the compact between viewer and editor: they argued that a picture should represent reality, not a computer-ized version of reality in the service of an editorial statement.

TIME managing editor James R. Gaines responded by noting that "altering news pictures is a risky practice, since only documentary authority makes photography of any value in the practice of photojournalism. On the other hand, photojournalism has never been able to claim the transparent neutrality attributed to it. Photographers choose angles and editors choose pictures to make points . . . and every major news outlet routinely crops and retouches photos to eliminate minor, extraneous elements, so long as the essential meaning of the picture is left intact. Our critics felt that Matt Mahurin's work changed the picture fundamentally; I felt it lifted a common police mug shot to the level of art, with no sacrifice to truth. If there was anything wrong with the cover, it was that it was not immediately apparent that this was a photo-illustration rather than an unaltered photograph; to know that, a reader had to turn to our contents page or see the original mug shot on the opening page of the story."

Yet few noticed or objected when TIME used computer retouching to alter the famous image of jeering Somalis drag-

The funeral procession of Queen Victoria *Photographer unknown.* The picture was retouched to accentuate details.

TAKE OUT MAN

President Woodrow Wilson with U.S. General John Pershing *Photographer unknown, U.S. Army Signal Corps.* In this picture a retoucher has partially removed a figure behind the two famous men.

ging a dead U.S. soldier through the streets of Mogadishu. In the original picture the genital organs of the soldier are clearly visible; the editors chose to alter the image as a final gesture of decency to one whose violation would be so universally witnessed. The altered version of the picture appears in this book.

These issues are important because the expanding domain of pictures is sure to expand further. It has now been more than a century since photography first poked its head into the pages of the press. Soon pictures shouldered aside columns of print. And we can be sure that they will continue to press upon space that words alone once occupied, obliging us to weigh carefully the ways that each form operates upon the understanding. A picture is not worth a thousand words. Pictures and words deal in separate coin that is not fully convertible. They reach in different directions, report to different faculties, create different impressions. In the practice of telling the news, pictures and words are like essential trading partners, two realms that deeply require each other. The form of their exchange will be the future of journalism itself.

O.J. Simpson *Photo-illustration by Matt Mahurin.* TIME's adaptation of a police mug shot on its cover angered readers.

Yalta Conference? *Paul Higdon, 1990.* New technology made it possible to include some latter-day gatecrashers among the Yalta Conference participants: Sylvester Stallone and Groucho Marx.

The fall of the Berlin Wall
Alexandra Avakian, 1989

The collapse of communism across Eastern Europe
made 1989 one of the most momentous years of the
20th century. Though much of the upheaval was
bloodless, it produced many memorable images, the
most symbolic being the demolition of the Berlin
Wall. Before moving on to Berlin and Prague,
Avakian spent several years covering the Middle East
for various publications.

Farewell to Lenin
Alfred, 1990

In another picture that perfectly captures the twilight
of the old order, the statue of Lenin that occupied a
prominent position in Bucharest is prepared for
removal by a metal cable—a 20th century noose.

Capping a burning oil well in Kuwait
Stephane Compoint, 1991

As allied forces put an end to Saddam Hussein's
takeover of Kuwait, retreating Iraqi troops set fire to
hundreds of oil wells. The massive operation to shut
down the wells yielded this remarkable picture,
in which the oil covering the workers lends the
burnished repose of metal sculpture to a scene of
frenzied activity.

America gets the news: War in the Gulf
Steve Liss, 1991

Reminiscent of Carl Mydans' picture of commuters on a train reading of the assassination of John F. Kennedy, Liss's picture was taken at a coffee shop in the small town of Rock Falls, Illinois.

Grieving soldier in the Gulf war *David Turnley, 1991*

Turnley snapped this memorable picture just after Sergeant Ken Kozakiewicz, on left, was notified that the body in the bag at right was that of a close friend, killed by friendly fire.

Politics in Panama *Ron Haviv, 1989*

His shirt was bloodied by an attack on his chauffeur; now vice-presidential candidate Guillermo Ford faces a beating by a member of the pro-government "Dignity Brigade."

Death in Somalia
Paul Watson, 1993

The body of a U.S. soldier is dragged through the streets of Mogadishu as Somalis jeer. Demonstrating the continuing power of still pictures to move minds, this image became a call-to-arms for those who opposed the U.S. mission in Somalia, and is still cited as a symbol of the perils of foreign engagement.

A funeral pyre in Nicaragua
Susan Meiselas, 1979

As a portrait of President Somoza bursts into flame, it partially obscures the horror behind it—the burning body of one of Somoza's National Guard. Political revolution and repression made Central America a major destination for photojournalists in the 1980s.

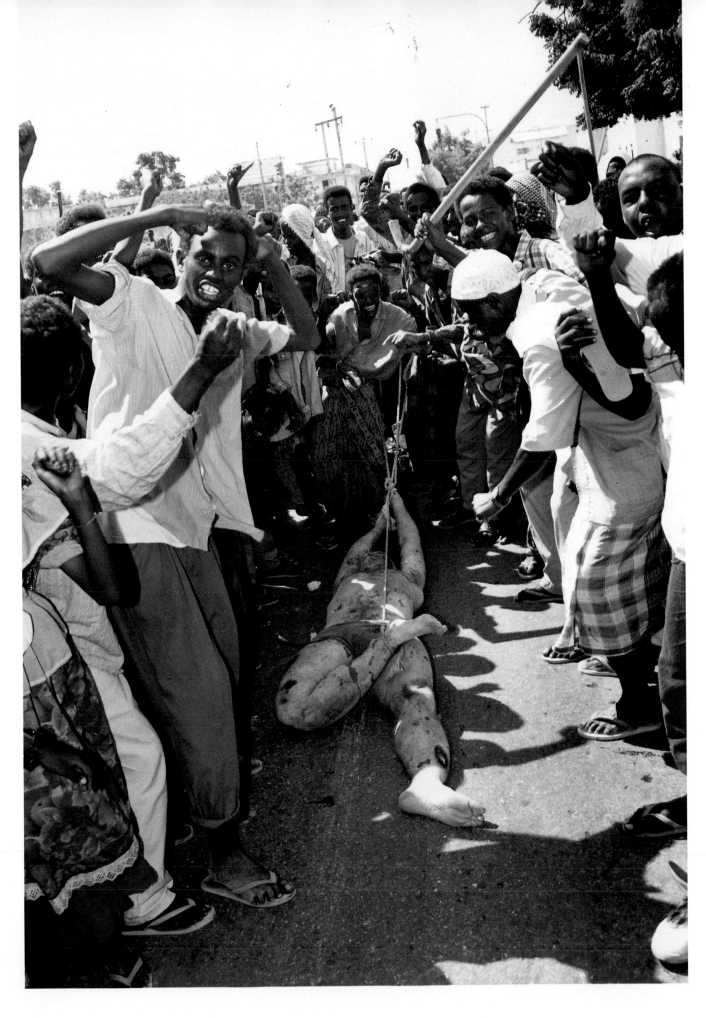

Having employed poison gas as a weapon in the war against Iran, Iraq's dictator Saddam Hussein did not hesitate to use the same deadly method against his own nation's Kurdish minority.

A cemetery in Sarajevo
Antoine Gyori, 1993

In its formal composition and elegiac tone, this image is in stark contrast to most pictures taken in the besieged Bosnian capital—blurred action shots taken on the fly that reflect the skittish quality of life in a city encircled by enemy troops and under constant bombardment and sniper fire.

A funeral in Croatia
Christopher Morris, 1991

A young boy weeps for his father, a victim of the war between Croatia and Serbia, the first of the recent conflicts between the republics of the former Yugoslavia. Like James Nachtwey, Morris often places himself in danger to capture pictures of people in extreme situations; he was captured and held for several days by Iraqi troops during the Gulf war.

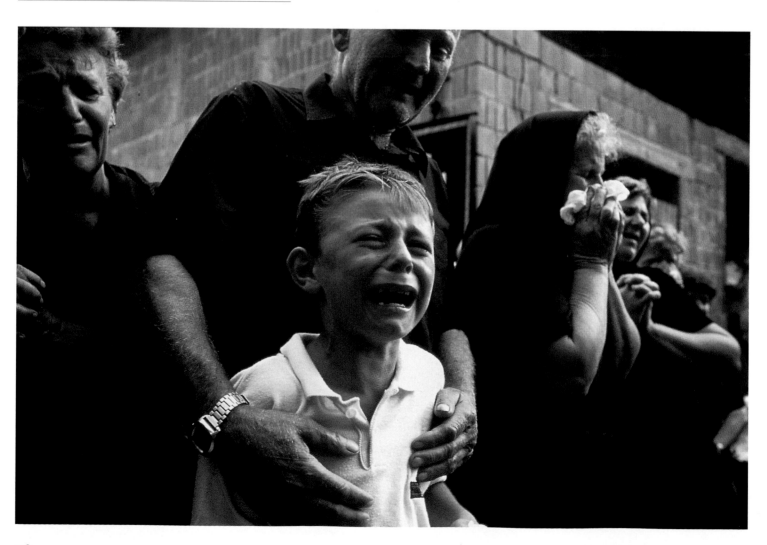

Death vigil in Sudan
Kevin Carter, 1993

This picture shocked the world and earned the Pulitzer Prize for South African photographer Carter. After taking it, Carter chased away the vulture that threatened the child—but the memories of the many violent scenes he recorded in the waning years of apartheid were not so easily shaken. *"You are making a visual here,"* he said of the photojournalist's plight, *"But inside something is screaming, 'My God!'"* A despondent Carter committed suicide in 1994.

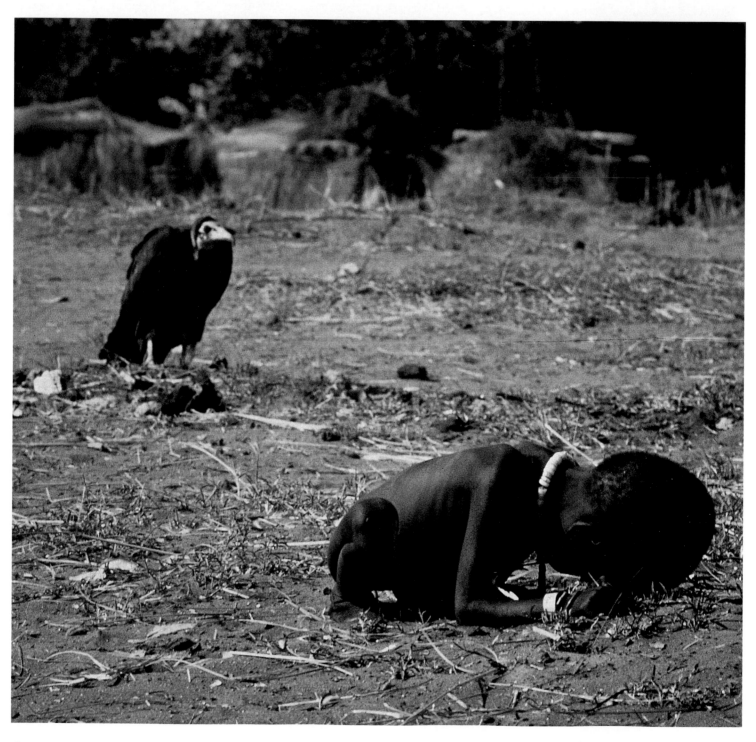

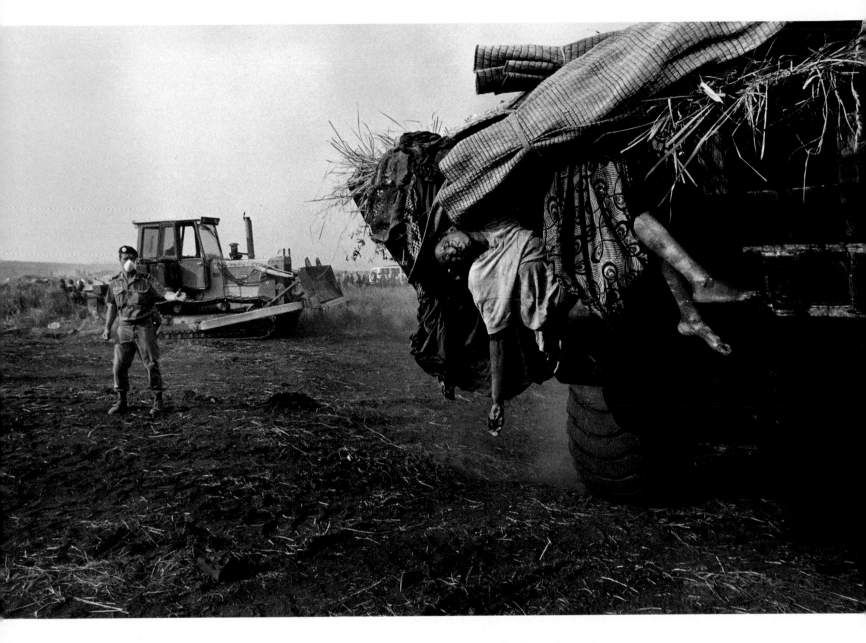

At a camp for Rwandan refugees
James Nachtwey, 1994

As horrific genocidal warfare convulsed Rwanda in the summer of
1994, hundreds of thousands of refugees fled to camps in Zaïre.
When an epidemic of cholera spread through the camps, Nachtwey
recorded the grisly labor of overwhelmed rescue workers as they
gathered up the dead in bulldozers for mass burial.

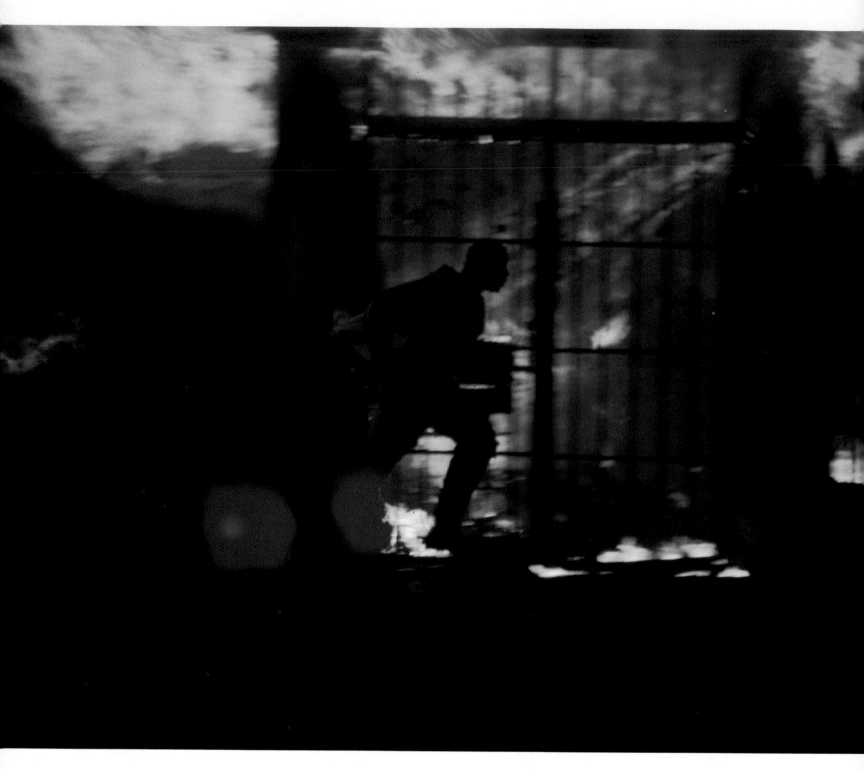

Rioting in Los Angeles
Ed Carreon, 1992

Ground zero on April 29, the first night of the riots in Los Angeles that followed the verdict absolving L.A. policemen in the beating of black traffic violator Rodney King. The riot's final toll: 53 dead, 2,383 injured, $775 million in property damage—and a profoundly shaken community.

Robert ("Yummy") Sandifer, executed at 11
Steve Liss, 1994

Three days after killing a 14-year-old girl in a botched revenge shooting, Chicago gang member Sandifer, 11, was executed by two teenage confederates. *"It was embarrassing, to be perfectly blunt,"* said photographer Liss. *"I stayed to the side, but I still felt like I didn't belong there."*

A woman smoking crack with her child beside her

Eugene Richards, 1990

In the course of preparing a photo essay about childhood in North Philadelphia's poorest slums, Richards made this picture of a woman smoking crack, a drug that was laying waste to neighborhoods already under assault from poverty. *"My baby always seems to know when the pipe comes out, and she fights it,"* the woman remarked. *"It makes me want to hurt her."*

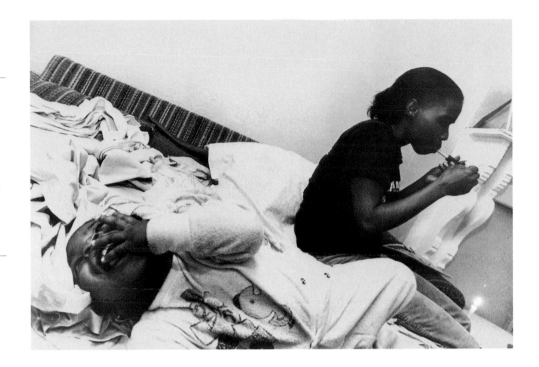

Mary Decker falls at the 1984 Olympics
David Burnett, 1984

After stumbling in a collision with runner Zola Budd, Decker grimaces in pain and anguish as she watches the 3,000-meter race proceed without her. Decker had grazed Budd, whose left leg then angled out, tripping Decker. *"I felt I was tied to the ground,"* she said later. *"All I could do was watch them run off."*

Tonya Harding pleads for mercy
Jack Smith, 1994

Tonya Harding arrived at the 1994 Winter Olympics in Norway
trailing clouds of scandal; she later admitted her complicity in the
vicious attack that left rival Nancy Kerrigan with an injured knee, and
accepted a plea bargain that included a fine and community service.
Here she appeals to judges when a lace on her skate broke in the first
moments of her free-skating routine. She failed to win a medal.

The great Mississippi flood
Bill Gillette, 1993

In the summer of 1993 a "500-year flood" left some
70,000 people homeless when roiling floodwaters
broke through the levees along the Mississippi River
and its tributaries. From earthquakes in Los Angeles
and Tokyo to raging fires in the hills of California
to volcanic eruptions in the Philippines, natural
disasters in the 1990s have provided photographers
with striking images of nature's power—and man's
stubborn endurance in its wake.

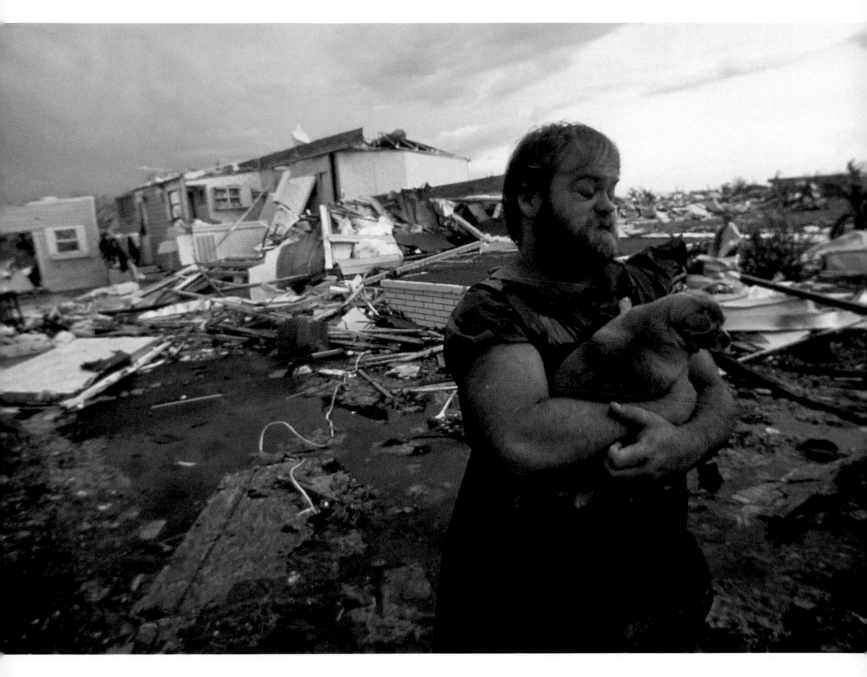

After the hurricane
Lannis Waters, 1992

In August 1992, Hurricane Andrew rampaged from
the Bahamas across south Florida and into Louisiana
with winds raging up to 164 m.p.h. Photographer
Waters captured Gary Davis of Homestead, Florida,
as he stood outside the wreckage of his mobile home
cradling one precious possession denied the hurricane.

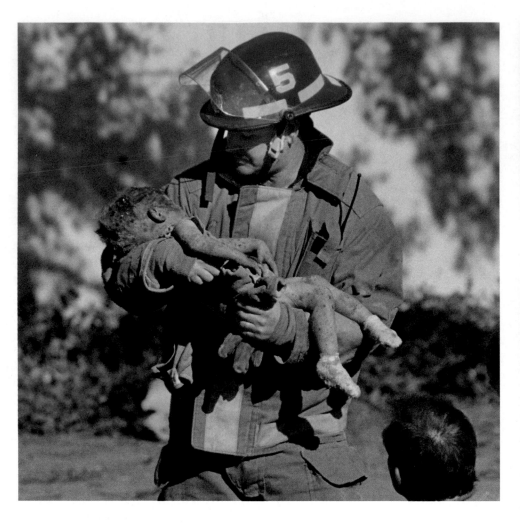

Fireman and child in Oklahoma City
Charles H. Porter IV, 1995

Appearing in newspapers from coast to coast, this picture of firefighter Chris Fields cradling the body of one-year-old Baylee Almon in his arms came to symbolize both the tragedy and the heroism involved in the terrorist bombing of the federal building in Oklahoma City in April 1995.

Remembering the victims of the bomb
Steve Liss, 1995

A young boy joins in the prayers at a candlelight vigil in Stillwater, Oklahoma, in memory of those who died in the Oklahoma City blast. The bombing of the Alfred P. Murrah Federal Building by terrorists seemed particularly ruthless, since a large day-care center was located within it.

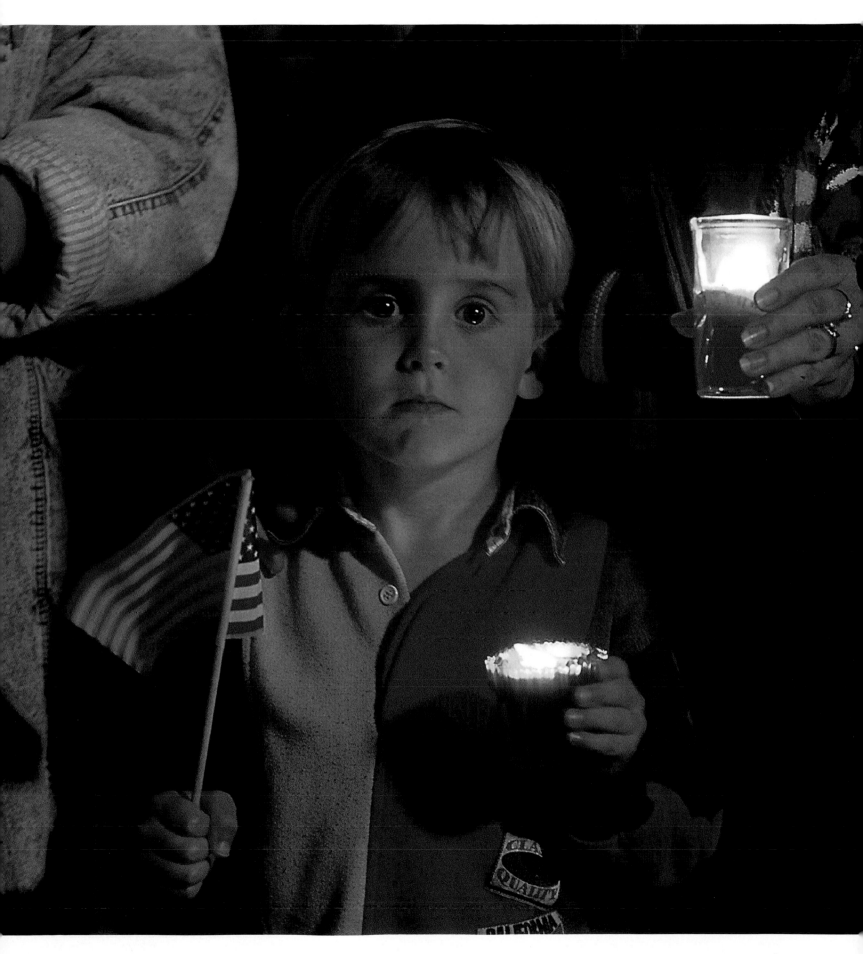

PHOTOGRAPHY CREDITS

8: Louis Jacques Mandé Daguerre, Bayerisches National Museum, Munich; 10 *left:* Timothy H. O'Sullivan, Library of Congress; *right: Harper's Weekly,* July 16, 1864, Library of Congress; 11: Roger Fenton, Library of Congress; 12-13: Timothy H. O'Sullivan, Library of Congress; 14: Alexander Gardner, Culver; 15: Félice Beato, Radio Times Hulton Picture Library, BBC; 16: Maxime du Camp, Victoria and Albert Museum, New York Public Library; 18 *top:* Carl Ferdinand Stelzner, Bildarchiv Preussischer Kultur Besitz, Berlin; *bottom:* William Henry Fox Talbot, The Science Museum, London; 19: Paul Nadar, Harry Ransom Humanities Research Center, U. of Texas at Austin; 20: George N. Barnard, George Eastman House; 21 *top:* Platt D. Babbitt, Harry Ransom Humanities Research Center, U. of Texas at Austin; *bottom:* George Barker, George Eastman House; 22 *top:* unidentified photographer, Library of Congress; *bottom:* unidentified photographer, Library of Congress; 23 *top:* Mathew Brady, National Archives; *bottom:* unidentified photographer, Library of Congress; 24 *top:* Alexander Gardner, Library of Congress; *bottom:* Timothy H. O'Sullivan, National Archives; 25 *top:* Mathew Brady, National Archives; *bottom:* Alexander Gardner, Metropolitan Museum of Art; 26 *top:* Francis Frith; *bottom:* Robert Howlett, George Eastman House; 27 *top:* John Moran, George Eastman House; *bottom:* Bisson Brothers, Bibliotheque Nationale, Paris; 28 *top:* Andrew J. Russell, courtesy Union Pacific Historical Museum; *bottom:* Timothy H. O'Sullivan, National Archives; 29: Eadweard Muybridge, U. of Calif. Los Angeles, U. Research Library, Spec. Collections; 30: Leon Gimpel, Collection of the Société Française de Photographie, Paris; 33: S.W. Westmore, Library of Congress; 34: unidentified photographer for The Pictorial News Company, Keystone View Co.; 36 *top left:* Paul Nadar, Pictures Inc.; *top right:* Paul Nadar, Pictures Inc.; *bottom left:* Paul Nadar, George Eastman House; *bottom right:* Paul Nadar, Pictures Inc.; 37: Frances Benjamin Johnston, Library of Congress; 38: Arnold Genthe, The Fine Arts Museum of San Francisco, Aschenbach Foundation for Graphic Arts; 39 *top:* Barney Roos, John Faber Collection; *bottom:* William Warneke, Press Publishing Co. (New York *World*); 40 *top:* James Hare, Harry Ransom Humanities Research Center, U. of Texas at Austin; *bottom:* James Hare, Harry Ransom Humanities Research Center, U. of Texas at Austin; 41: Roland W. Reed, National Geographic; 42: Harlan A. Marshall, Library of Congress; 43 *top:* unidentified photographer, UPI/Bettmann; *bottom:* unidentified photographer, Underwood & Underwood; 44-45: unidentified photographer, Imperial War Museum, London; 44 *bottom:* unidentified photographer, Underwood & Underwood; 45 *bottom:* unidentified photographer, Underwood & Underwood; 46 *top:* unidentified photographer, Underwood & Underwood; 46 *bottom:* unidentified photographer, Imperial War Museum, London; 47: unidentified photographer, Underwood & Underwood; 48: unidentified photographer, Imperial War Museum, London; 49: unidentified photographer, National Archives—U.S. War Dept.; 50 *top:* Max Pohly; *bottom:* unidentified photographer; 51 *top:* unidentified photographer, Imperial War Museum, London; *bottom:* Horace Nicholls, Imperial War Museum, London; 52: unidentified photographer, Underwood & Under-

wood; 53: Tom Howard, New York *Daily News;* 54: Jacob A. Riis, Museum of the City of New York, The Jacob A. Riis Collection; 57: Lewis W. Hine, George Eastman House; 58: Lewis W. Hine, Amon Carter Museum, Fort Worth, Texas; 60: John Thomson, New York Public Library; 61 *top:* Jacob A. Riis, Museum of the City of New York, The Jacob A. Riis Collection; *bottom:* John Thomson, New York Public Library; 62 *top:* Lewis W. Hine, New York Public Library; *bottom:* Lewis W. Hine, Museum of the City of New York; 63: Lewis W. Hine, New York Public Library; 64 *top:* Lewis W. Hine, George Eastman House; *bottom:* Jacob A. Riis, Museum of the City of New York, the Jacob A. Riis Collection 65 *top:* Lewis W. Hine, George Eastman House; *bottom:* Lewis W. Hine, New York Public Library; 66: Willi Ruge, Collection of Dr. N. Tim Gidal; 68 *left:* Willi Ruge, Bildarchiver Kultur Besitz, Berlin; 68 *right:* Willi Ruge, Bildarchiv Preussischer Kultur Besitz, Berlin; 69: Martin Munkacsi, Bildarchiv Preussischer Kultur Besitz, Berlin; 70: unidentified photographer, Paulus Lesser; 72: Boris Ignatovich; 74 *top:* Dr. Erich Salomon, Collection of Dr. N. Tim Gidal; *bottom:* Dr. Erich Salomon; 75: Alfred Eisenstaedt, LIFE; 76 *top:* Felix H. Man, Bildarchiv Preussischer Kultur Besitz, Berlin; *bottom:* Carl Mydans, LIFE; 77 *top:* André Kertész, Estate of André Kertész; *bottom:* André Kertész, Estate of André Kertész; 78: Carl Mydans, LIFE; 79: Alfred Eisenstaedt, LIFE; 80 *top:* H.S. ("Newsreel") Wong, UPI/Bettmann International News Photo; *bottom:* Robert Capa, Magnum; 81: Sam Shere, UPI/Bettmann; 82 *top:* Weegee (Arthur Fellig), © 1994 International Center of Photography, New York. Bequest of Wilma Wilcox; *bottom:* Weegee (Arthur Fellig), © 1994 International Center of Photography, New York. Bequest of Wilma Wilcox; 83: I. Russell Sorgi, Buffalo *Courier Express;* 84 *top:* Martin Munkacsi, Estate of Martin Munkacsi, courtesy of the Howard Greenberg Gallery; *bottom:* © The Harold E. Edgerton 1992 Trust, courtesy of Palm Press, Inc.; 85: Hy Peskin, LIFE; 86 *left:* Alfred Eisenstaedt, LIFE; *right:* Berenice Abbott, Commerce Graphics Ltd., Inc.; 87: Barney Cowherd, Louisville *Courier Journal;* 88 *top:* Robert Capa, Magnum; *bottom:* © Ruth Orkin; 89: Nina Leen, LIFE; 90 *top:* Henri Cartier-Bresson, Magnum; *bottom:* John Vachon, Library of Congress; 91: Milton ("Pete") Brooks, AP/Wide World, (The Detroit *News*); 92: Nat Farbman, LIFE; 93 *top:* Henri Cartier-Bresson, Magnum; *bottom:* Dmitri Kessel, LIFE; 94: Nina Leen, LIFE; 95: Arthur Rothstein, Library of Congress; 96 *top:* Margaret Bourke-White, LIFE; *bottom:* unidentified photographer; 97 *top:* Margaret Bourke-White, LIFE; *bottom:* Margaret Bourke-White, LIFE; 98: Arthur Rothstein, Library of Congress; 99 *top:* Walker Evans, Library of Congress; *bottom:* Russell Lee, Culver; 100 *top:* Dorothea Lange, Library of Congress; *bottom:* Paul Taylor, © the Dorothea Lange Collection, the Oakland Museum; 101: Dorothea Lange, Library of Congress; 102: Kelso Daly, UPI/Bettmann International News Photo; 103: unidentified U.S. Navy photographer, UPI/Bettmann; 104: Robert Jakobsen, Los Angeles *Times;* 105 *top:* Robert Capa, Magnum; *bottom:* Ralph Morse, LIFE; *top:* Charles Kerlee, U.S. Navy Photo; 106 *bottom:* Cecil Beaton, Sotheby's London; 107: John Topham, UPI/Bettmann International News Photo; 108: Dr. N. Tim Gidal, Bildarchiv Preussischer Kultur Besitz,

Berlin; 109: Carl Mydans, LIFE; 110: Henri Cartier-Bresson, Magnum; 111: Dmitri Kessel, LIFE; 112 *top:* W. Eugene Smith, LIFE; *bottom:* Bernie Schoenfeld; 113: W. Eugene Smith, LIFE; 114: Dmitri Baltermants; 115 *top:* Robert Capa, Magnum; *bottom:* Lee Miller, © Lee Miller Archives; 116 *top:* David Seymour, Magnum; *bottom:* Margaret Bourke-White, LIFE; 117: Ernst Haas, Magnum; 118: Joe Rosenthal, AP/Wide World; 119 *top:* David Douglas Duncan; 119 *bottom:* unidentified photographer; 120: Carl Mydans, LIFE; 121: Alfred Eisenstaedt, LIFE; 122: Fritz Goro, LIFE; 123: unidentified photographer, U.S. Air Force; 124: Loomis Dean, LIFE; 126: W. Eugene Smith, LIFE; 128: Stanley J. Forman; 129: Malcolm Browne, AP/Wide World; 130-131: Larry Burrows, LIFE; 132: Dan Weiner, courtesy Sandra Weiner; 133 *top:* Walter Sanders, LIFE; *bottom:* Loomis Dean, LIFE; 134: Philippe Halsman © Halsman estate; 135: Bill Ray, LIFE; 136: David Douglas Duncan; 137: Carl Mydans, LIFE; 138 *top:* David Douglas Duncan; *bottom:* Henri Cartier-Bresson, Magnum; 139 *left:* Dennis Stock, Magnum; *right:* Burt Glinn, Magnum; 140: Loomis Dean, LIFE; 141: Leonard McCombe, LIFE; 142: Bob Jackson, Dallas *Times Herald;* 143 *top:* Carl Mydans, LIFE; *bottom:* Howard Sochurek, LIFE; 144: Bill Eppridge, LIFE; 145: John Filo; 146: Bruce Davidson, Magnum; 147 *top:* Leonard Freed, Magnum; *bottom:* Gordon Parks; 148: Bruce Davidson, Magnum; 149: James H. Karales; 150 *top:* John Loengard, LIFE; *bottom:* Slim Aarons; 151: Matthew Zimmerman, AP/Wide World; 152: Ralph Morse, LIFE; 153 *top:* Alfred Eisenstaedt, LIFE; *bottom:* Gjon Mili, LIFE; 154: Wallace Kirkland, LIFE; 155 *top:* Leonard McCombe, LIFE; *bottom:* Raymond Depardon, Magnum; 156 *all:* Eddie Adams, AP/Wide World; 157 *top:* Sal Veder, AP/Wide World; *bottom:* Huynh Cong ("Nick") Ut, AP/Wide World; 158: W. Eugene Smith, © the Heirs of W. Eugene Smith, courtesy Black Star; 159 *top:* W. Eugene Smith, LIFE; *bottom:* W. Eugene and Aileen Smith, the heirs of W. Eugene Smith, courtesy Black Star; 160 *top:* Henri Cartier-Bresson, Magnum; *bottom:* Paul Schutzer, LIFE; 161: W. Eugene Smith, LIFE, Center for Creative Photography, Tucson; 162: Don McCullin, Magnum; 163: William Anders, NASA; 164: Stuart Franklin, Magnum; 166: Mary Ellen Mark/Library; 167: Alex Webb, Magnum; 168: Sebastião Salgado, Magnum; 169: James Nachtwey, Magnum; 170 *top:* unidentified photographer, *Illustrated London News; bottom:* unidentified photographer, U.S. Army Signal Corps; 171 *top:* photo-illustration by Matt Mahurin for TIME; *bottom:* Paul Higdon, New York *Times;* 172: Alexandra Avakian, Woodfin Camp; 173: Alfred, SIPA; 174: Stephane Compoint, Sygma; 175 *top:* Steve Liss, TIME; *bottom:* David Turnley, Detroit *Free Press,* Black Star; 176 *top:* Ron Haviv, AFP; *bottom:* Susan Meiselas, Magnum; 177 Paul Watson, Toronto *Star,* Sygma; 178 Christopher Morris, Black Star; 179 *top:* Ramazan Oztürk, SIPA; *bottom:* Antoine Gyori, Sygma; 180: Kevin Carter, Sygma; 181 James Nachtwey, Magnum 182: Ed Carreon, Orange County *Register,* SIPA; 183: *top:* Eugene Richards, Magnum; 183 *bottom:* Steve Liss, TIME; 184: David Burnett, Contact Press Images; 185: Jack Smith, AP/Worldwide; 186: David Gillette, Gamma Liaison; 187: Lannis Waters, Palm Beach *Post,* Sygma; 188: Charles H. Porter IV, Sygma; 189: Steve Liss, TIME.

INDEX